Parachute:
The Anthology
(1975–2000)
[Vol. 1]

Chantal Pontbriand
[ed.]

Parachute:
The Anthology (1975–2000)
Museums, Art History,
and Theory [Vol. 1]

JRP|RINGIER & LES PRESSES DU RÉEL

Table of Contents

Introduction
Alexander Alberro
and Nora M. Alter

In 1975, a small group of enterprising, ambitious members of the art community in Montreal posed the following questions: "What do we know of contemporary art outside of Quebec, in Canada or abroad? Do we even know what contemporary art exists in Montreal … How does information about art circulate?"[1] By way of an answer, the artistically unconventional and theoretically cutting-edge magazine *Parachute* was launched. Founded by Chantal Pontbriand and France Morin, the emergence of this Montreal-based magazine coincided with that of a number of other international art journals in art world capitals, including *October* (New York), *Art Press* (Paris), *Flash Art* (Milan), and a few years later *Parkett* (Zurich).[2] The proliferation and success of these print publications is symptomatic of the unprecedented expansion of the art world's discursive spheres that took place in the 1970s. What is often forgotten today, however,

is that this expansion (for some it came to characterize "postmodernism") affected not only the production and exhibition of art, but also the sites where theoretical debate could take place. Following Conceptual art's problematization of the function of the art magazine in the late 1960s and 1970s, few would now question the important role that magazines and journals play in the operation of the art world.[3] Art periodicals today operate as vehicles for the evaluation and dissemination of artistic practices, as well as locations for the elaboration of interpretive approaches capable of addressing the extraordinary complexity and sudden tentativeness of art following the collapse of the modernist paradigm. Furthermore, they address a remarkably diverse readership comprised not only of artists and those connected with exhibiting and marketing their work, but also of academics and a general public increasingly interested in art and culture. It is within this expanded field that *Parachute* must be considered.

When *Parachute* first appeared alongside other periodicals in the art section of magazine stands, a significant difference was immediately apparent: the essays and reviews it featured were in both French and English. This promptly rendered the magazine the most important dual-language publication in the art world, which it remained until its interruption for financial reasons in 2007. Inaugurated in a predominantly French-speaking city in a country where the majority use English as their primary language, from the outset the editors of *Parachute* understandably felt the need to cater to both audiences. Indeed, the title, *Parachute*, was selected in part because the word is spelt the same in both French and English. Yet, even in Canada, *Parachute* was an anomaly from the beginning. In the 1970s, the Liberal government of Prime Minister Pierre Elliot Trudeau sponsored a number of initiatives that sought to create a truly bilingual nation through the support of art and culture. But in reality there was a significant division between the French- and English-speaking sectors of the country—a breach manifest most poignantly in the cultural domain. From its inception, *Parachute* responded to the often self-imposed segregation by both constituencies with the belief that such prejudices promoted a provincialism of thought and practice.

The new magazine, the editors hoped, would "achieve an interdisciplinary and international exchange which [would] break down the cultural barriers and find an antithesis to regionalism."[4] Just as a parachute is designed to save lives, so *Parachute* was conceived of from the outset as a necessary remedy for the shortcomings of the contemporary cultural scene in Canada and abroad.

The ramifications of *Parachute's* bilingualism are far broader than may at first be apparent. For instance, by publishing in both French and English the magazine could cater to an international constituency of readers, extending beyond traditional national (and hence linguistic) borders. With an average circulation of over 4,000 copies per issue, *Parachute* was distributed well beyond the context of North America. Furthermore, in geographical and linguistic terms *Parachute* was from the outset self-consciously placed between the two capitals of modern and contemporary art: New York and Paris. Of course, this was in tandem with the magazine's mission to establish Montreal, and by extension Canada, as a vital site in the international art community. Indeed, *Parachute* was to function as an important organ in several different ways. In the first place, it was designed to exchange information and raise the level of discussion on American and European art within the Canadian and North American context. In addition, it aimed to introduce Canadian and Quebecer artists to the rest of the world. Moreover, by featuring Canadian artists, writers, and critics alongside their American and European counterparts, the magazine served to establish through parallelism an equivalence between the three cultural contexts. Finally, and in retrospect perhaps most importantly, the magazine provided and developed a much-needed venue for serious art criticism, not only in Canada but also internationally, as the essays collected in this volume attest.

By publishing in two languages, *Parachute* functioned paradigmatically as a hybrid entity. It combined Francophone and Anglophone voices from North America and Europe, and increasingly over time from other continents, with each contributing to an essential international dialogue. From the standpoint of the contributors, the possibility of publishing in either French or English, and to have one's work disseminated in a bilingual context, was from the

beginning an attractive prospect. The dynamic effect of the placement of essays by these figures alongside each other in issue after issue of the magazine radically questioned and helped to dismantle the established national and cultural borders that had impeded intellectual exchange. Furthermore, the mix of cultural traditions was paralleled by the authoritative roster of writers from different disciplinary backgrounds: philosophy, art history, literary criticism, cultural anthropology, sociology, and art. An inventory of contributors reveals a truly impressive international list.[5] The result is an intricate mixing and interweaving of the local with the international, Francophone with Anglo-American intellectual traditions, creating a multicultural intervention in the field of contemporary art.

From the beginning, then, the editors of *Parachute* emphasized the multi-disciplinary aspects of art and recognized these hybrid practices as major sites of creativity. The magazine's mission was thus to break down all barriers: linguistic/cultural, national/political, and disciplinary/institutional. As underscored by Pontbriand in 1999, "the traditional boundaries of art continue to explode under similar circumstances as those of territory and language; technological advances are in the process of transforming art and perception."[6] Indeed, the conviction that new media, genres, and concepts for creating and understanding both art and the world need to be invented was central to the editors of *Parachute*. This process, also known as heuretics or the logic of invention, explains, for example, the strong link between photography and the genre of portraiture in the 19th century, or between cinema and narrative in the 20th century.[7] Pontbriand continues, "communication has engendered a blurring of artistic disciplines, which relates to the urgency of creating new languages for a new and changing world."[8]

Pontbriand's notion of hybridity is illustrated by the list of art and artists featured in *Parachute* over the years. Many of the artists given prominence in the magazine produce works that in some form or another transcend conventional media and genre boundaries. This is coupled by a list of contributors that emphasizes writers who self-reflexively question not only art but the practice of writing

as well. Indeed, the world of artists who explore new media such as video, performance, the body, installation—works that pushed beyond conventional parameters toward multi-media, multi-disciplinary, hybrid creations—has been a consistent point of focus for the magazine from the beginning. Furthermore, *Parachute* has also been persistent in its effort to erase the barrier between the makers of art and the writers of art by including the voice of the artist alongside reviews and essays written by critics, art historians, and theorists.[9]

In order to find writers to address the work of these experimental, innovative, and often not yet established artists in all of its complexity, the editors sometimes found it necessary to go outside the disciplines of art history and criticism. To fully articulate the novelty of these practices required a familiarity with contemporary ideas, and thus it was essential for *Parachute* to look to the related fields of philosophy, sociology, anthropology, literary criticism, film theory, and psychoanalysis. Moreover, *Parachute* sought to tap into the contemporary interrogation of social and cultural values naturalized over the years by presenting a venue for voices of contestation. The aim was to change the field of art radically and fundamentally. To a certain extent, then, the magazine continued, through the medium of print culture, the political activism of the 1960s and 1970s. From the beginning, the editors sought to avoid producing yet another "modernist" tract with the attendant "prejudice, partisanship, and snobism."[10] Rather, as the editorial to the first issue explicitly stated: "Information about art must be placed not only within its own historical frame of reference but the political, social, and economic context must also be taken into account."[11] Furthermore, from its inception Pontbriand and Morin were firm in their belief that writing about visual art must be theoretically informed. As the essays collected in this volume reveal, the magazine remained true to both of these goals.

Parachute was a quarterly journal since its inception in 1975. Changes in its format over the past two decades have tended to reflect the increasing expansion and significance of the publication. Thus, in 1980 a "Reviews" section was added that was designed to provide coverage of current national

and international exhibitions and shows in a more concise form than was previously the case. At the same time, beginning in 1984 there was a move to focus more closely on specific topical themes and developments, with at least one volume a year devoted to a "Special Issue." The topics of the latter are revealing, and include, among others, cinema, architecture, sculpture, installation, video, new technologies, photography, mass culture, fashion, gardens, museums, collections, the city, and the body. Some of the essays reprinted in this publication were originally published in this context. In 1985, a part of the magazine was consecrated to a lively debate section, and in 1989 the column "Books and Magazines" was added to meet the growing interest and demand from readers for reviews of recent publications in French and English. Following the year 2000, the journal decided to focus one issue a year on "cities of emergence," namely cities presently coalescing cultural conditions that in turn generate novel art practices such as Mexico City and Beirut, thereby keeping abreast of shifts in the center of the art world. *Parachute* has continuously represented a crucial and dynamic flank within the realm of art publications, and firmly established itself alongside its counterparts.

The essays collected in this volume of an anthology that will count four have been selected from the first 25 years of *Parachute's* publication history. They reflect important trends and transformations in contemporary art practices and theory of the past quarter century. Part of the value of this anthology is that it documents changes and transformations in both art practice and writing over the past quarter of a century. Needless to say, as with any anthology, it has been difficult to decide which texts to include. An attempt has been made to paint as broad a swath as possible by selecting representative essays from an array of perspectives and backgrounds. Moreover, a number of texts that were particularly significant in redefining art practice or art writing have also been included in the anthology. However, attempts have been made not to reprint articles that address issues or the work of artists taken up by other entries in the different volumes, even if they do so from different perspectives. This has obliged us to exclude a considerable number of valuable contributions to the magazine over the years.

As it now stands, this anthology in four volumes serves as a kind of time capsule that, when opened, allows the reader the opportunity to glimpse back into the past and discover artists, ideas, and theories about art in their developmental stage as they first came into focus. It is fascinating to observe the initial impact and influence of some of these artists and concepts. In some instances, that impact has faded over time, while in others it remains as trenchant and timely today as it was when it was first addressed in *Parachute*. For some, the experience of reading these essays will prompt recollections of changes in the discipline that took place for over a quarter of a century. The experience will be different, but equally rich, for readers whose interest in art is more recent. For, from the start, *Parachute* gravitated toward the latest creative tendencies and critical approaches in art, and thus the essays featured in the following pages provide a useful genealogy of the emergence and development of new artistic practices and the extent of their repercussions.

One of *Parachute's* strengths over the years has been its early coverage of the work of important artists who have gone on to receive broad acclaim. Artists such as Jeff Wall, Bill Viola, Stan Douglas, Eija-Liisa Ahtila, and many others, had the first significant critical reception of their work in *Parachute*. Similarly, figures such as Douglas Crimp, Thomas Crow, Thierry de Duve, Georges Didi-Huberman, Hal Foster, Reesa Greenberg, Serge Guilbaut, and Laura Mulvey, all of whom have helped define the parameters of art history, theory, and practice, published rigorous, highly pertinent essays in the journal early on in their careers. Many of the articles published in *Parachute* have gone on to serve as valuable reference tools for artists, historians, students, curators, and researchers. Although the 48 essays reprinted in the four volumes are but a small portion of what has appeared in the magazine over the years, they are representative of its contents and of its uniquely constructed identity. Each book thus serves as an important resource for anyone interested in tracking the development of art and art writing over the last quarter of the 20th century.

The anthology is divided into four volumes: I. Museums, Art History, and Theory; II. Performance and Performativity; III. Photography, Film, Video, and New Media;

IV. Painting, Sculpture, Installation, and Architecture. Within each volume the essays have been ordered chronologically in order to provide the reader with a sense of the development both of the "media" under consideration and of the particular focus of the art writing. Given that *Parachute* has constantly sought to erase and transgress conventional borders, the decision to construct categories following traditional lines of demarcation may at first seem contradictory to the overall mission of the magazine. Yet the categories have been erected with the hope that such divisions will aid in making each volume more accessible to the outside reader while still providing a source for the art specialist.

The volumes are to be taken as signposts or markers. As will be immediately evident, neither the categories, nor the media, nor the theoretical essays, are pure. Rather, they are continuously juxtaposed and blurred, thereby calling into question the very attempt to separate them into distinct practices. Moreover, the chronological ordering will aid the reader in discerning the parallel and divergent developments in different media. For instance, during the 1970s and early 1980s the magazine published an abundance of theoretical essays informed by post-structuralism, institutional critique, and psychoanalysis, as well as writings that attempted to rethink the medium of painting and the limits of performance and Body art. The medium of photography received particular attention in the early 1980s, and those of film and video later in that decade and in the beginning of the next. More recently, texts that explore issues of postcolonialism, the idea of community, and the cultural politics of transnationalism are predominant, as is the focus on various forms of installation art and new media. Overall, the essays reflect the intellectual and artistic breadth and diversity of the first 25 years of *Parachute*.

* * *

The eight essays that comprise this first volume all address the state and function of art history, criticism, and theory in their own particular moment. Most have subsequently come to be considered as crucial attempts to redefine the way art is written, taught, and thought about. It is as significant as it is revealing that most of the articles appeared

during the first decade of *Parachute's* publication—a period that witnessed the proliferation of "theory" in art writing and production alike.

The volume begins with a seminal interview, "De la fonction critique à la transformation" [From Critical Function to Transformation] conducted in 1978 between Jean Papineau and Jean-François Lyotard. In the interview, Lyotard stresses that artistic activity is positive, not negative; it is a process of transformation. Mainly referring to the work of Marcel Duchamp, but also to that of Paul Cézanne and John Cage, Lyotard claims that art is not made to communicate a reality but rather is itself a reality. It is not to be understood, or known, but to be experienced as a self-evident statement, or utterance ("énoncé"), without a metalanguage to guide it to a communicable explanation.

A very different methodology informs Serge Guilbaut's "Les nouvelles aventures de l'avant-garde en Amérique" [The New Adventures of the Avant-Garde in America] of 1979. The essay is directly related to the thesis of Guilbaut's seminal study of 1983, *How New York Stole the Idea of Modern Art: Abstract Expressionism, Freedom, and the Cold War*. Guilbaut's argument addresses the conditions not only of the production of Abstract Expressionism, but also of the elaboration of Clement Greenberg's modernist paradigm and its role in the ratification of the New York School of painting in ways that misrepresented its causal conditions. Guilbaut relates the development of US modernism to the de-Marxification of the American intelligentsia that began in 1937 with the conversion to Trotskyism by former supporters of the Popular Front. He then tracks the disaffection of the American Left with the development of Greenberg's criticism and the rise of American liberalism. Guilbaut's text is significant not only because of the conclusions the author draws, but also for its development of a social historical mode of investigative research within the context of art history.

Reesa Greenberg's institutional critique, "MoMA and Modernism: The Frame Game," 1986, examines the reframing of MoMA's permanent collection under the direction of William Rubin. Although focusing on but one historical instance, Greenberg's scholarship is exemplary in that it addresses the significance of framing, exploring the

development of the frame from standing in as a surrogate for the hand of the artist to representing the signature of the owner of the work. Greenberg also demonstrates how frames are designed to support dominant trends and theories in art history, with modernism being the key trope at New York's Museum of Modern Art.

Greenberg's in-depth analysis of MoMA constitutes just one example of how an art institution shapes a collection in order to best suit its needs. Hans Haacke's seminal "Museums Managers of Consciousness," 1987, goes one step further, to argue that museums are just one part of a much larger all encompassing network, or "industry," comprised of exhibiting institutions. Haacke's argument borrows from the work of Hans Magnus Enzensberger, who proposed that "consciousness" is actively produced, shaped, manipulated, and controlled by the interplay of a variety of social, political, economic, and cultural forces. Enzensberger refers to this process as the "consciousness industry." Haacke, in turn, applies Enzensberger's concept to the art world, viewing the latter through the lens of a complicated business operation rather than as gestures of individual means of expression. As he plainly states at the outset, "Artists as much as their galleries, museums, and journalists, not excluding art historians, hesitate to discuss the industrial aspect of their activities. An unequivocal acknowledgement might endanger the cherished romantic ideas with which most entered the field, and which still emotionally sustain them today." Haacke then details the ever-increasing bureaucratization of the art world, from a new "breed" of "art managers" who appear on the "industrial landscape," to artists who take courses to learn how to professionalize the practice. The art market depends upon the smooth operations of a vast network of components that are part of the art industry. Museums, whether private or public, play a key role—which in Haacke's view is always political—in this intricate web. The implications of this "consciousness industry" are significant, exceeding the limited sphere of culture and aesthetics. Haacke notes, "the term 'culture' camouflages the social and political consciousness resulting from the industrial distribution of consciousness." Haacke justifies his self-conscious positioning as a player in this industry by suggesting that even though the situation is dire,

there are always ambiguities, always tears in the fabric that allow for new possibilities to emerge.

René Payant's "L'art à propos de l'art : la question de la citation" [Art on Art: The Question of Quoting], 1979–1980, insightfully examines the function of citation in works of art. Using Leo Steinberg's introduction to the catalogue for the Whitney Museum of American Art's 1978 show, "Art about Art," as a point of departure, Payant skillfully expands on and complexifies Steinberg's theses by drawing on Julia Kristeva's concept of intertextuality and Claude Lévi-Strauss' theory of bricolage. Payant was a professor of art history at the University of Montreal and a member of the editorial board of *Parachute* before his untimely death in 1988. His essay still stands today as an extremely useful theoretical model for understanding art that references art.

Bruce Barber, in "Appropriation/Expropriation: Convention or Intervention?" 1984, charts a history of appropriation art that dates back to the early 15th century and is linked to the emergence of copyright laws. His detailed analysis of a number of practices, ranging from copying to borrowing, "making in the style of" to outright forgery, makes clear just how murky and complicated the matter of appropriation is. In addition to examining the legal and practical aspects of appropriation, Barber traces the conscious theoretical act of borrowing. He shows the various ways in which appropriation in modernity became a political gesture. Within contemporary practice, Barber locates several different models of appropriation that include readymades, montages, performances, and the like. He concludes with two examples from Walt Disney comic strips to illustrate how what he refers to as "low culture" critiques its opposite, "high culture," through the appropriation of various gestures and forms.

Hal Foster's "RE: POST," 1982, functions as a progress report on the state of criticism and the manner in which several critics "pose postmodernism as a rupture with the aesthetic order of modernism." Foster's essay was significant for a number of reasons when it was first published. For one thing, it delineated in a clear and concise form what was then perceived to be the extremely muddled and murky terrain of postmodernism. But by publishing the text in a Montreal-based magazine, Foster was also able to attain

a critical distance from the New York-based postmodern critics whom he addresses (e.g., Rosalind Krauss, Douglas Crimp, Craig Owens) that might not otherwise have been possible. The essay remains a valuable historical document today.

The following year, *Parachute* published Thomas Crow's seminal treatise, "Modern Art in the Common Culture," 1983, in French translation. At the time, Crow was a junior professor at Princeton University, whose work was known primarily by an English-speaking public. *Parachute's* publication of this essay on the symbiotic relationship between modernism and mass culture was also of considerable importance insofar as it further contributed to breaching the divide between French- and English-speaking scholars of art history—a divide that manifested itself not only linguistically but also methodologically. Crow examines the steady infiltration of instrumentalized mass culture into the relatively autonomous sphere of modernist art, concluding that the modernist avant-garde has come to serve as a "research and development art of the culture industry: it searches out areas of social practice not yet completely available to efficient manipulation and makes them discrete and visible." Two decades later, the analysis advanced in this text seems as pertinent as it did when it was first published.

* * *

The essays in this volume, as do others to be published in subsequent volumes, indicate that *Parachute's* initial pledge to its readers to function as "a magazine preoccupied with the tendencies specific to the times within an historical perspective ... [focusing on] those who have made history and whose work remains important today," was consistently and perpetually fulfilled. For over a quarter of a century, the magazine played a crucial role by providing a critical voice in the increasingly expanding field of art. Having achieved what it initially set out to do, *Parachute* never settled into any form of comfortable complacency, and succeeded in maintaining its critical edge. The journal continues to push the limits and to maintain its cutting edge identity. What is not revealed in these essays, however, is that over the years *Parachute* has spread

its mantle beyond the printed page and made possible a program of activities, including public symposia, exhibitions, and multi-disciplinary festivals. The novel ideas and inter-pretive approaches presented within its pages have thus been further disseminated through other means.

As will become amply evident to anyone who reads through the essays in this volume, *Parachute* evolved dramatically over the years. What commenced with a certain "urgency" about the need to relate art practice and theory gave way to another central concern, namely that of discern-ing the points of intersection between art and the many crises in world politics faced in the new century. What is the role of art and culture in such a disastrous and potentially catastrophic world situation? Can art play a role in the construction of a cosmopolitan public sphere? Pontbriand and the editors subsequently devoted several special issues to this theme in the new series started after the turn of the millennium. In 2000 and 2001, the magazine published three volumes on "The Idea of Community." As Pontbriand, paraphrasing the Italian philosopher Georgio Agamben, put it in a public lecture in 1999: "The articulation of the self with community is a crucial issue which performative acts, with pragmatist underpinnings, such as those that we experience more and more with contemporary art, reveal in challenging ways." Three years later, Pontbriand coupled Agamben's theory of community with Jacques Derrida's concept of hospitality in the following way: "The idea of hospitality itself brings about a conception of the world as a place of hosting, of letting the other enter into one's privileged space." Hospitality is culture; it generates culture and brings about the relationship to the other, the place of individuality and the meaning of collectivity. *Parachute* thus presented itself at the beginning of the 21st century as a community where the exchange of hospitality can take place.

Parachute has undergone several highly significant changes since its 25-year anniversary. One criticism that may have been leveled at the early *Parachute* was that it was too focused on North America and Europe, although it was one of the first magazines to do so and to include the new dynamics between the continents as an object of research. However, as of the year 2000, *Parachute* devoted one out of every four issues to a city previously considered to be on the

periphery of the art world. These have included Mexico City in 2001, Beirut in 2002, Shanghai and São Paulo in 2004, and La Havana in 2007. The magazine thereby demonstrated its attentiveness to new zones of emergence and contact. Furthermore, starting in October 2000, each issue was based on a subject, rather than theme, the latter being seen as too homogenic. These theoretical and research axes, according to the editor, were meant to be analytic and pragmatic— "to provide an analytical context in which to operate and regroup relevant art practices." Ideally, it is important to remember, an art magazine will perform a double function: both to address the most significant contemporary art of its time and to feature writings by influential art critics and theorists. According to these criteria, the first 25 years of *Parachute* were remarkably successful. As the essays in this anthology make plainly evident, the magazine has served as an extraordinary vehicle for both communicating and shaping art theory and practice.

[1] Editorial statement, *Parachute*, no. 1 (October/November/December 1975), p. 48.

[2] Pontbriand became sole editor and publisher of *Parachute* in 1979 when Morin departed.

[3] See Dan Graham, "My Works for Magazine Pages: 'A History of Conceptual Art,'" in Gary Dufour, *Dan Graham*, exh. cat., The Art Gallery of Western Australia, Perth 1985; reprinted in Brian Wallis, ed., *Rock My Religion: Writings and Art Projects 1965–1990 / Dan Graham*, MIT Press, Cambridge, Massachusetts 1993, p. xviii–xx.

[4] Editorial statement, *Parachute*, no. 1, p. 48.

[5] As of May 2002 the range of contributors included over 3000 from Canada and Australia, Britain, France, Germany, Italy, Switzerland, and many others. Over 750 artists have been covered from Canada and 750 internationally from across Europe, as well as Japan, South Africa, Australia, among others.

[6] Chantal Pontbriand, from "Echoes and Shifts" (1999), a text that was given at the symposium "Art at the Turn of the Century," held in the context of *Art Focus* at the Israel Museum on October 25, 1999. Published in French as "Echos, mouvances," in *Communauté et Gestes*, *Parachute*, Montreal 2000, p. 83. Unpublished in English.

[7] For "heuretics," see Gregory Ulmer, *Heuretics: The Logic of Invention*, Johns Hopkins University Press, Baltimore 1994. The idea of establishing a connection between certain media and genres and the moment of their emergence was, of course, noted by Walter Benjamin in "A Small History of Photography" (1931), in *One-Way Street and Other Writings*, trans. Edmund Jephcott and Kingsley Shorter, Verso, London & New York 1979, p. 240–257.

[8] Pontbriand, "Echoes and Shifts." See "Echos, mouvances," in *Communauté et Gestes*, p. 84.

[9] Thus, one of the first interviews in *Parachute* was with Yvonne Rainer, followed by essays by artists such as Jeff Wall, Dan Graham, Rodney Graham, and others.

[10] Editorial statement, *Parachute*, no. 40 (Fall 1985), p. 4.

[11] Editorial statement, *Parachute*, no. 1.

From Critical Function to Transformation
Jean-François Lyotard in
Conversation with Jean Papineau

Parachute, no. 11, Summer 1978

Marcel Duchamp
Étant donnés: 1. La Chute d'eau, 2. Le Gaz d'éclairage …
Given: 1. The Waterfall, 2. The Illuminating Gas …), 1946–1966
Mixed media assemblage, 242.6 × 177.8 × 124.5 cm

JEAN PAPINEAU

In your "Notes sur la fonction critique de l'œuvre" (1973a, p. 235–236) you wrote that, "all current plastic and musical expression either fosters the illusion of a 'formal' participation between people, or attacks the illusion of a false communion." In what way does the deconstruction of communicative spaces (plastic, musical, etc.) differ from that of Adorno's negative dialectic, where we find a rejection of communication at least as insistent as your own?[1]

JEAN-FRANÇOIS LYOTARD

I would say two things. Our ideas are very close, but at that time (1970) I had not read Adorno. I read him later and then I wrote the shortext, *Adorno come diavolo* (1973b, p. 115–133), where I distanced myself from the negative dialectic. But at that time—and there was quite a trajectory involved—the idea of critique seemed essential to me and, if I may dare compare myself to him, I think that Adorno said

much more than I did on all these questions, and he said it
more seriously. What I expressed was written from a generally
deconstructive attitude, in an attempt to differentiate works
according to their critical function. The general attitude
came out of a reflection in progress related to *Discours, figure*,
or from the research on what I came to call the figural (1971,
p. 9–23, 271–279) in works equally concerned with music,
literature, and the plastic arts. I think there was at that time
a train of thought derived from Marxism, meaning that the
category of critique had been developed in relation to Marx,
and quite carefully. The problem could be formulated in
quite a precise way if we tried, for example, to distinguish
what Marx proposed as the difference between what he
called a reversal and what he sometimes understood as an
overturning (*retournement*), between a work—theoretical
or plastic (in the end he only thought about theoretical,
political works)—that only consisted in reversing the
relation between, for example, the worker and the machine
(a simple reversal that lends itself finally to Feuerbach, or
even to utopic socialism)—and a work of overturning. The
latter does not consist in a superficial reversal of the relation
between worker and machine (in other words, the work of
capital), but rather in demonstrating, by entering the deeper
strata of relations of production—and relations in produc-
tion—how labor itself was implicated in the circulation of
capital. It was this relation that had to be done away with,
and not simply an immediate relation. This is what I tried
to work out in the article on Marx concerning Althusser
("La place de l'aliénation dans le retournement marxiste";
1973a, p. 78–166). I based it on that and also on a work
on Freud that continued for quite a long time.

JP In contrast to Adorno, who ignored Freud?

JFL Who probably completely ignored Freud. This was part
of his strategy so to speak. The return to aesthetic ques-
tions—I say return even though I had never written anything
on art, but it had always been important to me—the return
had to happen, I suppose, especially through Freud, or
through Freud's theory of representation and particularly
his theory of fantasy and dreams. From there I was led—
I would almost say *we* were led for I have always worked in

a kind of collective of students and teachers—to go back to and clarify the Freudian analyses of representation in the works to see if we could understand how he conceived the function, both representative and illusory, of certain figures on the effect of the works. I think that the idea of deconstruction belongs to this sphere of research; both the Marxist critique and then what we would call—it cannot be called a Freudian critique because it is not a critique—the Freudian analysis of images. And so it doesn't owe anything "historically" to Adorno; it was only after I had read a certain number of Adorno's texts that I realized that all this had been said three times as well—I am thinking in particular of his works on new music.[2] But I was already in the process of criticizing this idea of critique, by saying that deconstruction was something that also belonged to communication, that it was not to be given a privileged status, that critique was a way of staying in the field of that which was criticized, and so it was necessary to consider another approach.

JP How does transformance—"the transformation of the perspectival transformation," (1977d, p. 37) as you said in relation to Duchamp—manage to escape the field of the criticized, how is it not a metalanguage? More specifically, by bringing about the transformation of classical perspective, and not deconstruction in the sense that Clement Greenberg or Michael Fried used it, how did Duchamp avoid remaining a prisoner of, or avoid remaining in the field of, classical perspective?[3]

JFL In putting forward the idea of transformation or transformance—the results of that trajectory that began with the idea of critique—my intention was to succeed in conceiving artistic activity in an affirmative way, and not negatively. Thus the break with Adorno.

Duchamp had always fascinated me, and helped me to understand how we could conceive of this activity in a non-negative way. For Duchamp, the problem is one of projection—we can use this example because he often uses it and, to a large extent, it's a problem of perspective. If we take the Quattrocentro treatises and the perspective apparatus,[4] whether those of Dürer or Brunelleschi, we see

that it is always a matter of projection, of subjecting an object in the perspectival field to modifications in order to represent it; so that we can present it in a new way, in another field, on another support—on a two-dimensional support, for example. In the minds of the Quattrocento artists, if we read their texts, this operation had the force of truth, which means that they described the projection as true to the eye, to ocular vision. When we take a closer look at the operations to which they subjected the object to be represented (and we can be sure that Duchamp did so), we realize that these operations were extremely selective and they absolutely could not, under any pretext, be thought of as yielding results on the sheet of paper or support (usually two-dimensional) that were faithful to the object of sight. In reality, these operations were very selective and, with respect to Dürer's devices for example, we realize that they are made up of a series of prostheses: a chin strap that holds up the painter's chin, an eye-patch with one eye closed, the Archimedes screw that controls the distance of the hand to the support, the adjustable tripods that fix the height of the device in relation to the object to be represented. All of these mechanics—almost *fabricae*—were in fact operators that would transform the thing seen into the painted or drawn thing. In Dürer this is obvious because we have drawings of the apparatus. For us, and especially for someone like Duchamp—but already for someone like Cézanne (I worked a great deal on Cézanne and this was very important ["Freud selon Cézanne," 1973b. p. 71–94]—what is striking is that the awareness dawns on us that perspectival representation, let's call it classical, is not the truth, but a transformative operation or a group of transformations, because it *is* a group of transformations. This shows that perspectival representation, the quite strange modifications—of manufacture, of the apparatus, of classical machinery—were almost at the level of a corporeal asceticism. Cézanne tried to find, at least that's how he thought about it and how Merleau-Ponty interpreted it,[5] the vision of the object without using a perspective apparatus of the 15th or 16th centuries and, more specifically, he tried to locate the curved space that surrounds focused vision, and so make visible in his paintings, and in his watercolors in particular, the almost anamorphic character of the periphery of the

visual field. And it was the same thing for the rest of his quite extraordinary work on color; for example the disappearance of the scale of tones, a work that had already been undertaken by the Impressionists, but which for Cézanne was much more than the scale's disappearance, because it was not a matter of producing an atmosphere. In fact, his approach was always concerned with the object and, especially in the last watercolors of 1904 and 1905 when his work distinguished itself from that of the Impressionists, color was used in place of drawing. And if there was practically no more drawing, it was because Cézanne was aware that the line itself was an artifice, and you well know that this artifice was almost the essence of the perspective known as linear that is described as classical. Duchamp traveled the same road— apart, of course, for the byways and a completely different philosophy. For Cézanne there is still this idea—we see it in his letters—of projecting onto the support the thing in a nascent state (as Merleau-Ponty put it), the thing as it is perceived on the very threshold of perception, even before it comes into focus, before it is classified in three-dimensional space, located within the system of Cartesian space, and, finally, made identifiable and recognizable. He therefore seeks, if I may so put it, to show how something appears to us for the first time. Duchamp abandons an idea that restricts Cézanne, the idea of nature. While in the case of the Quattrocento it is a matter of a nature *naturée* [diversified, finite in mode]—and it is endowed with this nature by the perspectival devices according to Cartesian and Galilean ordering principles—for Cézanne nature is *naturante* [active substance, infinite] or, in other words, it is the color that composes *Mont Sainte-Victoire*. But in Duchamp's work, the very idea that there is something to represent disappears. There is no longer nature, there are only representations or the operations that are always a kind of artifice, allowing the transition from one state of the object to another, and the function of art requires that these transformative operations be both extremely precise, and produce results that are extremely new. In the end, between the thing to project and the thing projected, there is an absolute rift in under- standing. From this came the research Duchamp made into space, more precisely into four-dimensional space, or non-Euclidean geometry. And it is the same thing in his

notes on color, for if we look carefully into the *Boîte Verte* (*The Green Box*) and the *Boîte Blanche* (*The White Box*),[6] we clearly see that he rejects the approach to colors characteristic of Cézanne—to know the reproduction of colors as a constitutive function of objects, in their liminal condition, or even preliminary to perception. On the contrary, Duchamp has a completely nominalist attitude to color, a quite surprising relation between color and name. He thus comes to use colors as names and, from a certain moment on, he composes paintings not through the visual effects of color, but through the nominal effects of color. These effects are thoroughly disconcerting and imperceptible to the eye, but they maintain an absolute coherence in the corrective system of the eye.

It is the same thing for movement. His first studies made me think somewhat of the chronophotographs of Marey,[7] by which we might have imagined that his studies had been inspired; but if he knew the works of Muybridge and Marey, what interested him was to destroy the idea that a canvas or a painted work had to give the impression of movement. On the contrary, what he wanted was to take an object in motion and arrange it as a series of immobile events. It is obvious that what interested him here were the paradoxes of Zeno, the arrow and the tortoise.

If we look at the constitutive and constituting elements of a painted work, we realize that Duchamp explored them all with the same problematic, which consists in taking out what is given in the field, to subject the given which is always both a physical and cultural given (as is the case for the Quattrocento; the works left to us by the 15th- and 16th-century painters have educated our eye, enabling us to identify the objects) to analysis, and thus to escape from these identifiable objects as they are revealed to us by our physical and cultural organization and, that done, to try to alter them. And not just in any way. Always at the price of a completely artificial asceticism: to produce systems, little systems and little transformative apparatuses. So, taken in that way, I don't think that transformation—and here I return to your question—could fall under the same critique, and I think we fooled ourselves about Duchamp, he really didn't care … to sign a urinal was not a critique of museums, it was something else: it is always a problem of the projection.

JP In this sense, the analysis you propose of Duchamp's works is very close to a new reading or to a new current of interpretation of which Jean Clair is the main representative.[8]

JFL Yes, absolutely. For that matter, we wrote our texts at the same time, and although I was in the United States and he was in France, we frequently discussed these problems. He moved away from the classical portrayal of Duchamp.

JP So you would refuse to take into consideration the portrayal called classical that, notably, we find in criticism and among American artists, and which claims that the readymades formally reveal the socio-political conditions of the reception of the work of art?

JFL Yes, I believe that I would refuse it. Although I have not really worked on the question of readymades—or, if you wish, it remains somewhat vague in my work—the attempt must be made to understand how they also enter into this general problem of transformation. It is paradoxical at first sight because, by definition, the readymades are not trans-formed; but in fact they are transformed, they are always transformed—by a nothing. In relation to this general problem of deconstruction, and pending deeper study, the readymades would be transformational minima, which means that instead of having complicated transformative apparatus as is the case with *Grand Verre* (*The Large Glass*) and *Étant donnés* (*Givens*), we would have extremely simple apparatus because we take an object of industrial manufacture that we subject to very slight transformations, and somehow these transformations are enough. It's one thing to say this, and altogether another to say, for example, that what Duchamp intended with the readymades was to show that any object could be a work of art. This was something he could not stomach, something he called the taste for turpentine; it is the channeling of the transformative activity into a specific field that, in the end, will always be defined by the use of certain materials, of certain supports, or of a certain rule of production. Now, all this is recognizable; in other words, if you make a canvas, and you spill some oil paint on it and hang it in a gallery with the support, materials, conditions of production, and exhibition,

they will say that it is art. Done in this way, it is not specifically a critique of art.

If it were necessary to compare Duchamp to someone, I would compare him to Leonardo da Vinci, who would have nothing to do with art either. Like Duchamp, what interested him were transformations; so he made models of submarines and airplanes, precisely because they are admirable transformers since they give us gills and wings. And Duchamp obviously worked like that. We can only regret that he was not a great mathematician, and he should have been, for his relation to science was that of someone who in the end understands, as people can who are not themselves specialists in mathematics or logic, that science is an art in the sense that it is always involved with the production of new and strange transformations. Isn't it true that he never repeated himself? He said in interviews that he had a horror of repetition, and so one always had to contend with a different operating mode. For example, if you take wordplay or puns—I have made a thorough list of them and a minor linguistic analysis—we realize that almost none of them are repeated or, even if it isn't conscious, they are not situated at the same linguistic level, and this is as true for the smallest and subtlest elements (for instance, in French, when the l takes the place of a p) as it is for the largest linguistic features (rhetorical rules). It is thus the product of the transformation that interests him. No, I don't at all believe that Duchamp's problematic is a matter of a negative dialectic.

JP So the work of Cage would be similar to that of Duchamp, not only in the sense that he never repeats himself from one work to the next, but also in the sense that he constructs apparatuses, beginning with the prepared piano, that transform the sound.[9]

JFL Absolutely. Cage is probably the most notable heir to Duchamp.

JP Based on these considerations, how do you consider the work of repetitive American music?

JFL I think that the repetition in question, in repetitive American music, is not the same as that which horrified

Duchamp. I don't say that what Steve Reich (for example)
tries to do, always succeeds; personally I have some reser-
vations in this respect. I remember hearing Steve Reich in
Paris, during a concert in a church, and I wasn't very im-
pressed. If, on the other hand, we take the Dagar brothers,[10]
classical Indian music, I feel that it goes further, but I am not
a specialist, and it would be hard for me to argue the point.

For that matter, we can include the aim of this repetitive
music in a problematic like the one I just described: what is
transformed, what they seek to transform in this music,
is the musical beat itself. In Western classical, baroque, or
modern music, there is an idea of time [beat] that supports
the musical work and which, in fact, is an idea of memory.
We have, on the one hand, the harmonic system, and on the
other, the melodic theme; they constitute or permit the
reference points that, at the temporal level, are equivalent
to the perspectival systems in pictorial space. These reference
points must allow an identification, not only the identification
of the melody to be heard, but I would almost say the
identification of the listener himself who, in certain respects,
always knows how he relates to it, and this is true even if we
subject him to deconstructions as would be the case beginning
with the 19th century, in the last quartets of Beethoven for
example.[11] If they undermine the rules of composition—
to some degree in the harmony, certainly in the melody—
these deconstructions maintain nevertheless the unity of the
work in this type of memorable time which is the absolute
rule of the work; and this is true even more so for Schoenberg
and the Vienna School. But repetitive music undermines
this, it undermines the memorable time and what it wants
to produce is a time of forgetting, in other words a real
perception, to believe Daniel Charles. In any case, what it
wants to produce is a relation with time that, finally,
places the listener in front of or in the beat, and makes him
forget the sound. Contrary to all that happens in the musical
tradition—the sound comes first and the beat is used so
that the sound is memorized—here there is an inversion,
and it is the beat that is really the master, the beat that
comes first, and the sound passes through this temporal
master and is forgotten, and so here repetition is the occasion
of forgetting and not at all a spur to memory. I think we are
dealing with a transformation that is obviously extremely

important, above all in the Western tradition because
it wasn't like this before; and the transformation is not
oriented toward the sound but, in contrast to all that was
done in music previously, to musical timing.

JP I believe Daniel Charles did not have much to say about
repetitive music but, concerning the problem that you raise,
he wrote a short text entitled "La musique et l'oubli,"[12] in
which it is a question of music that is very different from
repetitive music, a music that works more on the sound
itself than on the timing, and which shares a continuity with
the musical aesthetic of Cage.

JFL It's an objection that you are justified in raising—
because it is an objection? The problem would in fact be the
following: where to place people like Cage in relation to this
music? We see very clearly that the musical lineage descends
from Schoenberg[13] to Cage—if not from Schoenberg, then
from Webern—because Cage was Schoenberg's student,
and so we can trace the influences of this exceptional
attention to all dimensions of sound. But can we gain this
kind of reversal or overturning with respect to the temporal
quality of the musical work through this research into
sound, at least in the way Cage has done? I think that Cage
tried to achieve what the American repetition is trying to
achieve. He tried to get it in another way, by isolating
sounds, and not through a continuous stream of sounds that
disappear into forgetting—disappear because there is
nothing to pay attention to, because they don't teach us
anything, they don't tell us anything. Nothing is happening,
but it goes on.
 Cage wanted to restore a relation to beat that is not
beat—the memory of traditional music—nor is it this beat
of forgetting belonging to repetitive music. It would be
necessary to pinpoint Cage's relation to the timing of this
music—Cage's or Feldman's, who is more of a purist in this
respect. I think that it involves a transition that anticipates
what will be produced with repetitive music, but is not yet
repetitive music. I would almost be tempted to put Cage in
Cézanne's place: just as the colors compose the objects, the
sounds are taken as constituents, and so they had to be
isolated, captured in themselves. For that matter Cage has

an entire philosophy of sensation that is debatable, which
results in the fact that the musical objects are not presented
by the musician as constituted, but are to be constituted by
the ear of the listener, a little bit like the eye of the viewer
of Cézanne's work that constitutes *Mont Sainte-Victoire.*
Obviously, I don't believe that it is the same thing as the
beat of forgetting that we just talked about.

JP You have emphasized the mechanical aspect of Cage's
music and the work of Duchamp, and then all of these
mechanics are related not to the intentions of the composer,
the painter, or the artist, but to what you have called
anonymous intensities (1973b, p. 115ff.). Don't you think that
American repetitive music, for people like Steve Reich (to be
more specific), is still more mechanical than Cage's music,
because once the process is set in motion all the rest follows
without need of intervention? [14]

JFL This could be said if it allows us to show how we pass
from one to the other. I don't think that the machine is
oriented toward the same object. For Steve Reich or Philip
Glass, and already in La Monte Young's work, the machine is
oriented toward the timing, while for Cage the process
orients rather to the sound. Which means that if we seek an
equivalent in spatial art—something that is always risky—
one would have to look for the painters, sculptors, or
architects for whom the work makes not only the object but
also space itself disappear. Cézanne is someone who seeks
to make the object disappear: he shows it in its constitution,
he leaves it to constitute. Could we say that Duchamp is
someone who seeks to make space disappear and, because
we are in spatial and not temporal art, seeks to induce
vertigo? The forgetting of space is vertigo.

JP The contribution that you make to a topology of politics
(1977d, p. 30–31), and the demand that follows from it to
not privilege any situation, any discourse, is it not in
contradiction to the actual choice that you made to "inter-
pret" Duchamp? In other words, to choose to interpret
Duchamp rather than someone else—isn't this already
to set him up as someone whose narratives are relevant or,
in Habermas' terms, someone who has achieved a high

degree of communicative competence? Renouncing the idea
of truth and all normative procedures, don't you run the
risk—by creating the opposite effect—of falling back into
a theology of history, an expression that you used in relation
to Adorno? (1973b, p. 115). What then would be the difference
between *the* universal pragmatic—Habermas and Apel[15]—
and the [plural] pragmatics?

JFL Well, to deal with the last question (!), I don't think it
can be linked to the thought of Habermas, especially not to
this history of communicative competence. I don't think
that it's my problem at all, and you are suggesting that it
risks being so despite myself. At first sight, in any case, it is
not; what interests me is not to produce a universal pragmatic
but, on the contrary, to try to define the pragmatic games,
to specify each one, to show how they should be taken as so
many works of art, or kinds of artworks. And these different
games, whether they are games of language or games involving
materials such as sounds or pigments, are not in communi-
cation with each other. I see this type of language as not
being a communicative language at all, but rather a language
filled with different games of pragmatics, and so producing
effects that must not be called communicative because they
are not communicative, they are effects of transformation.
In what I was able to say the other night[16] on the pictorial
pragmatic, on the painting games, what interests me is the
very idea of transformation, and its extension in the "human"
field, in other words to show how the work that is done by
someone like Duchamp on the formal level of material and
its organization produces transformational effects, both on
Duchamp himself and on the people who are going to look
at the work. But there are a number of games of pragmatics,
there must be many of them; Wittgenstein counted a great
number of them, a long series, and he rightly says that it
is like a city, the construction of which has not yet been
finished and will never be, an idea that is really quite
Duchampian. The interesting thing about language is not
that it allows us to communicate, but that it offers us the
possibility of new transformations, in other words the
possibility of establishing new games. So I wouldn't say
there is a communicative competence, there is a competence
in certain games of language, not a single competence in

this game of language that is eristical and polemical, which is a very difficult game. No, I don't believe there can be a universal competence, because I don't believe there is a universal pragmatic. In the last part of your question you object (this interests me very much) that this risks making us fall back into historicism. That's very legitimate, cruelly so! I think I always had a tendency in that respect, but I don't believe it is historicism in the usual sense of the term. So I will ask you a question: what do you say to me when you see me threatened by this painful malady?

JP If we take the case of Adorno, since it is with regards to Adorno that you used the expression "the religion of history," and if we choose as an example the way that Adorno attributes a certain predominance to Schoenberg at the expense of Bartok, Hindemith, and even Stravinsky, this quality that he recognizes in the works of Schoenberg is deduced, so to speak, from theoretical positions on socio-political history since the birth of capitalism and, moreover, from a history of music or, more precisely, the formal possibilities offered by this history. From which, for example, comes the following sequence: Beethoven, Mahler, Schoenberg. In the same way, to privilege Duchamp, does this not already determine a problematic, and one only: that there is in the history of Western painting, since the Renaissance, a problematic that is that of classical perspective, and we will only be competent to the degree that we know how to identify the problems that it raises and not by situating ourselves outside of this problematic?

JFL And Duchamp, is he competent or not?

JP In your commentary on Duchamp, yes, Duchamp is very competent because he transforms classical perspective. Now, if we look at it from the point of view of Sol LeWitt or even Donald Judd, the problems identified are no longer the same: they are situated this time outside of the specific field, outside of the concept of classical perspective. In this sense, still in relation to what I think is presupposed in your texts, LeWitt or Judd would not be competent. We inherit problems; we inherit them, for instance, from the Judeo-Christian tradition, and these problems must necessarily dictate our

responses. Attempts to be situated outside of the problematic are thus doomed to fail.

JFL And in this sense, the communicative competence of Duchamp is more serious than the non-competence of Judd. And so, where is the objection?

JP Communication—that of language or of the plastic arts—must necessarily obey certain rules, certain rules of transformation. If we try to eliminate them, communication is necessarily doomed to fail, doomed to confusion.

JFL What does that mean, doomed to fail? That the message doesn't get through, that it's a failure of communication? This is where I question myself about someone like Duchamp. It seems to me that the answer is in the question because, when we speak of communicative competence, we admit not only that this competence comes from the fact that we're aware of the conditions of communication and, consequently, we are going to bring about a significant modification in it. But there is also, implicitly or explicitly, the idea that if we don't deal effectively with the conditions of communication, we will fail. But this idea of failure presupposes that of communication. So, is it true for someone like Duchamp? Can we say that someone like Duchamp has competence? If he has competence, it's because he is recognized, because his message gets through. And what always struck me about someone like Duchamp is precisely the misunderstanding to which he gives rise, and I would say to which he thoroughly lends himself.

JP What you have called the "ruse."

JFL Yes, and such a good one that he was somewhat ignored in France, more than in the United States, because the French are less nominalist than the Anglo-Saxons, and one has to be fairly nominalist to understand him. Insofar as he was recognized, it was often on the basis of a misunderstanding. So what is this misunderstanding in the communicative problem or problematic? Is it a failure or a success? If you say that Duchamp is the subject of a misunderstanding, this means both that he modified the rules of communication, and that

for this reason what he communicates fails to get through, because the rules are different. So, if he modified the rules of communication, it's a success in terms of competence, but it's a failure in terms of communication. I am not familiar with this problematic and I fear saying something stupid about Habermas, but I am afraid that his idea that the principal function of language is a communicative one is forced on the interpretation of artworks or social conditions. It's a debatable idea, and I would almost be tempted to say that we speak in order to *not* be understood, that a painter paints and a writer writes to prevent communication. There is a secret function, I would say a function of secrecy, in language, but also in an artistic activity, and this is what interests the artist. There is a kind of profound rupture, in the end, between the communicative approach—at first sight and relative to what I know about it—and the artistic approach of language, and when I say artistic I don't mean that it is only so for Duchamp and a few others. I think that it's true for natural language and that we make an artwork of language, in the true sense of the word, only and insofar as we produce in this language these utterances that may be very short or very long, utterances that are obscure. Later, they will themselves enter into the rules of communication and will be, if I may so put it, *dis*-obscured and then they will belong to this system that allows people to communicate with each other. This is how abstract art becomes advertising and hyperrealism ends up on a billboard, but it doesn't matter. The fact is that one thing was done that transformed the established rules, and at that point there was another thing that appeared. In order not to dramatize by oversimplifying things, there are two general working hypotheses: either we think of the problem as one of the symmetry of speakers, or, to use a Nietzschean term, that of the will. In my opinion what is interesting is not the bringing into symmetry of partners with the goal of making communication transparent, quite the contrary; it is the manufacture of obscurity because at that moment what we want is simply the wanting. We can want, that is to say we want to produce works—of language, of music—that will be obscure to the extent that there is no way to comprehend them, and thus to bring the partners into symmetry. That they are bought into symmetry afterward, yes, in that case, it is a success.

And here there is an enormous problem; it is here that we see that Habermas fails, or clings to the Marxist heritage, and it is finally the idea of a society transparent to itself. This is not at all, obviously, the problem that refers us back to Duchamp because he would like, on the contrary, to confirm the possible by saying: these are the works of will. I find myself rather on this side, after having been on the other. It is not a betrayal.

JP The example that you chose to interpret in your conference on painting games, *Les jeux de peinture: un exemple*,[17] was in fact exemplary because you retrieved the pragmatic on the one hand and diegesis on the other, categories that you defined in your *Instructions païennes* (1977a, p. 16–18). It was an example very close, in fact, to historical painting, in which are present *dictum* and *pictum*, and of which Louis Marin described the mechanisms very well.[18] What happens when all figuration is absent and there only remain the formal elements, the play of materials and their transformations? Are we always brought back to the question of perspective, or are there other rules?

JFL I don't at all believe that we are brought back to the problem of perspective. If you think more specifically about "abstract" painting (I put it in quotation marks because it is such a horrible word), which is independent of the representation of objects, I am absolutely certain that the analysis I was able to make of this example—an extremely good example, because it is very simple and also because the relation between *dictum* and *pictum*, which is not very simple, is nevertheless obvious—this analysis must be able to work here as well. But it is going to have to carefully discover—or rather determine—the pragmatic effects of this painting, of a Rothko for example; to carefully evaluate the references it implies that pass from the painting's addressor to its addressee. At first sight, it seems that the most difficult thing for a normally cultivated mind when faced with a painting like one of Rothko's is the question of references. I hesitated to involve myself in this conference because, as I said, I haven't worked on painting for three years, and I didn't feel I had either the time or the strength to do it, but I have the intention to do it. I think that what I did say falls within the scope of your critique …

JP It wasn't a critique …

JFL No, it was an observation that the example was a good
one, and that in many respects it resembles historical
painting. The question is—and it is this question that
interests me—what is it, already in Cézanne's work for that
matter, that would allow us to say that there is a motif as
reference, as in, for example, the great American lyrical
abstraction? What I want, and here I'm very Cartesian, is to
leave the simple things and go to the more complex; I know
that with an example like the one I chose, which pictorially
is very simple, there is already some difficulty, and for
Rothko's work it will be extremely difficult. I want at first to
establish experimentally how it is different, how these little
operators in the commentary on painting can work on
relatively simple examples, and then we will see. Maybe
there are many things that will have to be modified, it's quite
possible, but this doesn't seem insurmountable. In particu-
lar, from the point of view of reference, or of the diegesis, is
all painting in the end referenced by a *dictum*? If you say that
it isn't, that it can be referenced by the visual objects, you
fall back into the classical description where we must
measure the effects of painting by the gap that this painting
produces in relation to that which it represents, and we will
then be sensitive to the distortions, the lighting, etc. …
I would almost be tempted to put forward the hypothesis
that there are always *dicta* in the background, even in a Rothko
painting, with the distinction that these *dicta* are obviously
not *narrata*. And this would be what distinguishes it from
traditional painting in general: there is no obligation that
the referent of a pictorial work be a narration, that it be a
story. In other words, there are other language games that
appear here that can be consistent with the referents in the
painting game, and thus there may be utterances that are
not necessarily utterances of the type: "The marquise went
out at five," or, "Jesus Christ died for us," which in essence
are formally the same thing. We can very well imagine
utterances that are not narratives and I am absolutely sure
that behind Rothko's work there are utterances, and I would
be almost tempted to believe that these utterances are
prescriptive. But this is not the place for intuitions, it must
be established. So one must have a working hypothesis and

this hypothesis must be extremely "complete," but at the same time very flexible, and it must provide us with the means to discover the references of works that apparently don't have any—works that are called abstract for this reason—and these references must not be narratives that are simply language games.

JP Could we speak of theatricality with respect to Rothko, and so recover Michael Fried's expression,[19] "art that includes the beholder," the idea of art that, if I can so put it, "positions" the receiver, and thus substitute it for the word "performative?" In other words, is the effect described by Fried the same as, or analogous to, that which you name when you employ the term "performative" in relation to the utterances that are behind Rothko's painting?

JFL No, because in this case we would like to say that the prescriptive of which we are speaking is the analogue through which we are going to think through the effect of this Rothko painting on the viewer, and that means we are in the painting game. What I was thinking about is that I imagine that this painting game has a referent, like a message, and that it speaks about something, and I hypothesize that the referent of a painting game is an utterance, or a group of utterances, and I tell myself this: it is possible that in the case of Rothko the utterance that serves as the secret referent for these vast, flat chromatic washes is perhaps a prescriptive utterance, and this utterance would be rather of the type: "Listen!" An utterance that is, probably, a paradox. We say "language," we speak of narration—but it's not that at all, we only think this way about painting. If you take a simple paradox as the Sophists elaborated them, you are going to be very bothered by the problem of reference. Here is a language game, or a part of a language game, where the question of the referent is a very difficult one because, in general, it is characteristic of these paradoxes to turn their referents into kinds of paradoxical objects. So we can well imagine that the referent of a painted work, which is not, in language, the equivalent of the pragmatic effects on the viewer, but is that of which the referent speaks—not that which speaks it—we can well imagine that this referent is an object of language or a paradoxical utterance.

JP In the chapters of the *Critique of Judgment* that deal with
the communicability of judgments of taste, through their
universality, Kant writes that common sense, a necessary
condition of this universality, "aims to justify the judgments
that contain an obligation."[20] Regarding the transposition
that Kant made of the principle of moral obligation, from
the *Critique of Practical Reason* to *The Critique of Judgment*: is it
this that allows you to reproduce here the analysis, or rather
the pragmatic, that you outlined in our conference on "Les
énoncés prescriptifs et le métalangage?"[21] In other words, if
you change the *you must* into *you are obliged to*, or obligations
into a primary obligation, how would the possibilities be affect-
ed in the case of a judgment of taste, in aesthetic judgment?

JFL I can't respond to this question as it is, but you are
putting your finger on something very important because in
my opinion there is still some work to do, the *Critique of
Judgment* is by far the most important and the most difficult
[of Kant's critiques], and it is here that the whole theory of
the imagination underlying Kantianism appears. It is
especially palpable in the second preface of this *Critique* and
I would say that there cannot be a *Critique of Judgment* in
the same way there is a *Critique of Pure Reason*. Already in the
Critique of Practical Reason—and this is what I tried to show—
the very possibility of preserving a prescriptive metalanguage
means that the prescriptive is obliged to mold itself to
the possibility of a metalanguage, meaning we are going to
discover the demand for a metalinguistics in the prescriptive
itself in the form: "always act in such a way that." And "in
such a way that, I, Kant, can talk about your action, can
make a commentary, a metalanguage." So we see that the
very category of critique, with its transcendental pretentions,
is obliged to modify, even to undermine its purpose, which
is the prescriptive. In the case of a judgment of taste and
teleological judgments, I have the impression that the gap is
such that the critical discourse fails, and we cannot treat the
Critique of Judgment as a critique, in the Kantian sense,
because ultimately it doesn't make any sense. If what he says
about the imagination and its relation to understanding and
reason—or the relation of faculties among themselves—
is really what he says it is (and here I believe his thought
displays an exceptional subtlety), then how can a metalanguage

be possible after that? We see clearly how a metalanguage for the theoretical use of reason is possible, but the use that a transcendental imagination serves, and the use of sensibility and understanding—an analogical use, the use of the guide which is almost parodic in matters of taste and in creation—will have to be excluded so that we can make a metalanguage for it. At the level where Kant considers things in the *Critique of Judgment*, which cannot be that of a metalinguistic reason but, in the end, of a metalinguistic imagination, we are entering a kind of pseudo-theory. With this text, we are confronted with the problem of the possibility, for theoretical discourse, of speaking about artworks, or the field of art-works. This work would be justified by the fact that we are dealing, in these three critiques, with an approach oriented toward three kinds of language, three different language games: the language of understanding, the prescriptive language which is that of ethics and politics, and the artistic language. The possibility of a meta-discourse for each of these games is not an automatic given, because metalanguage belongs to the field of knowledge. When it is oriented toward the prescriptive level or the artistic work—the work that I call transformative—the metalanguage is no longer oriented to an object that is part of a language of under-standing, but to a completely different game. What is the competence of a metalanguage in relation to artistic language? Would it not be necessary that it become itself artistic? It's something to think about.

In this respect Kant is much more interesting than Hegel; he was much more sensitive to the incommunicability of language games [between each other], because he knew this. He doesn't manage to restitute it in his metalanguage; he knows perfectly well that there is no way to treat the prescriptive like the theoretical. And this is something Hegel never understood: there is no prescription in Hegel, there is a universal metaprescription of reason, of the Mind that says to itself: "be yourself," and that's all. While in Kant there is already a philosophy of multiplicity.

JP The common sense that leads Kant to say that each person is obliged to tolerate the judgments of another—does this work in the same way as the common sense of practical reason, and so will we analyze it in the same way?

JFL As an analogy, I don't know about that. But we are going
to return to this operator that I pointed out yesterday, the
Kantian meta-operator of "you ought." Nevertheless one
must be careful because the expression "you ought" doesn't
always mean the same thing. At the surface level, the use of
the modal in a Kantian text was absolutely terrible; in the
end, the transcendental is modal, it is nothing but modal,
and it is always the modal of "you ought." This must be so
if it is true that reality is reality—the reality of science, of
morality, or of taste. So we are always going to retrieve again
the "ought" that is the index of the transcendental, or the
entry into a metalanguage. It is the "if … then," is it not?
It is a deduction, but always working from the basis of
experience, or the equivalent of experience, toward that
which makes it possible. Nevertheless, the construction or
deduction of conditions for the possibility of taste must
be different. Thus we see very well how, starting with a
discourse about science, the idea of the condition of possib-
ilities can arise because these conditions of possibility are
the very questions that science asks itself about objects.
When we are dealing with the prescriptive it is much more
questionable. Are the conditions for the possibility of
obligation given in experience? Not at all. It is necessary to
continually amputate experience. While experience can
readily be used by science, in matters of morality and taste
it cannot be. So it is always implicated in a kind of quasi-
experience, quasi-*facta*. This presupposes some serious
compromises, and so it would be interesting to restore the
language game that it describes in the name of taste, and its
own language game on this language game. This would be
interesting not only for an understanding of Kant, but also
for the understanding of the language game we call "artistic,"
because this facilitates the refinement of the pragmatic. In
fact, in the first part of the *Critique of Judgment* Kant describes
the pragmatic, the pragmatic effects.

Translated from the French by Mark Heffernan.

1954 *La Phénoménologie*, coll. "Que sais-je?" (no. 625), Presses
Universitaires de France, Paris, 127 pages.

1971 *Discours, figure,* coll. d'Esthétique (no. 7), éditions
Klincksieck, Paris, 428 pages, 45 illustrations.

1973a *Dérive à partir de Marx et Freud,* coll. 10/18 (no. 754), Union
Générale d'Éditions, Paris, 316 pages.

1973b *Des dispositifs pulsionnels,* coll. 10/18 (no.812), Union
générale d'Éditions, Paris, 250 pages.

1974 *Économie libidinale,* coll. "Critique," éditions de Minuit,
Paris, 314 pages.

1976 "Jean-François Lyotard", *L'ARC* (no. 64), quarterly revue,
Aix-en-Provence, 90 pages. Texts by Daniel Charles,
Hubert Damisch, Mikel Dufrenne, Louis Marin, etc.
It includes a bibliography of articles (by and about),
not yet anthologized, which appeared before 1976.

1977a *Instructions païennes,* coll. Débats, éditions Galilée, Paris,
87 pages.

1977b *Récits tremblants* (in collaboration with Jacques Monory),
coll. Écritures/Figures, éditions Galilée, Paris, 125 pages,
32 "illustrations."

1977c *Rudiments païens, genre dissertatif,* coll. 10/18 (no. 1187),
Union Générale d'Éditions, Paris, 250 pages.

1977d *Les transformateurs Duchamp,* coll. Écritures/Figures,
éditions Galilée, Paris, 155 pages, 16 illustrations.

[1] "This idea of communication is in its rightful place in the culture industry," and, "in the midst of a complete social blindness, only that which refuses communication is in its rightful place, instead of passing on laws, real or pretended." Theodor W. Adorno, *Vers une musique informelle*, translated from the German by B. Lortholary, in "La musique et ses problèmes contemporains : 1953-1963," cahiers Renaud-Barrault, éditions Juillard, Paris 1963, p. 266–267. [Ed. translation].

[2] See, in particular, *Philosophie de la nouvelle musique*, translated from the German by H. Hildenbrand and A. Lindenberg, Bibliothèque des Idées, N.R.F., Gallimard, Paris 1962, 222 pages; and *Mahler, une physionomie musicale*, translated form the German by J.-L. Leleu and T. Leydenbach, coll. Le sens commun, éditions de Minuit, Paris 1976, 266 pages.

[3] The most characteristic account is that given by Michael Fried in *Three American Painters* ... Fried could almost be an "Adorno art critic" with, to a lesser degree, the philosophic dimension and emancipatory mission.

[4] For his machine designs see Pierre Descargues, *Traités de perspective*, coll. Dossiers graphique du Chêne, éditions du Chêne, Paris 1976, 174 pages.

[5] Maurice Merleau-Ponty, "Le doute de Cézanne," in *Sens et non-sens*, coll. Pensées, éditions Nagel, Paris 1966, p. 15–44.

[6] Marcel Duchamp, *Duchamp du signe, écrits*, éditions Flammarion, Paris 1975, 314 pages.

[7] Jean Clair, *Duchamp et la photographie*, coll. L'œil absolu, éditions du Chêne, Paris 1977, 119 pages.

[8] Jean Clair, *Marcel Duchamp ou le grand fictif*, coll. Écritures/Figures, éditions Galilée, Paris 1975, 172 pages. See also, *L'œuvre de Marcel Duchamp, Abécédaire, Approches Critiques*, vol. III of the catalogue of the exhibition at the Centre National d'Art et de Culture Georges Pompidou, Paris 1977, 208 pages. For an illustrated English translation of Jean Clair's article see: *Artforum* (March 1978), p. 40–49.

[9] "I derived the method I use for writing music by tossing coins from the method used in the *Books of Changes* for obtaining oracles. The method itself is fairly complicated to describe and I shall not to do that now. If you are interested you can read a detailed description of it that will appear in the forthcoming issue of *Trans/formations*. Suffice it to say that tables are arranged referring to tempi, the number of superimpositions, that is to say the number of things that can go on at once, sounds and silences, durations, loudnesses, and accents. At a given instant half of the tables are mobile and half of them immobile. Mobile means: if that element is tossed, it acts, but disappears." John Cage, "Juilliard Lecture," in *A Year From Monday*, Wesleyan Press, Middleton 1970, p. 107.

[10] Two records: *India III* (Dhrupad), coll. U.N.E.S.C.O., Anthologie musicale de l'Orient, Bärenreiter Musicaphon, BM 30 L 2018; *Northern Indian Vocal Music* (Dhrupad and Khyal), Coll. U.N.E.S.C.O., Musical Sources, Modal Music and Improvisation, Phillips, 6586 003.

[11] Joseph Kerman, *The Beethoven Quartets*, Oxford University Press, Oxford 1967, p. 386. See also "Beethoven", *L'ARC* (no. 40), a quarterly revue, Aix-en-Provence; 108 pages, with texts by Barthes, Boucourechliev, Adorno, Stockhausen, Stravinsky, etc.

[12] Daniel Charles, "La musique et l'oubli", in "Functionalismes en dérive," *Traverses*, no. 4 (May 1976), éditions de Minuit Paris, p. 14–23. This text begins with a discussion of Adorno, whom Daniel Charles critiques, and finishes with references to repetitive music. The musicians in question—Hidalgo, Marchetti, Jagodic, etc—all made recordings for the collection Nova Musicha (Cramps Records/Milano), whose first work was dedicated to the music of Cage: *Music for Marcel Duchamp* (1947), etc. ... J.F. Lyotard had already written: " ... Daniel Charles! To interpret Cage with Lévinas, not to say Heidegger, is to persist in nihilism." (1973b, p. 301).

[13] "New methods will be discovered, bearing a definite relation to Schoenberg's twelve-tone system." John Cage, "The Future of Music: Credo," in *Silence*, Wesleyan University Press, Middletown 1974, p.5.

[14] "I do not mean the process of composition, but rather pieces of music that are, literally, processes [...] I am interested in perceptible processes. I want to be able to hear the process happening throughout the sounding music [...] Though I may have the pleasure of discovering musical processes and composing the musical material to run through them, once the process is set up and loaded it runs by itself [...] John Cage has used processes and has certainly accepted their results, but the processes he used were compositional ones that could not be heard when the piece was performed." Steve Reich, *Music as a Gradual Process* (1968), in *Writings About Music*, The Nova Scotia Series—Source Materials of the Contemporary Arts, The Press of the Nova Scotia College of Art and Design/New York University Press, Halifax/New York 1974, p. 9–10. See also, "Steve Reich, Interview by Michael Nyman," in *Studio International*, vol. 192, no. 984 (November/December 1976), p. 300–307.

[15] Jürgen Habermas, "Toward a Theory of Communicative Competence," in *Patterns of Communicative Behaviour*, ed. H.P. Dreitzel, Recent Sociology, no. 2, The Macmillan Company, New York 1970, p. 115–148.

[16] A conference given at the Musée d'art contemporain, Montreal, March 30, 1978: "Les jeux de peintures, un exemple."

[17] Instead of giving the title of the conference as "Les jeux de peintures, un exemple," it had been announced as "Les jeux de peintures, un exemplaire" (a copy). In fact, the example chosen by J.F. Lyotard was a miniature painting.

[18] The contents of the seminars given by Louis Marin from 1975-1976 at the Université de Montréal, were published under the title *Détruire la peinture*, coll. Écritures/Figures, éditions Galilée, Paris.

[19] Michael Fried, "Art and Objecthood," in *Artforum*, June 1967. It reappeared in *The Great Decade of American Abstraction, Modernist Art 1960 to 1970*, The Museum of Fine Arts, Houston, 1974; p. 77–87.

[20] Immanuel Kant, *Critique of Judgment*, trans. J.H. Bernard, Hafner Publishing Company, New York 1951, p. 76. See also 1977d, p. 99 ff.

[21] Conference given at the Université de Montréal, March 31, 1978.

The New Adventures of the Avant-Garde in America. Greenberg, Pollock, or from Trotskyism to the New Liberalism of the "Vital Center"[1]

Serge Guilbaut

Parachute, no. 17, Winter 1979

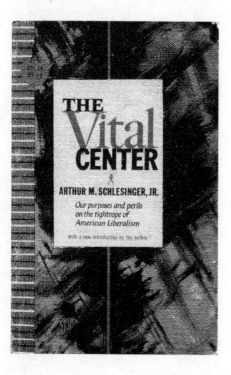

Cover of Arthur M. Schlesinger, Jr., *The Vital Center*, originally published in 1949

We now know that the traditional makeup of the avant-garde was revitalized in the United States after the Second World War. In the unprecedented economic boom of the war years, the same strategies that had become familiar to a jaded Parisian bourgeoisie were skillfully deployed, confronted as they were with a new bourgeois public recently instructed in the principles of modern art.

Between 1939 and 1948 Clement Greenberg developed a formalist theory of modern art that he would juxtapose with the notion of the avant-garde, in order to create a structure which, like that of Baudelaire or Apollinaire, would play an aggressive, dominant role on the international scene.

The evolution of Greenbergian formalism during its formative period from 1939 to 1948 cannot be understood without analyzing the circumstances in which Greenberg attempted to extract from the various ideological and aesthetic

positions existing at the end of the war an analytical system that would create a specifically American art, distinct from other contemporary tendencies, and international in import.

When we speak about Greenbergian formalism, we are speaking about a theory that was somewhat flexible as it began clearly to define its position within the new social and aesthetic order that was taking shape during and after the war; only later would it solidify into dogma. We are also speaking about its relationship to the powerful Marxist movement of the 1930s, to the crisis of Marxism, and finally to the complete disintegration of Marxism in the 1940s—a close relationship clearly visible from the writings and ideological positions of Greenberg and the Abstract Expressionists during the movement's development. Greenbergian formalism was born from those Stalinist-Trotskyite ideological battles, the disillusionment of the American Left, and the de-Marxification of the New York intelligentsia.

The first question we should ask is this: given the Popular Front's hostility to abstraction, how was it possible for Pollock, an engaged artist and stalwart member of the American Communist party who marched with his colleagues on the First of May, to become in such a short period of time an avant-garde artist caught in the labyrinth of modern formalist painting, as Hans Namuth's photographs so clearly reveal? How was Abstract Expressionist painting, avowedly apolitical, able to represent the new conservative liberalism that was on the ascendant? The cover of the 1962 edition of Arthur M. Schlesinger's celebrated bestseller *The Vital Center*, originally published in 1949, perfectly depicted this surprising alliance. The book—read as gospel by those who rejected fascism and communism in favor of the powerful rule of an aggressive Americanism developed during the war—has a cover design that reveals more than any text. The "vital center" (the intermediate liberal position between two totalitarian extremes) is represented by a red Barnett Newman-like bar, an authoritarian male axis erected against an expressively free abstract ground reminiscent of Kline's or de Kooning's brushwork. This symbolic contradiction represented the paradox contained in avant-garde art, which attempted to preserve freedom of critical expression (the artists of that generation had not forgotten the Depression years of their youth) within the conservative

American system. The fact that Abstract Expressiònism was used as an emblem of this new conservatism meant that the values articulated by the avant-garde were in accord with those of the progressive liberal ideology—a contradiction that the European avant-garde was slow to understand.

Since the history of Greenbergian formalism and that of the American avant-garde parallel rather closely the de-Marxification of the New York intelligentsia, I will attempt to trace the evolution and transformation of what we call radical thought in the United States—a position that was often difficult to hold, but which did allow some people to pass in good conscience, with a certain amount of adjustment, from revolutionary consciousness in 1937 to rightist liberalism in 1948.

De-Marxification really began in 1937 when a large number of intellectuals, confronted with the mediocrity of the political and aesthetic options offered by the Popular Front, became Trotskyites. Greenberg, allied for a time with Dwight MacDonald and *Partisan Review* in its Trotskyite period (1937–1939),[2] located the origin of the American avant-garde venture in a Trotskyite context: "Some day it will have to be told how anti-Stalinism, which started out more or less as Trotskyism, turned into art for art's sake, and thereby cleared the way heroically for what was to come."[3] When the importance of the Popular Front, its voraciousness and success are taken into account, it is hardly surprising that Trotskyism attracted a certain number of intellectuals. The American Communist party's alliance with liberalism disillusioned those who sought a radical change of the political system that had been responsible for the Depression. This alliance prepared the stage for revolution.

Until 1939, Marxist intellectuals were in the majority in the United States; according to Daniel Aaron, this was the simplest, most reasonable thing to be:

> You could be for every kind of social reform, for the Soviet Union, for the Communist party—for every-thing and anything that was at one time radical, rebellious, subversive, revolutionary, and downright quixotic—and in so doing you were on the side of all the political angels of the day ... This is the only period in all the world's history when you could be at

one and the same time an ardent revolutionary and an arch-conservative backed by the governments of the United States and the Soviet Union.[4]

It was the art historian Meyer Schapiro who initiated the shift. In 1937, abandoning the rhetoric of the Popular Front as well as the revolutionary language used in his article "Social Bases of Art," in which he emphasized the importance of the alliance between the artist and the proletariat,[5] he crossed over to the Trotskyite opposition. He published, in *Marxist Quarterly*, his celebrated article "Nature of Abstract Art,"[6] important not only for its intelligent refutation of Alfred Barr's formalist essay *Cubism and Abstract Art*,[7] but also for the displacement of the ideology of his earlier writing, a displacement that would subsequently enable the Left to accept artistic experimentation, which the Communist Popular Front vigorously opposed.

If, in 1936, in "Social Bases of Art," Schapiro guaranteed the artist's place in the revolutionary process through his alliance with the proletariat, in 1937, in "Nature of Abstract Art," he became pessimistic, cutting the artist off from any revolutionary hope whatsoever. For Schapiro, even abstract art, which Alfred Barr and others persistently segregated from social reality in a closed, independent system, had its roots in its own conditions of production. The abstract artist, he claimed, believing in the illusion of liberty, was unable to understand the complexity and precariousness of his own position, nor could he grasp the implications of what he was doing. By attacking abstract art in this way, by destroying the illusory notion of the artist's independence, and by insisting on the relationships that link abstract art with the society that produces it, Schapiro implied that abstraction had a larger signification than that attributed to it by the formalists.

Schapiro's was a two-edged sword: while it destroyed Alfred Barr's illusion of independence, it also shattered the Communist critique of abstract art as an ivory tower isolated from society. The notion of the non-independence of abstract art totally disarmed both camps. Leftist painters who rejected "pure art" but who were also disheartened by the Communist aesthetic, saw the "negative" ideological formulation provided by abstract art as a positive force, a way out. It was easy for the Communists to reject art that

was cut off from reality, isolated in its ivory tower. But if, as Schapiro claimed, abstract art was part of the social fabric, if it reacted to conflicts and contradictions, then it was theoretically possible to use an abstract language to express a critical social consciousness. In this way, the use of abstraction as critical language answered a pressing need articulated by *Partisan Review* and *Marxist Quarterly*: the independence of the artist vis-à-vis political parties and totalitarian ideologies. An opening had been made that would develop (in 1938 with Breton-Trotsky, in 1939 with Greenberg, in 1944 with Motherwell)[8] into the concept of a critical, avant-garde abstract art. The "Nature of Abstract Art" relaxed the rigid opposition of idealist formalism and social realism, allowing for the reevaluation of abstraction. For American painters tired of their role as propagandizing illustrators, this article was a deliverance, and it conferred unassailable prestige on the author in anti-Stalinist artistic circles. Schapiro remained in the minority, however, in spite of his alignment with J.T. Farrell, who also attacked the vulgar Marxism and the aesthetic of the Popular Front in his *Note on Literary Criticism*.[9]

In December 1937, *Partisan Review* published a letter from Trotsky in which he analyzed the catastrophic position of the American artist who, he claimed, could better himself, caught as he was in the bourgeois stranglehold of mediocrity, only through a thorough political analysis of society. He continued:

Art, which is the most complex part of culture, the most sensitive and at the same time the least protected, suffers most from the decline and decay of Bourgeois society. To find a solution to this impasse through art itself is impossible. It is a crisis that concerns all culture, beginning at its economic base and ending in the highest spheres of ideology. Art can neither escape the crisis nor partition itself off. Art cannot save itself. It will rot away inevitably—as Grecian art rotted beneath the ruins of a culture founded on slavery—unless present day society is able to rebuild itself. This task is essentially revolutionary in character. For these reasons the function of art in our epoch is determined by its relation to the revolution.[10]

Inspired by this letter, by Schapiro's article, and by an article published in *Partisan Review* in the fall of 1938 by Rivera and Breton, Greenberg, who for the moment was allied with Trotskyism, wrote "Avant-Garde and Kitsch" for *Partisan Review* in 1939.[11] Trotsky and Breton's analysis, like Greenberg's, blamed cultural crisis on the decadence of the aristocracy and the bourgeoisie, and placed its solution in the hands of the independent artist; yet they maintained a revolutionary optimism that Greenberg lacked. For Trotsky, the artist should be free of partisanship but not politics. Greenberg's solution, however, abandoned this critical position, as well as what Trotsky called eclectic action, in favor of a unique solution: the modernist avant-garde.[12] In fact, in making the transition from the political to the artistic avant-garde, Greenberg believed that only the latter could preserve the quality of culture against the overwhelming influence of kitsch by enabling culture to continue to progress. Greenberg did not conceive of this cultural crisis as a conclusion, as had been the case during the preceding decade, that is, as the death of a bourgeois culture being replaced by a proletarian one, but as the beginning of a new era contingent on the death of a proletarian culture destroyed in its infancy by the Communist alliance with the Popular Front, which *Partisan Review* had documented. As this crisis swiftly took on larger proportions, absorbing the ideals of the modern artist, the formation of an avant-garde seemed to be the only solution, the only thing able to prevent complete disintegration. Yet it ignored the revolutionary aspirations that had burned so brightly only a few years before. After the moral failure of the Communist party and the incompetence of the Trotskyites, many artists recognized the need for a frankly realistic, non-revolutionary solution. Appealing to a concept of the avant-garde, with which Greenberg was certainly familiar, allowed for a defense of "quality," throwing back into gear the progressive process brought to a standstill in academic immobility— even if it meant abandoning the political struggle in order to create a conservative force to rescue a foundering bourgeois culture.

Greenberg believed that the most serious threat to culture came from academic immobility, the Alexandrianism characteristic of kitsch. During that period the power

struture was able to use kitsch easily for propaganda purposes.
According to Greenberg, modern avant-garde art was less
susceptible to absorbtion, not, as Trotsky believed, because
it was too critical, but on the contrary because it was
"innocent," and therefore less likely to allow a propagandistic
message to be implanted in its folds. Continuing Trotsky's
defense of a critical art "remaining faithful to itself,"
Greenberg insisted on the critical endeavor of the avant-
garde, but a critique that was directed inward, to the work
itself, its medium, as the determining condition of quality.
Against the menacing background of the Second World
War, it seemed unrealistic to Greenberg to attempt to act
simultaneously on both a political and cultural front.
Protecting Western culture meant saving the furniture.

"Avant-Garde and Kitsch" was thus an important
step in the process of de-Marxification of the American
intelligentsia that had begun around 1936. The article
appeared in the nick of time to rescue the intellectual
wandering in the dark. After passing through a Trotskyite
period of its own, *Partisan Review* emphasized the importance
of the intellectual at the expense of the working class. It
became preoccupied with the formation of an international
intellectual elite to the extent that it sometimes became
oblivious to politics itself[13]:

> To the editor of the *Partisan Review* the events of 1936
> and 1937 cast fundamental doubts on the integrity of
> communism. This process was first evident in their
> reassertion of the theoretical purity of Marxism through
> their temporary identification with Trotskyism. But
> in the long run it meant the beginning of a piecemeal
> rejection of Marxism itself.[14]

Greenberg's article should be understood in this context.
The delicate balance between art and politics, which Trotsky,
Breton, and Schapiro tried to preserve in their writings, is
absent in Greenberg. Although preserving certain analytical
procedures and a Marxist vocabulary, Greenberg established
a theoretical basis for an elitist modernism, which certain
artists had been thinking about since 1936, especially those
associated with the American Abstract Artists group, who
were also interested in Trotskyism and European culture.[15]

"Avant-Garde and Kitsch" formalized, defined, and rationalized an intellectual position that was adopted by many artists who failed fully to understand it. Extremely disappointing as it was to anyone seeking a revolutionary solution to the crisis, the article gave renewed hope to artists. By using kitsch as a target, as a symbol of the totalitarian authority to which it was allied and by which it was exploited, Greenberg made it possible for the artist to act. By opposing mass culture on an artistic level, the artist was able to have the illusion of battling the degraded structures of power with elitist weapons. Greenberg's position was rooted in Trotskyism, but it resulted in a total withdrawal from the political strategies adopted during the Depression: he appealed to socialism to rescue a dying culture by continuing tradition. "Today we no longer look toward socialism for a new culture—as inevitably as one will appear, once we do have socialism. Today we look to socialism simply for the preservation of whatever living culture we have right now."[16] The transformation functioned perfectly, and for many years Greenberg's article was used to mark the beginning of the American pictorial renaissance, restored to a preeminent position. The old formula for the avant-garde, as was expected, was a complete success.

The appearance of "Avant-Garde and Kitsch" coincided with two events that threw into question the integrity of the Soviet Union—the German-Soviet alliance and the invasion of Finland by the Soviet Union—and which produced a radical shift in alliances among Greenberg's literary friends and the contributors to *Partisan Review*. After the pact, many intellectuals attempted to return to politics. But the optimism which some maintained even after the alliance was announced evaporated with the Soviet invasion of Finland. Meyer Schapiro could not have chosen a better time to interrupt the self-satisfied purrings of the Communist-dominated American Artist's Congress and create a split in the movement. He and some 30 artist colleagues, in the minority because of their attempt to censure the Soviet Union, realized the importance of distancing themselves from an organization so closely linked not only to Stalinism, but also the social aesthetic of the Popular Front.

And so the Federation of American Painters and Sculptors was born, a nonpolitical association that would

play an important part in the creation of the avant-garde after the war, and from which would come many of the first generation painters of Abstract Expressionism (Gottlieb, Rothko, Poussette-Dart). After the disillusion of 1939 and in spite of a slight rise in the fortunes of the Popular Front after Germany attacked Russia in June of 1941, the relationship of the artist to the masses was no longer the central concern of major painters and intellectuals, as it had been during the 1930s. With the disappearance of the structures of political action and the dismantling of the Works Progress Administration programs, there was a shift in interest away from society back to the individual. As the private sector reemerged from the long years of the Depression, the artist was faced with the unhappy task of finding a public and convincing them of the value of his work. After 1940, artists employed an individual idiom whose roots were nevertheless thoroughly embedded in social appearance. The relationship of the artist to the public was still central, but the object had changed. Whereas the artist had previously addressed himself to the masses through social programs like the WPA, with the reopening of the private sector he addressed an elite through the "universal." By rediscovering alienation, the artist began to see an end to his anonymity, as Ad Reinhardt explained, "Toward the late 1930s, a real fear of anonymity developed and most painters were reluctant to join a group for fear of being labeled or submerged."[17]

The period between 1940 and 1945 was crucial for the United States. Not only had it defeated fascism, it was in the middle of the greatest economic boom in its history, was becoming aware of its new political power, and, related to this new position, and through the influence of European artists, it was witnessing a renewal of interest in modern art. Since the beginning of the War, the United States had become the defender of civilization, of Western culture, against the barbarism of fascism. As Marcelin Pleynet has said, fascism eliminated only one kind of culture: modernism.[18] In the United States the modernism rejected by fascism was confounded with a broader, more abstract definition of culture. Thus the American press unwittingly defended the concept of modernity and modern art, which had previously encountered such extreme resistance in the United States. As if through a secret door or by mistake, modernism

slipped into the national consciousness. The war did more
to establish modern culture in the United States than all
the efforts of *Partisan Review* during the preceding years.

1943 was a particularly crucial year, for quietly, without
shock, the United States passed from complete isolationism
to the most utopian internationalism of that year's best-seller,
One World by Wendell Wilkie.[19] Prospects for the inter-
nationalization of American culture generated a sense of
optimism that silenced the anti-capitalist criticism of some
of its foremost artists. In fact, artists who, in the best
tradition of the avant-garde, organized an exhibition of
rejected work in January 1943, clearly expressed this new
point of view. In his catalogue introduction Barnett Newman
revealed a new notion of the modern American artist[20]:

> We have come together as American modern artists
> because we feel the need to present to the public a
> body of art that will adequately reflect the new
> America that is taking place today and the kind of
> America that will, it is hoped, become the cultural
> center of the world. This exhibition is a first step
> to free the artist from the stifling control of an
> outmoded politics. For art in America is still the
> plaything of politicians. Isolationist art still
> dominates the American scene. Regionalism still
> holds the reins of America's artistic future. It is high
> time we cleared the cultural atmosphere of America.
> We artists, therefore, conscious of the dangers
> that beset our country and our art, can no longer
> remain silent.[21]

This rejection of politics, which had been reassimilated by
the propagandistic art of the 1930s, was, according to Newman,
necessary to the realization of international modernism. His
manifest interest in internationalism thus aligned him—in
spite of the illusory antagonism he maintained in order to
preserve the adversary image of the avant-garde—with the
majority of the public and of political institutions.

The United States emerged from the war a victorious,
powerful, and confident country. The American public's
infatuation with art steadily increased under the influence of
the media. Artists, strengthened by contact with European

colleagues, yet relieved by their departures, possessed new
confidence, and art historians and museums were ready
to devote themselves to a new national art. All that was
needed was a network of galleries to promote and profit
from this new awareness. By 1943 the movement had begun;
in March of that year the Mortimer Brandt Gallery, which
dealt in old masters, opened a wing for experimental art,
headed by Betty Parsons, to satisfy the market's demand for
modernity.[22] In April 1945, Sam Kootz opened his gallery.
And in February 1946, Charles Egan, who had been at
Ferargil, opened a gallery of modern art, followed in
September by Parsons, who opened her own gallery with the
artists Peggy Guggenheim left behind when she returned
to Europe (Rothko, Hofmann, Pollock, Reinhardt, Stamos,
Still, Newman). Everything was prepared to enter the
postwar years confidently.

The optimism of the art world contrasted sharply with the
difficulties of the Left in identifying itself in the nation that
emerged from the war. In fact, as the newly powerful middle
class worked to safeguard the privileges it had won during
the economic boom, expectations of revolution, even
dissidence, began to fade among the Communist party Left.
And the disillusions of the postwar period (the international
conferences, the Truman administration, the Iron Curtain)
did nothing to ease their anxiety. What began as a de-
Marxification of the extreme Left during the war, turned
into a total de-politicization when the alternatives became
clear: Truman's America or the Soviet Union. Dwight
MacDonald accurately summarized the desperate position
of the radical Left:

> In terms of "practical" political politics we are living
> in an age which consistently presents us with impossible
> alternatives... It is no longer possible for the individual
> to relate himself to world politics ... Now the clearer
> one's insight, the more numbed one becomes.[23]

Rejected by traditional political structures, the radical
intellectual after 1939 drifted from the usual channels of
political discourse into isolation, and, utterly powerless,
surrendered, refused to speak. Between 1946 and 1948, while
political discussion grew heated in the debate over the

Marshall Plan, the Soviet threat, and the presidential election in which Henry Wallace and the Communists again played an important part, a humanist abstract art began to appear that imitated the art of Paris and soon began to appear in all the galleries. Greenberg considered this new academicism[24] a serious threat, saying in 1945:

> We are in danger of having a new kind of official art foisted on us—official "modern" art. It is being done by well intentioned people like the Pepsi-Cola company who fail to realize that to be for something uncritically does more harm in the end than being against it. For while official art, when it was thoroughly academic, furnished at least a sort of challenge, official "modern" art of this type will confuse, discourage, and dissuade the true creator.[25]

During that period of anxious renewal, art and American society needed an infusion of new life, not the static pessimism of academicism. Toward that end Greenberg began to formulate in his weekly articles for the *Nation*[26] a critical system based on characteristics which he defined as typically American, and which were supposed to differentiate American from French art. This system was to revive modern American art, infuse it with a new life by identifying an essential formalism that could not be applied to the pale imitations of the School of Paris turned out by the American Abstract Artists. Greenberg's first attempt at differentiation occurred in an article about Pollock and Dubuffet. The prize went to the American because

> Pollock, like Dubuffet, tends to handle his canvas with an over-all evenness; but at this moment he seems capable of more variety than the French artist, and able to work with riskier elements ... Dubuffet's sophistication enables him to "package" his canvases more skillfully and pleasingly and achieve greater instantaneous unity, but Pollock, I feel, has more to say in the end and is, fundamentally, and almost because he lacks equal charm, the more original. Pollock has gone beyond the state where he needs to make his poetry explicit in ideographs.[27] [...]

He [Pollock] is American and rougher and more
brutal, but he is also completer. In any case he
is certainly less conservative, less of an easel painter
in the traditional sense than Dubuffet.[28]

Greenberg emphasized the greater vitality, virility, and
brutality of the American artist. He was developing an
ideology that would transform the provincialism of American
art into internationalism by replacing the Parisian standards
that had until then defined the notion of quality in art (grace,
craft, finish) with American ones (violence, spontaneity,
incompleteness).[29] Brutality and vulgarity were signs of the
direct, uncorrupted communication that contemporary life
demanded. American art became the trustee of this new age.

On March 8, 1947, Greenberg stated that new American
painting ought to be modern, urbane, casual, and detached,
in order to achieve control and composure. It should not
allow itself to become enmeshed in the absurdity of daily
political and social events. That was the fault of American
art, he said, for it had never been able to restrain itself from
articulating some sort of message, describing, speaking,
telling a story:

> In the face of current events painting feels, apparently,
> that it must be epic poetry, it must be theater, it must
> be an atomic bomb, it must be the rights of man. But
> the greatest painter of our time, Matisse, preeminently
> demonstrated the sincerity and penetration that go
> with the kind of greatness particular to 20th-century
> painting by saying that he wanted his art to be an
> armchair for the tired business man.[30]

For Greenberg, painting could be important only if it made
up its mind to return to its ivory tower, which the previous
decade had so avidly attempted to destroy. This position of
detachment followed naturally from his earlier critical works
(1939), and from many artists' fears of participating in the
virulent political propaganda of the early years of the Cold
War. It was this integration that Greenberg attempted to
circumvent through a reinterpretation of modernist detach-
ment—a difficult undertaking for artists rooted in the
tradition of the 1930s who had so ruthlessly been made a

part of the social fabric. The central concern of avant-garde artists like Rothko and Still was to save their pictorial message from distortion: "The familiar identity of things had to be pulverized in order to destroy the finite associations with which our society increasingly enshrouds every aspect of our environment."[31]

Rothko tried to purge his art of any sign that could convey a precise image, for fear of being assimilated by society. Still went so far as to refuse at various times to exhibit his paintings publicly because he was afraid critics would deform or obliterate the content embedded in his abstract forms. In a particularly violent letter to Betty Parsons in 1948, he said:

> Please—and this is important, show them [my paintings] only to those who may have some insight into the values involved, and allow no one to write about them. NO ONE. My contempt for the intelligence of the scribblers I have read is so complete that I cannot tolerate their imbecilities, particularly when they attempt to deal with my canvases. Men like Soby, Greenberg, Barr, etc., are to be categorically rejected. And I no longer want them shown to the public at large, either singly or in group.[32]

The work of many avant-garde artists, in particular Pollock, de Kooning, Rothko, and Still, seemed to become a kind of un-writing, an art of effacement, of erasure, a discourse which in its articulation tried to negate itself, to be reabsorbed. There was a morbid fear of the expressive image that threatened to regiment, to petrify painting once again. Confronted with the atomic terror in 1946, Dwight MacDonald analyzed in the same way the impossibility of expression that characterizes the modern age, thus imputing meaning to the avant-garde's silence. "Naturalism is no longer adequate," he wrote, "either aesthetically or morally, to cope with the modern horror."[33]

Descriptions of nuclear destruction had become an obscenity, for to describe it was to accept it, to make a show of it, to represent it. The modern artist therefore had to avoid two dangers: assimilation of the message by political propaganda, and the terrible representation of a world that was

beyond reach, unrepresentable. Abstraction, individualism, and originality seemed to be the best weapons against society's voracious assimilative appetite.

In March 1948, when none of the work being shown in New York reflected in any way Greenberg's position, he announced in his article "The Decline of Cubism," published in *Partisan Review*, that American art had definitively broken with Paris and that it had finally become essential to the vitality of Western culture. This declaration of faith assumed the decline of Parisian Cubism, he said, because the forces that had given it birth had emigrated to the United States.

The fact that Greenberg launched his attack when he did was not unrelated to certain political events and to the prewar atmosphere that had existed in New York since January of that year.[34] The threat of a Third World War was openly discussed in the press; and the importance accorded by the government to the passage of the European Recovery Plan reinforced the idea that Europe—France and Italy— was about to topple into the Soviet camp. What would become of Western civilization? Under these circumstances, Greenberg's article seemed to rescue the cultural future of the West[35]:

> If artists as great as Picasso, Braque, and Léger have declined so grievously, it can only be because the general social premises that used to guarantee their functioning have disappeared in Europe. And when one sees, on the other hand, how much the level of American art has risen in the last five years, with the emergence of new talents so full of energy and content as Arshile Gorky, Jackson Pollock, David Smith—then the conclusion forces itself, much to our own surprise, that the main premises of Western art have at least migrated to the United States, along with the center of gravity of industrial production and political power.[36]

New York's independence from an enfeebled, faction-ridden Paris, threatened by communism from within and without, was in Greenberg's eyes necessary if modern culture was to survive. Softened by many struggles and too much success,

the Parisian avant-garde survived only with difficulty. Only the virility of an art like Pollock's, its brutality, ruggedness, and individualism, could revitalize modern culture, tradition-ally represented by Paris, and effeminized by too much praise. By dealing only with Abstract Expressionist art, Greenberg's formal analysis offered a theory of art that finally brought "international" over to the American side.

For the first time an important critic had been aggressive, confident, and devoted enough to American art to openly defy the supremacy of Parisian art and to replace it on an international scale with the art of Pollock and the New York School. Greenberg dispensed with the Parisian avant-garde and placed New York at the center of world culture. From then on the United States held all the winning cards in its struggle with communism: the atomic bomb, a powerful economy, a strong army, and now artistic supremacy—the cultural superiority that had been missing.

After 1949 and Truman's victory, the proclamation of the Fair Deal, and the publication of Schlesinger's *The Vital Center*, traditional liberal democratic pluralism was a thing of the past. Henry Wallace disappeared from the political scene, the Communist Party lost its momentum and even at times ventured outside the law. Victorious liberalism, ideologically refashioned by Schlesinger, barricaded itself behind an elementary anticommunism, centered on the notion of freedom. Aesthetic pluralism was also rejected in favor of a unique, powerful, abstract, purely American modern art, as demonstrated by Sam Kootz's refusal to show the French-influenced modern painters Brown and Holty.[37] Individualism would become the basis for all American art that wanted to represent the new era, confident and uneasy at the same time. Artistic freedom and experimentation became central to Abstract Expressionist art.[38]

In May 1948, René d'Harnoncourt presented a paper before the annual meeting of the American Federation of Art in which he explored the notion of individuality, explaining why—his words were carefully chosen for May 1948—no collective art could come to terms with the age. Freedom of individual expression, independent of any other consideration, was the basis of our culture and deserved protection and even encouragement when confronted with cultures that were collectivist and authoritarian.

The art of the 20th century has no collective style, not because it has divorced itself from contemporary society but because it is part of it. And here we are with our hard-earned new freedom. Walls are crumbling all around us and we are terrified by the endless vistas and the responsibility of an infinite choice. It is this terror of the new freedom which removed the familiar signposts from the roads that makes many of us wish to turn the clock back and recover the security of yesterday's dogma. The totalitarian state established in the image of the past is one reflection of this terror of the new freedom.[39]

The solution to the problems created by such alienation was, according to d'Harnoncourt, an abstract accord between society and the individual:

It can be solved only by an order which reconciles the freedom of the individual with the welfare of society and replaces yesterday's image of one unified civilization by a pattern in which many elements, while retaining their own individual qualities, join to form a new entity ... The perfecting of this new order would unquestionably tax our abilities to the very limit, but would give us a society enriched beyond belief by the full development of the individual for the sake of the whole. I believe a good name for such a society is democracy, and I also believe that modern art in its infinite variety and ceaseless exploration is its foremost symbol.[40]

In this text we have, perhaps for the first time, the ideology of the avant-garde aligned with postwar liberalism—the reconciliation of the ideology forged by Rothko and Newman, Greenberg and Rosenberg (individuality, risk, the new frontier) with the liberal ideology as Schlesinger defined it in *The Vital Center*: a new radicalism.

To better understand the relationship between the avant-garde and the complicated Cold War ideology, we should consider what Schlesinger had to say about the new liberalism. By studying this seminal text we can understand why, without the avant-garde painter's being aware of it, his

work was accepted and utilized to represent liberal American values, first nationally (in the museum), then internationally (at the Venice Biennale), and finally as anti-Soviet propaganda in Berlin in 1951. How, in short, an art whose stubborn will to remain apolitical became, for that very reason, a powerful instrument of propaganda. In 1951, for art to be politicized it had to be apolitical.

The new liberalism was identified with the avant-garde not only because that kind of painting was identifiable in modern internationalist terms (also perceived as uniquely American), but also because the values represented in the pictorial work were especially cherished during the Cold War (the notion of individualism and risk essential to the artist to achieve complete freedom of expression). The element of risk that was central to the ideology of the avant-garde was also central to the ideology of *The Vital Center*.[41] Risk, as defined by the avant-garde and formulated in their work as a necessary condition for freedom of expression, was what distinguished a free society from a totalitarian one, according to Schlesinger: "The eternal awareness of choice can drive the weak to the point where the simplest decision becomes a nightmare. Most men prefer to flee choice, to flee anxiety, to flee freedom."[42] In the modern world, which brutally stifles the individual, the artist becomes a rampart, an example of will against the uniformity of totalitarian society. In this way the individualism of Abstract Expressionism allowed the avant-garde to define and occupy a unique position on the artistic front. The avant-garde appropriated a coherent, definable, consumable image that reflected rather accurately the objectives and aspirations of a newly powerful, liberal, internationalist America. This juxtaposition of political and artistic images was possible because both groups consciously or unconsciously repressed aspects of their ideology in order to ally themselves with the ideology of the other. Contradictions were passed over in silence.

It was ironic but not contradictory that in a society as fixed in a right-of-center position as the United States, and where intellectual repression was strongly felt,[43] Abstract Expressionism was for many people an expression of freedom: freedom to create controversial works, freedom symbolized by action and gesture, by the expression of the artist apparently freed from all restraints. It was an essential

existential liberty that was defended by the moderns (Barr, Soby, Greenberg, Rosenberg) against the attacks of the humanist liberals (Devree, Jewell) and the conservatives (Dondero, Taylor), serving to present the internal struggle to those outside as proof of the inherent liberty of the American system, as opposed to the restrictions imposed on the artist by the Soviet system. Freedom was the symbol most enthusiastically promoted by the new liberalism during the Cold War.[44]

Expressionism became the expression of the difference between a free society and totalitarianism; it represented an essential aspect of liberal society: its aggressiveness and ability to generate controversy that in the final analysis posed no threat. Once again Schlesinger leads us through the labyrinth of liberal ideology:

> It is threatening to turn us all into frightened con-
> formists; and conformity can lead only to stagnation.
> We need courageous men to help us recapture a
> sense of the indispensability of dissent, and we need
> dissent if we are to make up our minds equably
> and intelligently.[45]

While Pollock's drip paintings offended both the Left and the Right as well as the middle class, they revitalized and strengthened the new liberalism.[46] Pollock became its hero and around him a sort of school developed, for which he became the catalyst, the one who, as de Kooning put it, broke the ice. He became its symbol. But his success and the success of the other Abstract Expressionist artists was also the bitter defeat of being powerless to prevent their art from being assimilated into the political struggle.

The trap that the modern American artist wanted to avoid, as we've seen, was the image, the "statement." Distrusting the traditional idiom, he wanted to warp the trace of what he wanted to express, consciously attempt to erase, to void the readable, to censure himself. In a certain way he wanted to write about the impossibility of description. In doing this, he rejected two things, the aesthetic of the Popular Front and the traditional American aesthetic, which reflected the political isolationism of an earlier era. The access to modernism that Greenberg had theoretically

achieved elevated the art of the avant-garde to a position of international importance, but in so doing integrated it into the imperialist machine of The Museum of Modern Art.[47]

So it was that the progressively disillusioned avant-garde, although theoretically in opposition to the Truman administration, aligned itself, often unconsciously, with the majority, which after 1948 moved dangerously toward the Right. Greenberg followed this development with the painters, and was its catalyst. By analyzing the political aspect of American art, he defined the ideological, formal vantage point from which the avant-garde would have to assert itself if it intended to survive the ascendency of the new American middle class. To do so it was forced to suppress what many first generation artists had defended against the sterility of American abstract art: emotional content, social commentary, the discourse that avant-garde artists intended in their work, and which Meyer Schapiro had articulated.

Ironically, it was that constant rebellion against political exploitation and the stubborn determination to save Western culture by Americanizing it that led the avant-garde, after killing the father (Paris), to topple into the once disgraced arms of the mother country.

Translated from the French by Thomas Repensek.

TIMELESS POLITICAL CARTOON

Ad Reinhardt
"Timeless Political Cartoon: Abstract Art saving Art," published in *Newsweek*, December 8, 1946

[1] This article is a revised, expanded version of a paper delivered at the Conference on Art History and Theory: "Aspects of American Formalism," Montreal, October 1979.

[2] James Burkhart Gilbert believes that *Partisan Review's* interest in Trotskyism grew from the disappointment most intellectuals felt over the American Communist party's alliance with the liberal wing of the Popular Front. "But in the long run it meant the beginning of a piecemeal rejection of Marxism itself. For Rahv and Phillips, Trotskyism was simultaneously a critique of the Soviet Union and a restatement of fundamental Marxism, because the practical politics of the Trotskyist movement had little attraction for them" (J.B. Gilbert, *Writers and Partisans: A History of Literary Radicalism in America*, John Wiley and Sons, New York 1968, p. 159).

[3] Clement Greenberg, "The Late 30s in New York," *Art and Culture*, Beacon Press, Boston 1961, p. 230.

[4] Daniel Aaron, *Writers on the Left*, Avon, New York 1961, p. 287.

[5] Meyer Schapiro, "Social Bases of Art," *First American Artist's Congress*, New York, 1936, p. 31–37.

[6] Meyer Schapiro, "Nature of Abstract Art," *Marxist Quarterly* (January/February 1937), p. 77–98; comment by Delmore Schwartz in *Marxist Quarterly* (April/June 1937), p. 305–310, and Schapiro's reply, p. 310–314.

[7] Alfred Barr, *Cubism and Abstract Art*, The Museum of Modern Art, New York 1936.

[8] Leon Trotsky, "Art and Politics," *Partisan Review* (August/September, 1938), p. 310; Diego Rivera and André Breton, "Manifesto: Towards a Free Revolutionary Art," *Partisan Review* (Fall 1938), p. 49–53; Robert Motherwell, "The Modern Painter's World," *Dyn* (November 1944), p. 9–14.

[9] J.T. Farrell, *A Note on Literary Criticism*, Vanguard, New York 1936.

[10] Trotsky, "Art and Politics," p. 4. In spite of Trotsky's article, which was translated by Dwight MacDonald, the magazine's relationship with the movement remained unencumbered. In fact, Trotsky distrusted the avant-garde publication, which he accused of timidity in its attack on Stalinism and turned down several invitations to write for the magazine (Gilbert, *Writers and Partisans*, p. 200).

[11] Greenberg's article in fact developed Trotsky's ideas on the relationship between art and the bourgeoisie, with certain departures from the original that weakened its revolutionary content.

[12] Trotsky agreed with Breton that any artistic school was valid (his "eclecticism") that recognized a revolutionary imperative; see Trotsky's letter to Breton, October 27, 1938, quoted in Arturo Schwarz, *Breton/Trotsky*, Paris, 10/18, 1977, p. 129.

[13] Malcolm Cowley and Trotsky for once agreed to withhold support from the magazine, believing it had lost sight of the Marxist struggle.

[14] Gilbert, *Writers and Partisans*, p. 158.

[15] Many members of American Abstract Artists were sympathetic to Trotskyism but looked to Paris for an aesthetic standard; Rosalind Bengelsdorf interviewed by the author, February 12, 1978, New York.

[16] Greenberg, "Avant-Garde and Kitsch," *Partisan Review* (Fall 1939), p. 49.

[17] Ad Reinhardt, interviewed by F. Celentano, September 2, 1955, for *The Origins and Development of Abstract Expressionism in the US*, unpublished thesis, New York 1957, p. xi.

[18] See Marcelin Pleynet, "Pour une politique culturelle préliminaire," in *Art et Idéologies*, Université de St. Etienne, C.I.E.R.E.C., 1978, p. 90–92.

[19] 1943 was the year of internationalism in the United States. Although occurring slowly, the change was a radical one. The entire political spectrum supported United States involvement in world affairs. Henry Luce, speaking for the Right, published his celebrated article "The American Century" in *Life* magazine in 1941, in which he called on the American people vigorously to seize world leadership. The century to come, he said, could be the American century as the 19th had been that of England and France. Conservatives approved this new direction in the MacKinac resolution. See Wendell Wilkie's bestseller, *One World*, New York, 1943.

[20] Catalogue introduction to the *First Exhibition of Modern American Artists* at Riverside Museum, January 1943. This exhibition was intended as an alternative to the gigantic one organized by the Communist-dominated Artists for Victory. Newman's appeal for an apolitical art was in fact a political act since it attacked the involvement of the Communist artist in the war effort. Newman was joined by M. Avery, B. Brown, G. Constant, A. Gottlieb, B. Green, G. Green, J. Graham, L. Krasner, B. Margo, M. Rothko, and others.

[21] Ibid.

[22] Betty Parsons, interviewed by the author, New York, February 16, 1978.

[23] Dwight MacDonald, "Truman's Doctrine, Abroad and at Home," May 1947, published in *Memoirs of a Revolutionist*, World Publishing, New York 1963, p. 191.

[24] The abstract art fashionable at the time (R. Gwathmey, P. Burlin, J. de Martini) borrowed classical themes and modernized or "Picassoized" them.

[25] Greenberg, "Art," *Nation*, February 1, 1947.

[26] Greenberg's articles were published by the *Nation* through the late 1940s.

[27] Greenberg, "Art," *Nation*, February 1, 1947, p. 138–139.

[28] Ibid.

[29] For an analysis of the ideology of this position see S. Guilbaut, "Création et développement d'une Avant-Garde: New-York 1946-1951," *Histoire et critique des arts*, "Les Avant-Gardes," July 1978, p. 29–48.

[30] Greenberg, "Art," *Nation*, March 8, 1947, p. 284.

[31] Mark Rothko, *Possibilities*, no. 1 (Winter 1947/48), p. 84.

[32] Clifford Still, letter to Betty Parsons, March 20, 1948, Archives of American Art, Betty Parsons papers, N 68–72.

[33] Dwight MacDonald, October 1946, published in *Memoirs*, "Looking at the War," p. 180.

[34] His article had an explosive effect since it was the first time an American art critic had given pride of place to American art. There were some who were shocked and angered by it. G.L.K. Morris, a modern painter of the Cubist school, former Trotskyite and Communist Party supporter, violently attacked Greenberg's position in the pages of his magazine. He went on to accuse American critics in general of being unable to interpret the secrets of modern art: "This approach—completely irresponsible as to accuracy or taste—has been with us so long that we might say that it amounts to a tradition." He ironically attacked Greenberg's thesis for being unfounded: "It would have been rewarding if Greenberg had indicated in what ways the works of our losers have declined since the 30s." Working in the tradition of Picasso, Morris was unable to accept the untimely, surprising demise of Cubism (Morris, "On Critics and Greenberg: A Communication," *Partisan Review* 15:6 [June 1948], p. 681–684; Greenberg's reply, p. 686–687).

[35] For a more detailed analysis of how events in Europe were understood by the American public, see Richard M. Freeland, *The Truman Doctrine and the Origins of McCarthyism*, Schocken Books, New York 1974, p. 293–306.

[36] Greenberg, "The Decline of Cubism," *Partisan Review*, March 1948, p. 369.

[37] When Kootz reopened his gallery in 1949 with a show entitled "The Intrasubjectives," Brown and Holly were no

longer with him. The artists shown included Baziotes, de Kooning, Gorky, Gottlieb, Graves, Hofmann, Motherwell, Pollock, Reinhardt, Rothko, Tobey, and Tomlin. It was clear what had happened: artists who worked in the tradition of the School of Paris were no longer welcome. In 1950 and 1951, Kootz disposed of Holly's and Brown's work, making a killing by selling the paintings at discount prices in the Bargain Basement of the Gimbels department store chain. It was the end of a certain way of thinking about painting. The avant-garde jettisoned its past once and for all.

[38] The ideology of individualism would be codified in 1952 by Harold Rosenberg in his well-known article "The American Action Painters," *Art News* (December 1952).

[39] René d'Harnoncourt, "Challenge and Promise: Modern Art and Society," *Art News* (November 1949), p. 252.

[40] Ibid.

[41] See discussion in "Artist's Session at Studio 35," in *Modern Artists in America*, ed. Motherwell, Reinhardt, Wittenborn, Schultz, New York 1951, p. 9–23.

[42] Arthur Schlesinger, *The Vital Center, Our Purposes and Perils on the Tightrope of American Liberalism*, Riverside Press, Cambridge, Massachusetts 1949, p. 52.

[43] We should recall that at that time the power of the various anticommunist committees was on the rise (HUAC, the Attorney General's list) and that attempts were made to bar persons with Marxist leanings from university positions. Sidney Hook, himself a former Marxist, was one of the most vocal critics; see "Communism and the Intellectuals," *The American Mercury*, vol. LXVIII, no. 302 (February 1949), p. 133–144.

[44] See Max Kozloff, "American Painting during the Cold War," *Artforum* (May 1973), p. 42–54.

[45] Schlesinger, *The Vital Center*, p. 208.

[46] The new liberalism accepted and even welcomed the revitalizing influence of a certain level of nonconformity and rebellion. This was the system's strength, which Schlesinger clearly explains in his book. Political ideology and the ideology of the avant-garde were united: "And there is a 'clear and present danger' that anticommunist feeling will boil over into a vicious and unconstitutional attack on nonconformists in general and thereby endanger the sources of our democratic strength" (p. 210).

[47] See Eva Cockcroft, "Abstract Expressionism: Weapon of the Cold War," *Artforum* XII (June 1974), p. 39–41.

MoMA and Modernism:
The Frame Game
Reesa Greenberg

Parachute, no. 42, Spring 1986

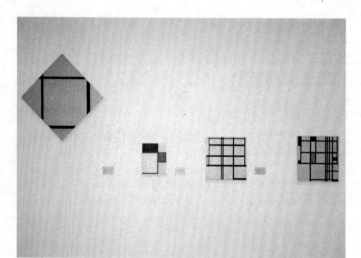

Installation view of Mondrian wall, The Museum of Modern Art, 1985

When an owner or an owner's agent frames a painting, the act of framing becomes an act of possession, a laying-on of hands. This appropriation of art objects as one's own is most obvious in collections, public or private, in which uniform, standard, or same framing is employed. His, and I use the word advisedly for most formers, framers, of painting collections have been men, his presence, then, is embodied by the frame, the frame which becomes the surrogate for his hand, the framing hand which takes hold and possesses, at the same time as it forms, frames, the owner's signature. The owner's claim is the frame.

The absence of the owner is a fiction. The owner is not invisible, has not been since the 16th century, when "house style" framing was adopted for private collections. Since then, even, especially in museums, the frame is the device, the agent, that allows the owner/ collector, him, to be present, to be

visible, as a creator, a creator other and more powerful than the artist, a curator/creator who is framer, author, of a text, a text that can be read apart from the text of the art object, a text, which by circumscribing that of the art object, inscribes its text within a meta-text, a super-text subsuming that of the art object.

What, then, is the text that The Museum of Modern Art in New York, through its agent, William Rubin, Director of the Department of Painting and Sculpture, frames for us in the recent reframing of its painting collection? With what discourse are we being presented? What language are we being asked to read?

"A frame is in essence constructed and therefore fragile, this is the essence or the truth of the frame." (Derrida[1])

The impetus for Rubin's reframing was the expanded MoMA, a space which doubled the number of paintings on exhibit from 15% to 30% of the one hundred thousand odd in the collection. Most of the paintings, those previously on the walls and those in storage, were not in their original frames to begin with, a situation, given the history of frame abuse, which is the norm in most collections. It is only from installation photographs dating from MoMA's first exhibition in 1929, to the early 1980s, that the extent of Rubin's reframing can be established. If one were to study MoMA's paintings solely from photographs of individual works in the archives or published in MoMA exhibition or permanent collection catalogues over these same years, including *The Museum of Modern Art, New York* published in conjunction with the reopening of the Museum in 1984, no frame changes would be visible, for MoMA, with few exceptions, followed, if not reinforced, the standard practice of not including the frame in the reproduction, a practice which tacitly suggests that the frame, whether designed and/or executed by the artist, a period frame chosen for the work when it was executed or one added at a later time, is not, was not, nor ever will be, considered an integral component of the painting and its history. Photographs of unframed paintings suggest the frame is easily detachable, contributing to the attitude that a painting can be reframed without consequence.[2]

"There is no one right frame." (Rubin[3])

Rubin has reframed parts of MoMA's collection before. In 1972, a few years after being named Director of the Department of Painting and Sculpture, he used the occasion of a reinstallation of the Museum's permanent collection to make some framing changes.[4] The 1983–1984 expansion and subsequent installation allowed him to reframe a great many other works, allowing us to see his concept of museum framing quite clearly. The full extent of the recent reframing, however, is much more extensive than the outcry over the removal of the previous Post-Impressionist frames leads one to suspect. With the entire permanent collection at his disposal during the construction period, any frame that did not fit Rubin's schema could be altered and was.[5]

"But a museum space is not neutral." (Rubin)

We begin, rather are directed by the spatial flow of the building itself to begin our tour in the room to the left of the first floor escalator. On the wall opposite the entrance-way are three paintings by Cézanne, a still life, a bather, a landscape, all contained in similar shadow boxes or L-frames: a single, "reeded," ¾" or 1" molding, the face of which is brushed gilt coloured with traces of red undercoat and the brighter polished gold gloss of the "joints"; the sides, dark brown stain thin enough to allow the grain of the wood to be seen. This type of frame predominates in the late 19th- and 20th-century galleries. It may vary in the brassiness of its gold, the thickness and width of its molding, the softness of its edges, the degree of actual or *trompe l'œil* roundness in its profile or its proximity to the support, but the overall impression is one of sameness.

The first noticeable change in framing procedure occurs in the Picasso and Braque gallery containing works associated with the African period, i.e., 1906. A good number of paintings in the room are framed in a thin, dark brown, wooden, L-frame. It is almost as if the dark brown sides of the reeded, gold frames in the rooms through which we have just passed have been stripped of their fronts. We follow these dark wood frames varying in width, depth, color, proximity to support, through rooms of Cubist, Futurist,

and Expressionist paintings until we enter the de Stijl room.
There the darkness becomes white. In only one other room,
the one in which Kandinsky's Campbell murals are hung,
are there so many white strip frames. I do not mean to say
that there are no white frames before the de Stijl gallery
or after the Campbell mural room, or that there are no gold
frames after the Post-Impressionist and Fauve rooms—
merely that in the first floor painting galleries there is a
framing color sequence running gold, brown, white, brown
coupled with a profile shift from rounded and slightly
articulated to flat and plain.

On the second floor, in the American galleries,
the pattern is repeated in a synoptic, more jumbled form,
until the large gallery containing Abstract Expressionist
large-scale paintings is reached. Here, for the first time,
we encounter unframed works, paintings such as Barnett
Newman's *Vir Heroicus Sublimus*, 1950–1951. MoMA's
unframed paintings are often edged with colored strips of
cloth-like tape stapled to the canvas. Slightly set back
from the face of the canvas, the tape is not visible when one
looks directly at these paintings; not tightly fixed along the
length of the sides, the tape is very much an added feature.
It is with this framing choice that the narrative of Rubin's
framing text becomes transparent. We leave the American
galleries as we are meant to, with no distinct sense of frame,
yet suspecting that we have been framed.

"Actually, the frame warps as it works." (Derrida, 34)

To my knowledge, only two of the numerous responses to
the new MoMA focus on Rubin's reframing. The first is an
article by Grace Glueck, cleverly titled "What's in a Frame?
Less and Less at the Modern," published in the *New York
Times*, July 15, 1984, in which Rubin comments at length on
his concept of framing. Glueck also interviewed Robert
Kulicke, who was called in as a consultant on MoMA's
reframing. Kulicke, one of North America's most influential
frame designers, invented, among other frames, what is
known as the Kulicke-Jamieson or Guggenheim frame,[6]
otherwise known as a box frame, a shadow box frame,
a floating frame, or an L-frame.[7] The Guggenheim appella-
tion refers to its initial use in 1972—the reframing of the

Justin Thannhauser Collection of late 19th- and early 20th-
century paintings at the Solomon R. Guggenheim Museum
with narrow gilded moldings of Kulicke's design. For
many the Kulicke-Jamieson frame was an improvement in
contemporary framing solutions when compared to James
Johnson Sweeney's radical removal of any framing element
in the Guggenheim permanent collection during the 1950s.
Glueck presented the case for retaining period frames by
interviewing Kathering Baetjer, Curator and Administrator
of The Metropolitan Museum's Department of European
Paintings, and Mark Davis, a professional picture framer
who participated in restoring The Met's 19th-century frames.
Both Glueck's article and the unsigned, untitled editorial in
The International Journal of Museum Management and Curatorship
(4, 1985, p. 115–117), probably written by Peter Cannon-
Brookes, one of the editors, concentrate on the removal of
the ornately carved, often gilded, frames from MoMA's
Post-Impressionist collection. The editorial, however, also
comments on the similarity between the box frame and
MoMA building style, and chastises Rubin for ignoring "the
delicate relationship between the frames and the paintings
themselves," two commentaries I shall reframe below.

> "The role of the frame is to mediate between the
> picture and the environment." (Rubin, July 2, 1985)

The editorial offers one explanation for what Mark Davis
refers to as MoMA's "reductivism": the creation of an
harmonious relationship between frame or object and
architecture. Seen straight on, Rubin's choice of a box frame,
a style he has used for a decade, does indeed echo the boxy
character of the rooms in both the old and new wings.
Unrelieved in any way by carving, and level with the support,
the flat, crisp-cornered boxes, regardless of color, reiterate
the wall planes and squared doorways of the museum's
unadorned Bauhaus-inspired structure; unframed canvases
function in a similar manner, as all are rectangular.
 Rubin's decision to recreate rooms similar to those
in the original painting galleries—small, white walled rooms
with low ceilings, one opening enfilade on to another—
suggests that the underlying symbolism of these spaces and
their contents has not changed. Carol Duncan and Allan

Wallach describe the spatial qualities of the original rooms: "There are no straight vistas, no large spaces, no organizing hallways. The route twists and turns. It is difficult to maintain a clear sense of direction. Of the 20 rooms along the main route, only one has windows despite the building's glass facades. To walk through the permanent collection is to walk through a labyrinth."[8] Although the path is somewhat straighter now and there are a few larger galleries—the Matisse room on the second floor, and Abstract Expressionist gallery and the Contemporary galleries on the third floor— the same sense of working one's way through or being propelled along a maze is retained. For Duncan and Wallach, "The labyrinth ritual glamorizes the competitive individual- ism and alienated human relations that characterize contemporary social experience."[9]

This competitive individualism and alienation is also present in the choice of frame for the dark sides of the gold, wood, stained frames and taped works isolate each painting on the wall as well as separate, in the sense of visually detaching, the paintings from the wall. These dark sides are not gentle mediators between picture and wall: together with the wide spacing between paintings, the dark edging contributes to constructing each work as an autonomous object. The isolation of paintings with dark sides and fronts is even more marked.

Rubin's dark-sided framing techniques incorporate the darker side of Modernism. The architectural harmony created by the rectilinearity and flatness of the frames and walls is, in fact, a chimera, constantly disrupted by dark edges, protrusions, which sever the works from their environment. Never created for a museum, these paintings, especially those with two-faced framing devices, are rendered even more non-site-specific, free-floating. Rubin's use of a "house style" does not create a home for MoMA's acquisi- tions. Quite the contrary.

> "Many frames that are appropriate in a home are not
> appropriate in a museum." (Rubin, July 15, 1984)

What uniformity exists in Rubin's reframing is subtle, not immediately obvious, for he did not reframe the entire collection, nor did he reframe each work in precisely the

same manner. "But the reframing was not done 'rigidly,'"
Mr. Rubin insisted. In many instances (Arp, Davis, Klimt,
Klee, for example), Rubin left the artists' frames entirely
untouched. This is not to suggest that historical accuracy,
however appropriate a criteria for a museum, accounts for
the variation. Rather Rubin uses the frame to create his own
history: the pattern he establishes unfolds only in time and
through space as the viewer moves from gallery to gallery.

Who's to Blame for the Frame

> "If we had stayed with the old elaborate frames it
> would have been impossible for the pictures to relate
> in the right way ... The old frames were very different
> from each other, even in terms of color, and would
> have obstructed a dialogue that has now been
> enhanced." (Rubin)

For Rubin, the "right way" is a "dialogue" between the
paintings within the framework of Modernist discourse, in
particular that branch of Modernist discourse that is insep-
arable from Clement Greenberg's evolutionary, nationalistic
formalism as set out in his 1955 essay, "'American Type'
Painting."[10] This schema posits art as autonomous with each
medium in search of its essence. For Greenberg (no relation
to this author as far as I know), the essence of painting
resides in non-descriptive color coupled with the factual
flatness of a support. By siting the importance of the framing
edge of the canvas as the arbiter of the painting's spatial
boundaries and determinant of its composition, Greenberg
implied that any other frame, what we have always assumed
by frame, what Michael Fried called the literal frame,[11] was
an anachronism. For Greenberg, and for Rubin as deduced
from his acquisitions and presentation of the painting
collection since coming to MoMA in 1964, the history of
Modernist painting is a chain of autonomous, related, and
progressive explorations in the search for the essence of
painting, a quest culminating in Abstract Expressionism.
Rubin's framing choices are framed by Greenberg's concept
of the non-frame as essential to the purity of painting:
within the constraints imposed by paintings on loan to the
museum that could not be reframed, Rubin establishes a

singular, linear history of the frame based on the belief that the best frame is no frame. "And formality always implies the possibility of a system of framing which is simultaneously imposed and effaced." (Derrida, 29)

Rubin could be seen as a product of his time, a follower of practices established by MoMA's founding director, Alfred Barr, and those propounded by Greenberg: "Personally I have no theory of art history, nor a prior concept, formalist or otherwise ... " (Rubin, 1974). Or Rubin could be criticized for not changing with the times as he has been by advocates of alternative histories of Modernism and/or Postmodernists.[12] Were Rubin more sensitive to other interpretations and more cognizant of the attention being placed on the frame, in painting itself since the mid-1960s as a reaction to the non-frame of High Modernism and in research on the history of artist-framing practices, perhaps he would not have made the choices he did. For those who do not subscribe to the Barr-Greenberg-Rubin lineage, the answer to the question posed by the witty, accusatory title of Germano Celant's article, "Framed: Innocence or Gilt?"[13] is clear: MoMA's framing is both pictoral and criminal.

Rubin's effacement of framing histories other than that which he imposes results in numerous distortions. "There is fiction and there is fiction" (Derrida, 40). Let us return to the Cézanne room where, as might be expected, MoMA's Modernist paradigm is first posited.

> "I see what has happened from the turn of the century until recently as, in part, an unfolding and an extrapolation of ideas that are implicit if not explicit in later 19th-century Modernism." (Rubin, 1974)

The three paintings opposite the entranceway are intended to represent the three late 19th-century subject matter categories—still life, figure, landscape—Rubin deems important for the development of Modernism, especially in its next major phase, Cubism. Rubin makes it clear that we are entering Modernism at a point beyond infancy by placing Cézanne's adolescent *Bather* directly in front of us. As has been pointed out, this image of a young man stepping forward is a metaphor for the progression which will follow[14]: what has yet to be stated is that Modernism

is presented to us in the guise of an all-male world.

The gold frames around the Cézanne paintings are historical cues but, like the choice of subject matter for the introductory wall installation, are, at one and the same time, presented as part of and ahead of their time. Like most of the frames in the pre-1906, pre-Cubist, section of the Museum, the antique gilding and *trompe l'œil* articulation of the surface of the frame recall, make allusion to, earlier framing styles even though box frames were not invented until 1972. Rubin's rationale for removing the ornate frames is that frames of this type were the taste of the collectors ... and quotes as evidence the framed paintings in the background of *The Artist's Studio* by Jean-Frédéric Bazille.[15] Unfortunately, for the purposes of this debate, Bazille was killed in 1870 and the framed works in the background of the work in question (1870) reflect mid-19th century taste in France rather than later 19th-century taste in framing ... Consequently, in attempting to reach an understanding of William Rubin's philosophical position with regard to the decision to reframe the earlier paintings in the style adopted, it is important to have a clear vision of their didactic function within the overall scheme. They constitute the Old Testament which lays the foundation for the Modern Movement, essential to the latter but not part of it, and consequently there is a certain ambivalence in their treatment which is thrown into sharp focus by both the decision to reframe and the style of framing chosen.[16]

The common color and pseudo-carving of these frames are camouflage devices, used to construct an image of a single framing style for a period in which heterogeneity of frame color and carving was the norm among the avant-garde. The bamboo-like effect projected by the surface treatment of the gold frames simulates only one tendency in late 19th-century art, Japonism. The majority of artists whose paintings have been encased in orientalized frames, if influenced by the movement at all, for the most part, were interested in other aspects of Japanese painting and prints. Whistler and van Gogh, two artists whose framing was most affected by exposure to Japanese art, designed frames[17] that bear little, if any, resemblance to MoMA's "reeding." The closest precedent in MoMA's collection for what Rubin has chosen is a Klimt frame which can be described as only

vaguely Japanese because, despite its gilt, it is relatively simple and flat when compared to what were its neighbours.

Rubin's aesthetic and practical justifications for homogenous framing in this section of the collection— "uncluttered appearance," "trimness relieves crowding," "if we'd left the paintings in their wider frames, it would have meant one less picture to achieve the same sense of space"—are predicated on the Kantian-defined, Derrida-elaborated, belief that frame is parergon—detachable ornament—what Rubin calls "eye-catching fluff"—not ergon, a non-separable component of painting, if not its essence. With frame as parergon, the artist's active partici-pation in the framing act is denied, suppressed, as is a history of painting which includes the frame. With frame as parergon, Rubin can construct a framing narrative that omits consideration of compliance or rupture with traditional framing practice.

Cézanne, championed by MoMA as the father of Modernism, was innovative in many ways but showed little interest in altering framing vocabulary. Cézanne "sent his unframed canvases in bundles to Vollard, but he had a very clear idea of the gilt frames which that dealer regularly employed."[18] That Cézanne did not object to his paintings being recessed in ornately carved, multi-level frames is fundamental to an understanding of his art.

Unlike Cézanne, Matisse experimented with various framing devices and MoMA's *The Red Studio*, 1911, a work which includes depictions of a number of the artist's earlier paintings, can be read as a compendium of Matisse framing styles to that date. Of the canvases shown hanging on the back wall, two have no frame, one has a wide white frame, one a simple, painted border or molding, and another, a carved, gilded frame. Other paintings and frames are painted on the floor, leaning against walls or furniture. Two other relatively ornate frames are visible, indicating that as late as 1911, *artists* as well as dealers and collectors used carved, gilt frames. Leaning against the side wall is a painting framed with a polychromatic, decorative border, a framing device Matisse adopted and adapted from Seurat.[19] Ironically, none of the framing styles depicted in *The Red Studio* were chosen to frame the painting; instead, Rubin put it into a dark wood box frame which absorbs and counteracts the brilliance of

Matisse's color. At least until 1972 (see Keller 605[20]), the painting was framed in white, a framing solution more in tune with Matisse's. A rounded gold molding with or without the simple beaded motif shown in Matisse's painting would have been equally acceptable. As it is, Rubin both abdicates and dominates.

With Seurat's *Evening at Honfleur*, 1886, Rubin's tenacity in adhering to the fiction of gold framing prior to 1906 is at its most blatant. Seurat's frame, broad, flat, stippled with polychromatic points of paint, is intended to posit the content of the scene on the canvas as an abstraction. The surround becomes a framing axiom embodying Seurat's belief that the primary components of painting are color and light whereas the support with its figurative landscape examines or applies the principle in detail.[21] Rubin appropriates *Evening at Honfleur* for his own purposes by encasing Seurat's frame in a gold frame of his own. As Félix Fénéon recounts, Seurat did use gold frames:

> Hence, he outflanked the foolishness of an owner whose idea (this case having often come up) would be to destroy a magical frame to replace it by a banal golden one.[22]

Given Fénéon's account, it is highly unlikely that Seurat, an artist who

> in the last years of his short life ... painted on his frame the tones and complimentary shades to the tones and the shades in the painting in order to excite these by contrast.[23]

would have subverted his intentions by using both a painted and a gold "bamboo" frame. It could be argued that the Seurat frame is so fragile and precious (only four survive) that it should be protected, and the main purpose of the tightly fitting gold frame Rubin has used is to hold the glass that covers the work. Protection of an artist-designed frame cannot be the reason for such treatment, for on an adjacent wall Theo van Rysselberghe's Seurat-like frame around *The Port of Sète*, 1892, has been placed in an equally misleading gold shadow box frame, but there is no glass.[24]

With one significant exception—van Gogh's *Starry Night*—Rubin is unwilling to acknowledge the existence of a framing history prior to 1906 based on the rejection of gold and mold. His authorship of a frame history through appropriation fashions a Modernist monolith in which difference is denied. Galleries of late 19th-century pictures which included deeply projecting, carved gilt frames next to wide, flat monochromatic, Impressionist frames next to Japan-inspired frames next to Neo-Impressionist, polychromatic frames next to Symbolist figurative frames would acknowledge the artist, not the owner, as author of a framing text, presenting a picture somewhat closer to late 19th-century framing facts while simultaneously recognizing the inherent fiction of all museum collections.

> "The *application* of the fiction must therefore be careful not to palm off metaphysical truth once again under the label of fiction." (Derrida, 40)

One significant feature of the frame which varies is the proximity of the frame to the support. Sometimes, on about ten works, an intermediary in the form of a white liner is placed between the gold frame and the work. In this section of the gallery the liner is used for works on paper by Cézanne, Redon, Degas, and Toulouse-Lautrec. Is the white of the liner meant to be a clue to the original color of the support? If so, a white liner is equally appropriate for works on canvas. A liner is not needed to facilitate putting a work under glass, as these are. Other systems exist. At MoMA, the liner is one of the devices in the "twilight zone" between frame and support utilized to establish a hierarchy of works within the pre-1906 collection.

By definition, a liner abuts or touches the edges of the support whereas the box frame, as its name implies, allows the work to "float" within it, allowing the viewer to see the entire surface of the support. In Cézanne's *Bather*, for example, the use of a box frame allows us to see that a thin band of yellowish-brown tape runs along the edges of the canvas and wraps its sides. With other paintings, such as van Gogh's *Starry Night*, 1889, we see that the artist did not paint the entire canvas but left the edges untouched. William Rubin comments,

... pictures should be shown as painted objects, not as windows. It's important to realize that to make perfect rectangles of pictures, the old framers often covered part of the originals. But you should see the painting as the painter saw it. Van Gogh's *Starry Night* had a fairly complicated frame that covered part of the original painted surface. Our decision was to reframe it showing all of the canvas as the artist painted it. Now, when you look at *Starry Night*, you see all of the painted part too.

Rubin does not consider the possibility that Cézanne's edges were taped by the framer or that van Gogh left the edges of his canvas unpainted because he knew they would be covered by a tape, then a frame, that van Gogh intended his unfinished edges to be hidden. All the known frames by van Gogh corroborate a tendency to tightly frame, if not slightly overframe the edges of the canvas, rather than insert a gap between frame and image as Rubin has done. Rubin's premise that the viewer is supposed to see all of the canvas is one more example of High Modernist theory determining MoMA's framing. To my knowledge, whatever the late 19th-century practice, traditional or not, with or without a liner, inner molding or matte, the framing vocabulary of early modernism did not include a space between canvas and frame.

"But you should see the painting as the painter saw it."

One difficulty with Rubin's statement is that most artists at the end of the 19th century did not paint with their support in a frame, a practice that was quite common in the Early Renaissance when frame and support were carved from the same piece of wood, but one which by the last decades of the 19th century was the exception, not the norm. Rubin's comment elides two moments, pre- and post-frame, in the history of the production of those paintings in MoMA's collection which are box framed. The introduction of a space, a gap, between frame and canvas posits a spatial no-man's-land which reads as a temporal caesura, a pause, that implies that the frame is an afterthought, a postscript, contradicting the implication in the above statement that

the artist "saw" the painting in the frame while working on it. Rubin's gap may suggest the truth of the matter, that the frame was applied at some point after the painting was finished, by the artist or by someone else, but the gap in the frame at MoMA literally becomes a time gap, a time warp, that moves some works into the 1970s when the museum-associated box frame was developed in conjunction with High Modernist framing edge theory. Rubin's selective use of the box frame in the pre-1906 galleries coupled with the variance in the width of the gap from painting to painting subtly separates certain works from their neighbors, declares them different, manipulates them to predict mainstream Modernism, places them at the beginning of a Darwinean linear evolutionary model based on the survival of the fittest.

> "Where is the gap? What gap are we talking about? And if it were the frame. If the gap constituted the frame of the theory. Not its accident but its frame. More or less restated: if the gap were not only the lack of a theory of the frame, but also the place of the gap in the theory of the frame." (Derrida, 9)

The gap is also an abyss, a frame within a frame. The gap creates a dark shadow, the shadow box frame, around the painting, the reverse of a white linen or wooden liner. If the gap is wide, the shadow is larger, more noticeable, so noticeable that we cease looking at the painting or the frame and focus on that unexplained, mysterious, dark space. "We are dealing again with the immense 'abyss' that separates the two worlds and the apparent Impossibility of throwing a bridge (Brücke) from one bank to the other." (Derrida, 4). But the gap does create bridges. Those dark black spaces which surround the canvas link visually to the all-black frame of the van Gogh, the only black box-framed painting in the pre-1906 galleries, a precursor of what is to come.

I have found no references to van Gogh using black frames. Of the frames we know he made, some, as mentioned, are Japanese-inspired, figured with characters or a landscape; others, such as the frame on *Lemons, Pears and Grapes*, 1887, is painted with large brush strokes in the same tones of the canvas. Perhaps the black MoMA frame is an attempt to recall the Dutch tradition of black ebony frames prized in

the 17th century. Perhaps MoMA's black frame is meant to serve as a foil for van Gogh's countryman, the even more Modernist Mondrian, and his white frames. Perhaps MoMA's black frame is a reference to primitivism, in which case it links up with, looks forward to, the Proto-Cubist African paintings where Rubin first uses dark stained wood frames as a dominant framing style.

The transition from gold to brown is abrupt, meant to visually cue the viewer to the magnitude of the change in works executed by Picasso and Braque after 1906. Rubin's choice of the dark, wood, stained frame materializes a connection between the "natural" material of the frame and the absent wood sculptures which inspired the "primitive," brown-skinned, striated figures depicted on some of the post *Demoiselles d'Avignon* canvases. Although a greater number of simple wood frames is characteristic of the first decades of the 20th century, the installation at MoMA suggests a new framing style initiated by Picasso and Braque, uniform in genre, with the canvas flush to the frame, not recessed behind it. Contemporaneous photographs of Picasso's and Braque's studios in 1910 and 1916 published in MoMA's *Pablo Picasso: A Retrospective*, 1980 (p. 122, 196), do contain simple wood frames but they are wider than Rubin's and protrude from the plane of the canvas, either with layers of moldings or beveling.

Sufficient evidence of Picasso's framing preferences during this and other periods is contained in the framed paintings within Picasso paintings in MoMA's collection. The background of his 1910 *Girl with a Mandolin* consists of stocks of framed canvases facing the wall. All the depicted frames are significantly wider than the thin wood frame now surrounding the painting itself and demonstrate that paintings of this period would have been set into frames which touched the edges of the canvas, in this instance probably covering the irregularly painted edges of the support, now visible. It could be argued that for Picasso and Braque between 1910 and 1912, when their work was becoming increasingly non-figurative, recessing a painting in a "window frame" clearly stated that their art with its multiple perspectival views was a refutation of Alberti's one-point-perspective-based dictum, "a painting is a window onto nature."

During the Cubist period Picasso and Braque experimented with various types of framing devices, a trait characteristic of most artists from the 1880s through the 1920s who challenged traditional theories of art. Between 1912 and 1914, many of their still lifes included a depicted frame as well as a literal frame, challenging the viewer to question the nature of a frame, the purpose it serves, the meaning it evokes. Picasso was particularly adept at playing with framing concepts and play he did, especially in Houston's *Pipe and Sheet Music*, 1914, where with collage papers he created a "rounded" molding and a leaf and berry motif "carved" flat that more or less doubled the design of the wood frame around the support. Braque's plain, fat, wide, sandy brown wood "frame" surrounding his mixed media *Clarinet*, 1913, is the only indication of Cubist framing games at MoMA. Installed somewhat apart from contemporaneous Cubist works, not in their midst, Braque's punning is too easy to miss. But humour in the form of poking fun at art conventions is not the tradition of Modernism espoused at MoMA: its stance of art as a precious object explains what happened in the framing of MoMA's non-rectangular Cubist paintings, works whose format by definition disrupts notions of Modernism and framing based on the rectilinear.

Around 1911, 1912, 1913, Picasso and Braque played with "oval" still lifes surrounded by depicted rectangular "frames," a framing ploy that subsequently resulted in their literally round and oval paintings being set into rectangular linen mattes or placed in rectangular panels and then framed, by dealers or curators (Keller 585). At MoMA, Braque's 1911 *Soda* is now a tondo and Picasso's *The Architect's Table*, 1912, an oval, each set into a hand carved, dark, wood, stained L-frame. Returning these paintings to what in all probability was their original format does not mean Picasso and Braque would have framed them as described. Rubin recounted to me the difficulty of carving these frames to fit, implying that the procedure was both arduous and costly, so much so that I wonder if Picasso and Braque would have gone to such lengths. Picasso's oval *Still Life with Chair Caning*, 1912, at the Musée Picasso offers an entirely different framing solution, a twisted cord, chosen for its punning, yes, but also for its flexibility, suggesting that similar, if less elaborate materials were used to edge the other oval and round canvases

intended to be read as table tops. Had the wood hugged the canvas, Rubin's frames could have become part of the "table's" literalness that Picasso and Braque were attempting to simulate, but the gap between Rubin's edge and the artists' images is both metaphoric and actual, an abyss into which anything can fall.

Rubin's use of the dark, stained, wood-grained box frame in the German Expressionist, Futurist, and Constructivist galleries presents other problems, many revolving around issues of nationalism. The decision to remove the white liners from the dark frames of a number of Expressionist and Futurist works was a wise one as this framing device has little to do with that of the artists, even though some Expressionists did employ a gold liner: in the case of the Die Brücke paintings, the resulting all-dark frames are quite close to those espoused by the movement. Unfortunately, however, not close enough ... Even darker than the brown of the Cubist frames, MoMA's Die Brücke frames can be seen as a quasi-attempt to approximate the solid black frames advocated by Kirchner and Nolde in their campaign to restore national characteristics to German art through, among other means, the revival of Germanic Early Renaissance framing devices. Yet MoMA's frames are too similar to the Cubist and Matisse frames for differences in framing traditions between Paris and Dresden-Berlin before World War I to emerge. When the Die Brücke paintings are floated in narrow-faced box frames as they are here, the tell-tale gap appears: the paintings are divorced from their frames, removed from the nationalistic implications of wide, black substantial frames absorbing the canvas, absorbed instead into the polygamy of international Modernism à la MoMA.

The use of a similar dark wood frame for Italian Futurist paintings by Boccioni, Balla, and Severini misleads in at least two directions. Balla and Severini's frames were not like those of Boccioni, who seems to have had little interest in incorporating frames into his art. Balla, whose pre-1911 frames and images were based on photographic, Symbolist, and Neo-Impressionist conventions, changed his framing style to correspond to his new interest, dynamic simultaneity, by continuing part of the image out onto a bevelled frame, as did Severini. The dark frames on the 1912–1913 Balla and Severini paintings give no indication of

the centrifugal explosion of energies these artists believed could spill beyond the canvas, onto and beyond the frame, to envelop, surround, frame, the spectator: Rubin's slightly wider than usual flat frame on Balla's *Speeding Automobile*, 1912, forces his Futurist force lines to remain within the frame.[25] Not only does any difference between Futurist framing techniques disappear, so too does any difference between contemporaneous Italian artists who are not Futurists. De Chirico, who turned a nostalgic eye toward Italy's glorious past rather than favoring the fast forward focus of the Futurists, included enough framed paintings within paintings to suggest that he probably used the simple, rounded, gold molding seen in his images to surround them, not the MoMA dark box: his *Double Dream of Spring*, 1915, for example, would be a very different image were it framed in the same way as the canvas on the easel in the painting. Although de Chirico is physically removed from the Futurists and positioned near the Surrealist galleries where he is separated from his compatriots, the similarity of MoMA's presentation of framing styles in Italian art of the 1910s establishes a false correspondence between two different aesthetics. Perhaps Rubin was trying to use the frame metaphorically, to construct an affinity, to draw an analogy between the nationalism at the heart of Italian art and German nationalism, but however germane nationalism may be to the upheavals of the Great War, it tended to inspire difference, not sameness, in framing.

Russia is a case in point. A quick look at the installation of the Soviet avant-garde gallery confirms Rubin's rule. The presentation of the Malevich paintings is particularly problematic. Five of the six hangings are in the familiar dark box frame; the sixth, perhaps not intended to be hung before it was framed to resemble the others, is a left-over, framed in white as were the others when exhibited in Alfred Barr's 1936 MoMA exhibition, *Cubism and Abstract Art* (Newhall 461). By 1972 the dark frames were in place (Keller 610). Installation photographs of Malevich exhibitions dating from 1915 and 1919–1920 published in Troels Andersen's 1970 Stedelijk Museum *Malevich* catalogue (p. 61–63), clearly show that Malevich did not frame his paintings, not in white, not in brown/black. Malevich's rejection of the frame corresponded with his intention of evoking associations with

Russian icons[26]: his increasingly abstract images of airplanes, aerial views, and magnetic reactions were to be icons of the new Russia, a secular, communist Russia built on the faith of the proletariat. Why Rubin did not return Malevich's paintings to a state as close as possible to the period in which they were produced is answered in a general way in Douglas Crimp's "The Art of Exhibition" when he critiques Rubin's installation as a whole, particularly the location and arrangement of the Russian avant-garde "now relegated to a cluttered stair hall."[27] Although Crimp does not address framing practices *per se*, his comments on the presentation of Soviet avant-garde works apply: "They are presented, insofar as it is possible, as if they were conventional master-pieces of fine art. The radical implications of this work have been distorted by the institution so as not to allow interference with its portrayal of modem art as a steady development of abstract and abstracting styles."[28] In terms of the frame, Malevich's non-frame was a radical act: on the one hand, a rejection of non-Russian, imported concepts; on the other, an affiliation with the frameless "minor" art of posters, framed, of course, as art at MoMA. Malevich's rejection of the frame refuses any barrier between art and life, between art and life transformed.

But Malevich's unframing came too soon. How could MoMA, so conservative, capitalist, and chauvinist in its *Realpolitik*, present Russian Revolutionary Malevich, who in many ways was not as revolutionary as his colleagues, as the precedent for the American Expressionist unframed canvas? The only example of unframed painting prior to Abstract Expressionism at MoMA is the c. 1920 Monet *Water Lilies* triptych. Whether this Monet installation is accurate in terms of how Monet would have installed the triptych is dubious but immaterial, for Rubin is establishing an affinity between the mural scale, abstract imagery, visible paint application, subject matter, and mood of Monet and the Abstract Expressionists, a comparison he articulated in his 1967 article "Jackson Pollock and the Modern Tradition, Part I,"[29] and one found throughout Greenberg's writings on Abstract Expression, most relevantly in "Modernist Painting," 1965. Even the white frame option used by Rubin's predecessors for the Maleviches was too dangerous: a white frame blends into the wall producing a no-frame effect when the

walls are white. Safer to use dark frames with the one white frame as a token to Malevich's non-frame. The dark links read backward to Cubism—Malevich was a Cubo-Futurist—and northern nationalism. Safer to use the dark frame in the room immediately following Mondrian's white framed paintings. Safer to bury Malevich paintings in a black box.

At MoMA, white framing has been used sparingly and selectively. The one gallery which contains only white-framed works is the de Stijl room, a space which, at the time I write (the "permanent" installations do change), contains 13 paintings and one sketch by Mondrian, one painting and three drawings by van Doesburg, and a sculpture by Vantongerloo. According to MoMA's non-verbal version of frame history, a history constructed through sequencing and emphasis, the de Stijl installation implies Mondrian is the inventor of the white frame. Long before Mondrian, Delacroix used white marble frames, the Impressionists and Seurat frames of white wood. If Mondrian is presented as the white knight or virginal bride of white framing, it is only because his frames survive and the others' did not. What is radical about Mondrian's framing, then, is not its color: Mondrian designed a narrow strip-frame which lay flush with the surface and edge of the canvas or, more provocatively, was set back from the face of the canvas allowing it to project from the frame, thus reversing centuries of framing practice. Mondrian's rejection of the raised frame and its "window onto nature" implications coincided with his return in late 1914 to Holland, where he met van der Leck and van Doesburg and became a member of de Stijl, a movement advocating an environmental approach to art in which painting was conceived of as a planar surface, akin to but independent of the wall on which it was placed rather than a "break" in the wall, an aperture, a hole in the wall, a window, a view through the wall. By definition, the function of the de Stijl frame changed: "The limit (frame, boundary, edge, base) must itself be both isolated and integrated; but its integration remains incomplete as long as the inside and the outside (which the limit articulates) lack a common denominator, that is, as long as the outside itself has not also been subjected to the same treatment."[30] Mondrian's response to the dual function of the de Stijl frame, a Derridean *Mittel-glied* bridging canvas and wall, was the flat, white, right-angle

jointed frame which linked and separated his white and grid imagery to and from the white, rectangular wall planes on which it was hung and from which, initially, it was derived.

MoMA's installation can be credited with making Mondrian's de Stijl break with framing history visible, especially by including and emphasizing one of Mondrian's diamond paintings, the format in which he first advanced the canvas, by more or less replicating Mondrian's hanging, placing the diamond high—too high in my opinion—on the wall, thereby alluding to Mondrian's source, 17th-century Dutch escutcheon paintings hung above eye level on columns in churches.[31] Breaking the MoMA eye-level museum hanging norm, the spectator looks up to the Mondrian diamond in more senses than one. The oddity of the diamond's placement is so great,[32] however, that attention focuses on its unusual format, and the change in framing goes unnoticed, so similar is it in colour and profile to the other frames in the room, its positioning so high that the configuration of the frame is hard to see, the label which we easily see lacking any mention of Mondrian's hand in the frame.

Rubin's pre- and post-de Stijl Mondrian framing is a distortion. Installation photographs of the Mondrian exhibition at the Sidney Janis Gallery in 1949, in other words not too long after Mondrian's death in 1944 and the opening of the Janis gallery in 1948 for wholesale or -scale framing changes to have taken place, show that frames on Mondrian's pre-de Stijl paintings were neither uniformly white nor were they in box frames flush to the fronts and sides of the canvases. Photographs of Mondrian in his studio, installation photographs of later exhibitions at Janis and 1972 installation photographs at MoMA point to yet another aberration in Rubin's Mondrian framing, the removal of any but one framing element. Mondrian continued to experiment with white on white framing devices, often placing a narrow strip-framed painting on a wider back panel, with or without protruding edges. Sometime after 1972, Rubin removed the back panel from Mondrian's 1925 *Composition*, diminishing the levels of planar differentiation between painting and wall, the extent to which the canvas protrudes into space and the proximity of the image to the viewer. Together, the white framing of Mondrian's pre-de Stijl paintings and the removal of back panels,[33] side edges, and the use of white

grosgrain ribbon stapled to the side of the support in post-de Stijl work create an erroneous, all too homogeneous, image of the history of Mondrian's frames, an image which, with the late 1930s and 1940s works in which Mondrian used broad, wall-like back panels, is designed to establish affinities with the almost contemporaneous Abstract Expressionists. Mondrian not only spent his last years in New York, where he created such mature "masterpieces" as MoMA's *Broadway Boogie Woogie*, 1942–1943, but was accepted and acclaimed in America as he had not been in Europe. Despite "the triumph of American painting," to use Irving Sandler's phrase, and Abstract Expressionism, Mondrian was almost a native son. He is allowed to fit within MoMA's frame.

Rubin distinguishes between van Doesburg and Mondrian framing by using a Mondrian framing format he rejected for Mondrian paintings: a white strip is placed around the edge of van Doesburg's c. 1929–1930 canvas, *Simultaneous Counter Composition*, which is then placed in a deep sided, wide gap, glassed, box frame. Van Doesburg used a variety of framing devices in his de Stijl and post-de Stijl work, beginning with black wood strip frames c. 1917, no doubt derived from his work with stained glass, then black strip frames on white flats or the reverse, white strip frames, white on white variations, and painted white frames, all of which can be seen in a 1932 Paris exhibition installation photographs.[34] His framing experiments, particularly those with black and white elements, are similar to those of van der Lack and Huszar, whose bright, multi-colored frames created a like division between wall and painting, reversing the emphasis on frame-wall affiliation characteristic of Mondrian's framing for a strong frame-image connection. A MoMA installation photograph of Barr's 1936 *Cubism and Abstract Art* exhibition (MMA 11.293) shows van Doesburg's painting with a narrow white strip frame around the canvas placed on a flat, wide, dark panel.[35] At some point prior to the 1968 Janis Collection exhibition photographs (Mathews 1280), the dark panel disappeared. Although at various times van Doesburg himself altered his framing, usually adding elements to already framed works, thereby changing their appearance and reading, MoMA's deep white box is not the type of supplement van Doesburg used. More important, the choice of a white on white frame, even if used by van

Doesburg on other paintings, obliterates coloristic framing differences between Mondrian and van Doesburg during the 1920s, obscuring other fundamental differences between the two artists, differences which resulted in disassociation, not the mis-association MoMA's reframing prefers.

As mentioned much earlier in this tale, one other room contains a concentration of white frames. In the Orphist/Blue Rider gallery two adjacent walls are hung with paintings framed in white, the other two with paintings in the artists' or dark frames. The diagonal division of the room into right-white and left-dark sections is reinforced by the positioning of the unaligned doorways which admit the viewer toward the right but necessitate an exit left, causing a corpo-real reconstruction of Rubin's white/black bisecting line when traversing the space.

Rubin's use of white frames on two paintings by Robert Delaunay, two by Marc, and four by Kandinsky, all dating from 1912–1914, is, I believe, an attempt, however misguided, to demonstrate that for some artists white frames signified white light even if none of the three in question framed in this manner at that time. Delaunay, attempting to combine color with Cubist transparent facets, continued a rectangular format window image onto the frame in Hamburg's *Simultaneous Windows*, but in related paintings without painted frames, such as MoMA's 1912 *Windows*, used wide, flat frames with mitred corner joints to underscore the picture-window pun. In his contemporaneous tondo and oval paintings, à la Picasso and Braque, the literal shape of the canvas reiterates that of the depicted image. Fortunately, MoMA's tondo *Simultaneous Contrasts: Sun and Moon*, 1913, has been removed from the square frame surrounding it in 1936 (see MMA 11.292 photo[36]) and returned to what was its original format which can now be read, without distraction, except for Rubin's white frame, as the macrocosmic symbol Delaunay intended, a reading Rubin reinforces by hanging the tondo very high on the wall. Rubin's choice of white frames for the Delaunay paintings is probably based on the knowledge that the artist was indebted to Marc Chevreul's 1839 *De la loi du contraste simultané des couleurs*, in particular Chevreul's color wheel diagrams, as the source for his initial tondo, *The First Disk*, 1912. Chevreul's inclusion of a chapter on the effects of framing with contrasting colors is, in my opinion, not

sufficient evidence to assume that Delaunay based his
framing solutions on his text, even if other artists interested
in color did.[37] Most likely, Rubin considered MoMA's
Impressionist-inspired, 1913–1914, Joseph Stella painting,
Battle of Lights, a tondo with a painted white border, a
depicted frame, corroboration for framing colorful circles
in white. Most of Delaunay's round and oval canvases are
usually hung unframed, certainly not surrounded by a white
frame that conjures up Impressionist or Neo-Impressionist
framing techniques. Besides, there was the expense of a
round wood frame, something the Delaunays, like Picasso
and Braque, could not afford.

Delaunay's c. 1912 contacts with Kandinsky and
Marc, two artists also interested in color,[38] may explain why
Rubin chose to frame their contemporaneous work like
the Delaunays. Little is known about Marc's framing
devices, but it is doubtful he would have framed in white.
The connotations of white framing prior to World War I
were French: Marc was more interested in northern
imagery, conventions, and color symbolism than the
scientific color theory at the root of French white framing.
Kandinsky's gold and splotchily-painted frames around
his glass paintings of this period attest to a concept of the
frame as a combination of traditional, decorative, and
"modern" elements.[39] He seems to have made no objection
to the very conventional proposed framing by A.J. Eddy,
the intermediary for the four Campbell murals, now hanging
beside the Delaunay tondo at MoMA. In a July 15, 1914,
letter to Kandinsky, Eddy describes the framing system:

> The idea is to put a *three-inch gold* [my emphasis] frame
> about each picture, and when this is done and the
> pictures are in place, just outside the frame there will
> be a small white molding, which is already on the wall,
> so that the pictures will be framed first in three inches
> of gold, and outside of that there will be the small
> raised molding, which is now part of the decoration.[40]

Rather than debating the merits of reconstructing framing
original to site-specific works in a new setting, the evidence
of Eddy's letter and Kandinsky's own framing practice is
sufficient to suggest the appropriateness of gold frames, not

white. MoMA's white frame obscures Kandinsky's symbolic, "inner" color concepts by associating them with Delaunay who, while concerned with the poetics of color, was equally interested in the scientific aspects of color theory. If I am correct in suggesting color theory linkage as the rationale for the white framed paintings in this room, only selected artists in the 1912–1914 Paris-Munich axis are given primacy. Kupka, classified as an Orphist, was heavily indebted to 19th-century color theory but is framed in dark wood, as are those paintings by Klee which do not retain their original color-coordinated frames. The white frames in this gallery, then, are arbitrary, artificial, appropriation.

In the remaining first floor galleries containing work from the 1920s and 1930s it is the dark box frame, whether close or distant to the canvas, that predominates, but some deviations do occur. Work by Arp, Ernst, and Schwitters is left in the artists' frame, but the two latter are reframed in larger, glassed, box frames which distort original size as well as literally cut off the work from the spectator, widening the very gap between art and life. Ernst's 1922 *Two Children Threatened by a Nightingale* ... and Schwitters' *Merz* reliefs were attempting to bridge with literal objects protruding onto or stuck to the frame, objects whose purpose is to "break" the frame. With MoMA's tiny Dalí canvases, the addition of wide, velvet flats between support and dark wood frame also enlarge and enrich. In *Illumined Pleasures*, 1929, a canvas measuring 9 3/8" x 13 ¾" [24 × 35 cm], the ornately carved "Spanish" frame which surrounded a dark flat in 1968 (Mathews 1278) has been altered to a simpler, rectilinear combination of a dark green velvet flat in a plain dark wood molding more in keeping with Rubin's stripped-down framing aesthetic. Neither of these framing solutions corresponds to the white box-framed images Dalí depicts in the painting, yet each, to a greater or lesser degree, does approach the jewel-like quality with which Dalí viewed his small-scale paintings, especially as both framing versions place the canvas under glass.[41]

Gold frames, the usual sign of art as precious object, appear sporadically, as in Picasso's 1927–1928 *The Studio*, one of the few works at MoMA where the basic color and profile of frames depicted in the painting itself is respected and

repeated. Gold frames around Magritte's *The Menaced Assassin*, 1926,[42] and Delvaux's *Phases of the Moon*, 1939,[43] serve a different purpose. Strategically placed, each painting is hung alone on one side of the free-standing wall that terminates the second-floor painting and sculpture galleries. In exiting or mistakenly entering this route, the viewer comes full circle, to or from the Cézanne gold framing at the other end. The third floor painting and sculpture galleries have a free-standing wall similar to the Magritte-Delvaux one downstairs, on which a painting by Augustus Tack both greets the viewer and blocks the view of what is beyond, including the Marsden Hartley on the back of the wall. Both Tack and Hartley were indebted to European art (Hartley was living in Germany when he painted *Painting No. 48, Berlin*, 1913): both paintings are framed in gold. The third floor may begin where the floor below left off but it does not "finish" the same way: gold frames are not found at the end passage. On the third floor, gold frames are quickly left behind. They belong to the old order, the past, Europe, not America.

As Hilton Kramer points out, American Early Modernist painting and painters are given short shrift in the new MoMA installation.[44] The small space given to this work is filled with a hodge-podge of styles both on canvas and in frames. Perhaps because work which does not neatly fit Rubin's chronological and geographical Modernist genealogy figures so little for him, his framing hand is not present in this gallery, with the result that artist frames around Stuart Davis' 1951 *Visa* and Gerald Murphy's 1927 *Pears and Wasp* are untouched.

The emphasis on this floor is Abstract Expressionism, first the Surrealist-based works of the early 1940s in their dark wood frames, then the "heroic" period of large-scale, mural-like, for the most part, unframed canvases of the late 1940s and 1950s. According to the patriarchal standard that size equals importance, found in art practice since Egyptian times, the large gallery in which the latter are hung is the apogee of MoMA's presentation of Modernism. What follows, even if Abstract Expressionist, framed or not, is exhibited in a random manner in terms of chronology and geography in a space unlike all others in the painting and sculpture galleries, a space without a carpet. It is as if the aural echoes and overlaps produced by the bare floor are

synonymous with the visual cacophony Rubin gives us at
the end of our tour. Gone is the hushed silence of the
carpeted spaces. Gone is the reverence accorded each object
by wide spacing. Instead, all our senses tell us that after
the post-mural Abstract Expressionist galleries, there is no
sense. Everything that follows is an appendage: what is
important stops before, especially during those times, such
as the *"Primitivism" in 20ᵗʰ-Century Art* exhibition, when the
space is used for temporary exhibitions. We have left the
sacred for the secular.

In the last, most sacred space nothing mediates
between spectator and those icons which are deemed the
embodiment, the summa, of the MoMA Modernist transcen-
dental experience as described by Duncan and Wallach.
Nothing distracts from the work, nothing, that is, unless one
is in any position other than the devotional dead center,
eyes directed in homage at a single painting. From any other
standpoint, framed sides, taped sides, or unfinished edges of
canvases are visible. No rationale for taping some works and
not others, or for the color choice of the tape, is obvious.
The Rothkos, no matter how ratty the sides, are not taped,
nor is Newman's *Vir Heroicus Sublimus*, 1950–1951, except for
the tape Newman himself glued to the right side of the
canvas and painted the same red as the ground. Newman's
1950 *Void*, however, is taped by MoMA, its white sides
continuing the white figure-ground coloration of the front
of the canvas. For the most part, when MoMA uses tape, its
color relates to the image rather than the ground, wedding
sides and script but divorcing ground from wall. In Gottlieb's
1951 *Tournament* the tape is brown, the color of the ideogram-
matic forms on the canvas, not the pink ground; in Pollock's
1950 *Echo* the black tape echoes the black drips; in Louis'
Russet the gray tape reiterates Louis' central, soft grayish
color-stain flows. Wherever the color of the tape deviates
from that of the ground, is darker than the wall and support,
the taped sides become prominent, eye-catching,[45] visually
functioning as both finish and frame, no different from the
few dark wood frames found in this space.

Regardless of color, the tape is attached to the support
with staples painted the same colour, a practice which
renders framers and conservators aghast. This stapled tape
lies flat in some places, rippling away from the support

in others, literally replicating its quasi-frame status
and indeterminacy in refusing to become part of the cloth
canvas or depart from it. This stapled tape, its looseness,
its spaces, its gaps, repeats Rubin's basic framing premise
first encountered in the box frame: MoMA's frames are
designed to support its version of Modernist art history,
a version which, for the most part, constructs a history
of framing that is as unrelated to the work as the spaces
Rubin inserts between frame and support. It is within these
spaces, however small, that I have attempted to insert
myself, to assert an alternative, to invert Rubin's maimed,
tamed, frame into one which is not so lame, all the while
remembering:

> Just as the author of a criminal frame transfers guilt
> from himself to another by leaving signs that he
> hopes will be read as insufficiently erased traces or
> referents left by the other, the author of any critique
> is himself framed by his own frame of the other, no
> matter how guilty or innocent the other may be.[46]

Though I am a she, I am as guilty as he.

Installation views of Malevich and Kandinsky-Delaunay-Marc walls, The Museum of Modern Art, 1985

[1] Jacques Derrida, "The Parergon," trans. Craig Owens, *October* 9 (Summer 1979), p. 33. Subsequent references to Derrida's article in the text will include the page number after his name.

[2] For a lengthier discussion of this phenomenon see my article "Unframing the Canadian Frame," *Vanguard* (February 1984), p. 34, 35. Surprisingly, MoMA has yet to take installation photographs of the permanent galleries. The best published photographs of the spaces under discussion were taken by Anthony Edgeworth and published in Carter Ratcliffe's "The Dazzling New Museum of Modern Art," *Travel and Leisure*, vol. 15, no. 1 (January 1985), p. 74ff. Unfortunately, they could not be published in this text, but the fact that *Travel and Leisure*, published by American Express, is documenting MoMA before MoMA itself, raises some intriguing questions about the relationship of art to consumerism.

[3] Unless otherwise noted, Rubin quotations have been taken from Grace Glueck, "What's In a Frame? Less and Less at the Modern," *New York Times*, July 15, 1984, Section 2, p. 1, 6. Statements designated "July 2, 1985" refer to a telephone interview with the author, while those identified by "1974" are taken from an interview with Lawrence Alloway and John Coplans entitled "Talking with William Rubin: The Museum Concept is Not Infinitely Expandable," *Artforum* (October 1974), p. 51–58.

[4] The framing changes are apparent in a comparison of MoMA 1972 installation photographs with earlier ones. For a discussion of the installation itself see Barbara Rose, "Oldies but Goodies: Modern Reinstallations, II," *New York Magazine*, May 14, 1973, p. 84–85.

[5] Hans Haacke's *Framing and Being Framed*, Nova Scotia College of Art and Design, Halifax 1975, was an early warning about the implications of museum framing.

[6] My account of the terminology and history of the Kulicke-Jamieson frame is indebted to Nick Patten of A.P.F. Kulicke, New York. According to Patten, the box frame facilitates framing by eliminating the problems associated with incorrect support measurements, irregular shaped canvases or canvases that are sloppily stretched.

[7] See Timothy J. Newberry, "Towards an Agreed Nomenclature for Italian Frames," *The International Journal of Museum Management and Curatorship*, vol. 4, no. 2 (June 1985), p. 119–128, for an indication of the complexity of sorting out the vocabulary of frames and framing in any period.

[8] "Museum of Modern Art as Late Capitalist Ritual: An Iconographic Analysis," *Marxist Perspectives* (Winter 1978), p. 37. An earlier version of this essay appeared in *Studio International*, no. 1 (1978), p. 48–57.

[9] Ibid., p. 46.

[10] Greenberg's essay first appeared in *Partisan Review*, vol. XXII, no. 2 (Spring 1955), p. 179–196. A revised version (1958) is included in his *Art and Culture: Critical Essays*, Beacon Press, Boston 1961, p. 208–229.

[11] Michael Fried in "Shape as Form: Frank Stella's New Paintings," *Artforum* (November 1966), p. 18–27 discusses frames as literal or depicted, a useful distinction as it classifies what is usually referred to as "border" as a type of frame.

[12] In addition to Duncan and Wallach see the Alloway-Coplans-Rubin interview cited above, as well as their second interview, "Talking with William Rubin: Like Folding Out a Hand of Cards," *Artforum* (November 1974), p. 46–53. More recent critiques of MoMA are found in Douglas Crimp's "The Art of Exhibition," *October* 30 (Fall 1984), p. 66–81 and Hilton Kramer's "MoMA Reopened: The Museum of Modern Art in the Post-Modern Era," *The New Criterion* (Summer 1984), p. 1–44.

[13] *Artforum* (Summer 1982), p. 49–55. Celant's provocative

[14] Ratcliffe, "The Dazzling New Museum of Modern Art," p. 3. Ratcliffe characterizes the placement of Cézanne's *Bather* as "a solitary male figure who plays the role of guardian. His message: all that follows begins here, with me and my excruciatingly subtle severities of form." Cézanne's *Bather* is the first illustration (in color) in the "Painting and Sculpture" chapter of *The Museum of Modern Art, New York*, 1984, p. 47.

[15] Bazille's painting *The Artist Studio* is illustrated in Germain Bazin, *Impressionist Paintings in the Louvre*, Thames & Hudson, London 1958, p. 35.

[16] "Editorial," *The International Journal of Museum Management and Curatorship* 4 (1985), p. 116.

[17] Three examples of van Gogh framed paintings are illustrated in *Il limite svelato: Artista, Cornice, Pubblico*, Electa, Milan 1981, p. 44–45, as are artist-framed works from Rossetti to Pistoletto. For Whistler, see Ira M. Horowitz, "Whistler's Frames," *Art Journal*, vol. XXXIX, no. 2 (Winter 1979), p. 124–131.

[18] "Editorial," p. 115.

[19] See Dominique Fourcade, "Rêver à trois aubergines." *Critique* (May 1974), p. 467–489 for a discussion of Matisse's painted border frames.

[20] A number or name and number in brackets refer to the MoMA photographic archive system of notation.

[21] See Didier Semin, "Note sur Seurat et le cadre," *Avant-guerre sur l'art, etc.* (2e Trimestre 1980), I, p. 53–59, for a detailed study of Seurat's frames and their meaning.

[22] Félix Fénéon, *Œuvre plus que complète*, Droz, Geneva-Paris 1970, p. 84, as quoted in Semin, p. 55. Original French text: "Ainsi déjouait-il en partie la sottise du détenteur qui s'aviserait (le cas s'est realisé plus d'une fois) de détruire un cadre magique pour le remplacer par un banal cadre d'or."

[23] Ibid. Original French text:"Dans les dernières années de sa vie brève ... peignait sur son cadre les tons et les teintes complémentaires de tons et teintes du tableau pour exciter ceux-ci par le contraste."

[24] Two other Seurat paintings now hang next to *Evening at Honfleur*, one to each side. *Port-en-Bessin*, 1888, which in 1972 (Keller 339) was quite elaborately framed is now in a simple gold box frame, whereas *The English Channel at Grandcamps*, 1885, is framed in a brown box frame, framing solutions equally unsympathetic to those of Seurat.

[25] In 1972, Balla's painting was framed with a dark wood frame but a white liner or tip separated the framing edge from the image (Keller 601). Balla was one of the most innovative artist-framers in the teens, a fact rarely taken into consideration when discussing or photographing his work.

[26] Alan C. Birnholz in "Forms, Angles and Corners: On Meaning in Russian Avant-Garde Art," *Arts* (February 1977), describes the relationship of Vladimir Tatlin's corner reliefs to Russian icons, suggesting that Russian vanguard artists other than Malevich were defining their art with specific reference to an indigenous artistic tradition.

[27] Crimp, "The Art of Exhibition," p. 69.

[28] Ibid., p. 68.

[29] *Artforum* (February 1987), p. 33. In all probability the long history of not framing MoMA's Monets is related to Germain Bazin's practice of removing frames from late Monets because, according to Bazin, these paintings were "conceived as fragments of space." See Germain Bazin, "An Experiment: The Impressionist Museum," *Museum*, vol. 1 (1948), p. 103.

[30] Yve-Alain Bois, "The de Stijl Idea," *Art in America* (November 1982), p. 109.

[31] See Meyer Schapiro, "Mondrian," in *Modern Art. 19th and 20th Centuries: Selected Papers*, George Braziller, New York 1978, note 7, p. 259, E.A. Carmean's *Mondrian: The Diamond Compositions*, National Gallery of Art, Washington 1979, is a detailed study of this aspect of Mondrian's oeuvre but aside from photographs of Mondrian's studio which show framed paintings, no frames appear on the illustrated works.

[32] The high hanging diamond is a carryover from the previous Mondrian installation; however, unlike its current status, it was not the only work hung so high (Keller 595, 596).

[33] Any number of published Mondrian studio or exhibition photographs show the range of Mondrian framing styles. To date, no one has compiled even the most fundamental chronology based on archive evidence.

[34] *Theo van Doesburg, 1883–1931*, Staatsuitgeverij, 's-Gravenhage 1983, p. 179. Numerous other installation and studio photographs published in this volume provide the necessary documentation from van Doesburg's archives to substantiate his framing practice.

[35] Reproduced in the Alloway-Coplans-Rubin interview cited above in *Artforum* (October 1974), p. 54.

[36] Ibid.

[37] See Semin for a discussion of Chevreul-inspired frames amongst Impressionist artists.

[38] Delaunay's relationship to Kandinsky, Marc, and Chevreul is discussed at length by Sherry A. Buckberrough in her doctoral thesis, *Robert Delaunay: The Discovery of Simultaneity*, UMI Research Press, Ann Arbor 1982. See in particular chapter 5, "The Windows—April–December 1912."

[39] Photographs of Kandinsky's glass painting frames are printed in *Kandinsky: Painting on Glass*, The Solomon R. Guggenheim Museum, New York 1968. Gabriele Munter, Kandinsky's lover at the time, also framed her glass paintings. Who influenced whom in this respect has yet to be determined with accuracy.

[40] Eddy's letter describes Campbell's reception hall in greater detail. See *The Guggenheim Museum Collection: Paintings 1880–1945*, vol I, Solomon R. Guggenheim Museum, New York 1976, p. 283.

[41] Dali's *Il piccolo teatro*, 1934, is set into a wall so that it appears to be framed in white. In doing so Rubin hides the double dark wood frame around the upper three sides. See *Il limite svelato: artista, cornice, publicco*, p. 85–87, a catalogue in MoMA's library.

[42] Although *The Menaced Assassin* is the only Magritte painting hanging framed in gold, Magritte used gold framing far more extensively than MoMA's installation indicates. See *Il limite svelato*, no. 93, p. 88 for a reproduction of *Representation* with a "shaped" gold frame.

[43] The frame now on the Delvaux is simpler than the combed gesso gold frame on the work in 1971 (Mathews 5648).

[44] "MoMA Reopened," p. 30–31.

[45] Meyer Schapiro in "On Some Problems in the Semiotics of Visual Art: Field and Vehicle in Image-Signs," *Semiotica*, I, no. 3 (1969), p. 223–242, is one of the first to discuss the frame as an eye trap, helping the viewer to focus.

[46] Barbara Johnson, "The Frame of Reference: Poe, Lacan, Derrida," in *Untying the Text*, ed. Robert J.C.Young, Routledge & Keegan Paul, London and Boston 1981 p. 238.

I wish to thank my accomplices; at MoMA, Mikki Carpenter in Archives and the Library staff led me to and provided evidence; Mathew Bullock at MoMA and M. Simon Levin in Montreal and Hamilton provided the photographic documentation; at Concordia, R. Bella Rabinovitch followed clues for years, helped me piece them together and, with Brian Foss and Catherine MacKenzie, refined the framing of my case.

Museums Managers of Consciousness
Hans Haacke

Parachute, no. 46, Spring 1987

The art world as a whole, and museums in particular, belong to what has aptly been called "the consciousness industry." More than 20 years ago, the German writer Hans Magnus Enzensberger gave us some insight into the nature of this industry in an article that used that phrase as its title. Although he did not specifically elaborate on the art world, his article did refer to it in passing. It seems worthwhile here to extrapolate from and to expand upon Enzensberger's thoughts for a discussion of the role museums and other art-exhibiting institutions play.

Like Enzensberger, I believe the use of the term "industry" for the entire range of activities of those who are employed or working on a freelance basis in the art field has a salutary effect. With one stroke that term cuts through the romantic clouds that envelop the often mis-leading and mythical notions widely held about the production, distribution, and consumption of

art. Artists, as much as their galleries, museums, and journalists, not excluding art historians, hesitate to discuss the industrial aspect of their activities. An unequivocal acknowledgment might endanger the cherished romantic ideas with which most entered the field, and which still sustain them emotionally today. Supplanting the traditional bohemian image of the art world with that of a business operation could also negatively affect the marketability of art world products and interfere with fund-raising efforts. Those who in fact plan and execute industrial strategies tend, whether by inclination or need, to mystify art and conceal its industrial aspect, and often fall for their own propaganda. Given the prevalent marketability of myths, it may sound almost sacrilegious to insist on using the term "industry."

On the other hand, a new breed has recently appeared on the industrial landscape: the arts managers. Trained by prestigious business schools, they are convinced that art can and should be managed like the production and marketing of other goods. They make no apologies and have few romantic hang-ups. They do not blush in assessing the receptivity and potential development of an audience for their product. As a natural part of their education they are conversant with budgeting, investment, and price-setting strategies. They have studied organizational goals, managerial structures, and the peculiar social and political environment of their organization. Even the intricacies of labor relations and the ways in which interpersonal issues might affect the organization are part of their curriculum.

Of course, all these and other skills have been employed for decades by art world denizens of the old school. Instead of enrolling in arts administration courses taught according to the Harvard Business School's case method, they have learned their skills on the job. Following their instincts they have often been more successful managers than the new graduates promise to be, since the latter are mainly taught by professors with little or no direct knowledge of the peculiarities of the art world. Traditionally, however, the old-timers are shy in admitting to themselves and others the industrial character of their activities and most still do not view themselves as managers. It is to be expected that the lack of delusions and aspirations among the new art administrators will have a noticeable impact on the state of

the industry. Being trained primarily as technocrats they are less likely to have an emotional attachment to the peculiar nature of the product they are promoting. And this attitude, in turn, will have an effect on the type of products we will soon begin to see.

My insistence on the term "industry" is not motivated by sympathy for the new technocrats. As a matter of fact, I have serious reservations about their training, the mentality it fosters, and the consequences it will have. What the emergence of arts administration departments in business schools demonstrates, however, is the fact that in spite of the mystique surrounding the production and distribution of art, we are now and indeed have been all along dealing with social organizations that follow industrial modes of operation, and that range in size from the cottage industry to national and multinational conglomerates. Supervisory boards are becoming aware of this fact. Given current financial problems, they try to streamline their operations. Consequently, the present director of The Museum of Modern Art in New York has a management background, and the boards of trustees of other US museums have or are planning to split the position of director into that of a business manager and an artistic director. The Metropolitan Museum in New York is one case where this split has already occurred. The debate often rages only over which of the two executives should and will in fact have the last word.

Traditionally the boards of trustees of US museums are dominated by members who come from the world of business and high finance. The board is legally responsible for the institution and consequently the trustees are the ultimate authority. Thus the business mentality has always been conspicuously strong at the decision-making level of private museums in the United States. However, the state of affairs is not essentially different in public museums in other parts of the world. Whether the directors have an art-historical background or not, they perform, in fact, the tasks of the chief executive officer of a business organization. Like their peers in other industries, they prepare budgets and development plans and present them for approval to their respective public supervising bodies and funding agencies. The staging of an international exhibition such as a Biennale or a Documenta presents a major managerial

challenge with repercussions not only for what is being
managed, but also for the future career of the executive
in charge.

Responding to a realistic appraisal of their lot, even
artists are now acquiring managerial training in workshops
funded by public agencies in the United States. Such
sessions are usually well attended, as artists recognize that
the managerial skills for running a small business could have
a bearing on their own survival. Some of the more successful
artists employ their own business managers. As for art
dealers, it goes without saying that they are engaged in
running a business. The success of their enterprises and the
future of the artists in their stables obviously depend a great
deal on their managerial skills. They are assisted by paid
advisors, accountants, lawyers, and public relations agents.
Furthermore, collectors too often do their collecting with
the assistance of a paid staff.

At least in passing, I should mention that numerous
other industries depend on the economic vitality of the art
branch of the consciousness industry. Arts administrators
do not exaggerate when they defend their claims for public
support by pointing to the number of jobs that are affected
not only in their own institutions but also in the communica-
tions, and particularly in the hotel and restaurant industries.
The Tut show of the Metropolitan Museum is estimated
to have generated $111 million for the economy of New York
City. In New York and possibly elsewhere real-estate
speculators follow with great interest the move of artists
into low-rent commercial and residential areas. From
experience they know that artists unwittingly open these
areas for gentrification and lucrative development. New
York's SoHo district is a striking example. Mayor Koch,
always a friend of the realtors who stuff his campaign chest,
tried recently to plant artists into particular streets on the
Lower East Side to accomplish what is euphemistically
called "rehabilitation" of a neighborhood, but what in fact
means squeezing out an indigenous poor population in
order to attract developers of high-rent housing. The
recent *Terminal Show* was a brainchild of the city's Public
Development Corporation. It was meant to draw attention
to the industrial potential of the former Brooklyn Army
Terminal building. And The Museum of Modern Art, having

erected a luxury apartment tower over its own building, is also now actively involved in real estate.[1]

Elsewhere city governments have recognized the importance of the art industry. The city of Hannover in West Germany, for example, sponsored widely publicized art events in order to improve its dull image. As large corporations point to the cultural life of their location in order to attract sophisticated personnel, so Hannover speculated that the outlay for art would be amortized many times by the attraction the city would gain for businesses seeking sites for relocation. It is well documented that Documenta is held in an out-of-the-way place like Kassel and given economic support by the city, state, and federal government because it was assumed that Kassel would be put on the map by an international art exhibition. It was hoped that the event would revitalize the economically depressed region close to the German border and that it would prop up the local tourist industry.

Another German example of the way in which direct industrial benefits flow from investment in art may be seen in the activities of the collector Peter Ludwig. It is widely believed that the motive behind his buying a large chunk of government-sanctioned Soviet art and displaying it in "his" museums was to open the Soviet market for his chocolate company. Ludwig may have risked his reputation as a connoisseur of art, but by buying into the Soviet consciousness industry he proved his taste for sweet deals. More recently he recapitalized his company by selling a collection of medieval manuscripts to the Getty Museum for an estimated price of $40 to $60 million (see *A.i.A.*, Summer 1983). As a shrewd businessman, Ludwig used the money to establish a foundation that owns shares in his company. Thus the income from this capital remains untaxed and, in effect, the ordinary taxpayer winds up subsidizing Ludwig's power ambitions in the art world.[2]

Aside from the reasons already mentioned, the discomfort in applying industrial nomenclature to works of art may also have to do with the fact that these products are not entirely physical in nature. Although transmitted in one material form or another, they are developed in and by consciousness and have meaning only for another consciousness. In addition,

it is possible to argue over the extent to which the physical object determines the manner in which the receiver decodes it. Such interpretive work is in turn a product of consciousness, performed gratis by each viewer but potentially salable if undertaken by curators, historians, critics, appraisers, teachers, etc. The hesitancy to use industrial concepts and language can probably also be attributed to our lingering idealist tradition, which associates such work with the "spirit," a term with religious overtones and one that indicates the avoidance of mundane considerations.

The tax authorities, however, have no compunction in assessing the income derived from "spiritual" activities. Conversely, the taxpayers so affected do not shy away from deducting relevant business expenses. They normally protest against tax rulings, which declare their work to be nothing but a hobby, or to put it in Kantian terms, the pursuit of "disinterested pleasure." Economists consider the consciousness industry as part of the ever-growing service sector and include it as a matter of course in the computation of the gross national product.

The product of the consciousness industry, however, is not only elusive because of its seemingly non-secular nature and its aspects of intangibility. More disconcerting, perhaps, is the fact that we do not even totally command our individual consciousness. As Karl Marx observed in the German ideology, consciousness is a social product. It is, in fact, not our private property, homegrown and a home to retire to. It is the result of a collective historical endeavor, embedded in and reflecting particular value systems, aspirations, and goals. And these do not by any means represent the interests of everybody. Nor are we dealing with a universally accepted body of knowledge or beliefs. Word has gotten around that material conditions and the ideological context in which an individual grows up and lives determine to a considerable extent his or her consciousness. As has been pointed out, and not only by Marxist social scientists and psychologists, consciousness is not a pure, independent, value-free entity, evolving according to internal, self-sufficient, and universal rules. It is contingent, an open system, responsive to the crosscurrents of the environment. It is, in fact, a battleground of conflicting interests. Correspondingly, the products of consciousness represent interests and

interpretations of the world that are potentially at odds with each other. The products of the means of production, like those means themselves, are not neutral. As they were shaped by their respective environments and social relations, so do they in turn influence our view of the human condition.

Currently we are witnessing a great retreat to the private cocoon. We see a lot of noncommittal, sometimes cynical playing on naively perceived social forces, along with other forms of contemporary dandyism and updated versions of art for art's sake. Some artists and promoters may reject any commitment, and refuse to accept the notion that their work presents a point of view beyond itself or that it fosters certain attitudes; nevertheless, as soon as work enjoys larger exposure it inevitably participates in public discourse, advances particular systems of belief, and has reverberations in the social arena. At that point, art-works are no longer a private affair. The producer and the distributor must then weigh the impact.

But it is important to recognize that the codes employed by artists are often not as clear and unambiguous as those in other fields of communication. Controlled ambiguity may, in fact, be one of the characteristics of much Western art since the Renaissance. It is not uncommon that messages are received in a garbled, distorted form and that they possibly even relay the opposite of what was intended—not to speak of the kinds of creative confusion and muddle-headedness that can accompany the artwork's production. To compound these problems, there are the historical contingencies of the codes and the unavoidable biases of those who decipher them. With so many variables, there is ample room for exegesis and a livelihood is thus guaranteed for many workers in the consciousness industry.

Although the product under discussion appears to be quite slippery, it is by no means inconsequential, as cultural functionaries from Moscow to Washington make clear every day. It is recognized in both capitals that not only the mass media deserve monitoring, but also those activities which are normally relegated to special sections in the backs of newspapers. The *New York Times* calls its weekend section "Arts and Leisure" and covers under this heading theater, dance, movies, art, numismatics, gardening, and other ostensibly harmless activities. Other papers carry these

items under equally innocuous titles such as "Culture," "Entertainment," or "Life Style." Why should governments, and for that matter corporations which are not themselves in the communications industry, pay attention to such seeming trivia? I think they do so for good reason. They have understood, sometimes better than the people who work in the leisure suits of culture, that the term "culture" camouflages the social and political consequences resulting from the industrial distribution of consciousness.

The channeling of consciousness is pervasive not only under dictatorships but also in liberal societies. To make such an assertion may sound outrageous because according to popular myth liberal regimes do not behave this way. Such an assertion could also be misunderstood as an attempt to downplay the brutality with which mainstream conduct is enforced in totalitarian regimes or as a claim that coercion of the same viciousness is practiced elsewhere, too. In non-dictatorial societies, the induction into and the maintenance of a particular way of thinking and seeing must be performed with subtlety in order to succeed. Staying within the acceptable range of divergent views must be perceived as the natural thing to do.

Within the art world, museums and other institutions that stage exhibitions play an important role in the inculcation of opinions and attitudes. Indeed, they usually present themselves as educational organizations and consider education as one of their primary responsibilities. Naturally, museums work in the vineyards of consciousness. To state that obvious fact, however, is not an accusation of devious conduct. An institution's intellectual and moral position becomes tenuous only if it claims to be free of ideological bias. And such an institution should be challenged if it refuses to acknowledge that it operates under constraints deriving from its sources of funding and from the authority to which it reports.

It is perhaps not surprising that many museums indignantly reject the notion that they provide a biased view of the works in their custody. Indeed, museums usually claim to subscribe to the canons of impartial scholarship. As honorable as such an endeavor is—and it is still a valid goal to strive after—it suffers from idealist delusions about the nonpartisan character of consciousness. A theoretical prop

for this worthy but untenable position is the 19th-century doctrine of art for art's sake. That doctrine has an avant-garde historical veneer and in its time did indeed perform a liberating role. Even today, in countries where artists are openly compelled to serve prescribed policies, it still has an emancipatory ring. The gospel of art for art's sake isolates art and postulates its self-sufficiency, as if art had or followed rules which are impervious to the social environment. Adherents of the doctrine believe that art does not and should not reflect the squabbles of the day. Obviously they are mistaken in their assumption that products of con-sciousness can be created in isolation. Their stance and what is crafted under its auspices has not only theoretical, but also definite social implications. American formalism updated the doctrine and associated it with the political concepts of the "free world" and individualism. Under Clement Greenberg's tutelage, everything that made worldly references was simply excommunicated from art so as to shield the grail of taste from contamination. What started out as a liberating drive turned into its opposite. The doctrine now provides museums with an alibi for ignoring the ideological aspects of art works and the equally ideological implications of the way those works are presented to the public. Whether such neutralizing is performed with deliberation or merely out of habit or lack of resources is irrelevant: practiced over many years it constitutes a powerful form of indoctrination.

Every museum is perforce a political institution, no matter whether it is privately run or maintained and supervised by governmental agencies. Those who hold the purse strings and have the authority over hiring and firing are, in effect, in charge of every element of the organization, if they choose to use their powers. While the rule of the boards of trustees of museums in the United States is generally uncontested, the supervisory bodies of public institutions elsewhere have to contend much more with public opinion and the prevail-ing political climate. It follows that political considerations play a role in the appointment of museum directors. Once they are in office and have civil service status with tenure, such officials often enjoy more independence than their colleagues in the United States, who can be dismissed from

one day to the next, as occurred with Bates Lowry and John Hightower at The Museum of Modern Art within a few years of each other. But it is advisable, of course, to be a political animal in both settings. Funding, as much as one's prospect for promotion to more prestigious posts, depend on how well one can play the game.

Directors in private US museums need to be tuned primarily to the frame of mind represented by the *Wall Street Journal*, the daily source of edification of their board members. They are affected less by who happens to be the occupant of the White House or the mayor's office, although this is not totally irrelevant for the success of applications for public grants. In other countries the outcome of elections can have a direct bearing on museum policies. Agility in dealing with political parties, possibly even membership in a party, can be an asset. The arrival of Margaret Thatcher in Downing Street and of François Mitterand at the Élysée noticeably affected the art institutions in their respective countries. Whether in private or in public museums, disregard of political realities, among them the political need of the supervising bodies and the ideological complexion of their members, is a guarantee for managerial failure.

It is usually required that, at least to the public, institutions appear nonpartisan. This does not exclude the *sub rosa* promotion of the interests of the ultimate boss. As in other walks of life, the consciousness industry also knows the hidden agenda, which is more likely to succeed if it is not perceived as such. It would be wrong, however, to assume that the objectives and the mentality of every art executive are or should be at odds with those on whose support his organization depends. There are natural and honorable allegiances as much as there are forced marriages and marriages of convenience. All players, though, usually see to it that the serene facade of the art temple is preserved.

During the past 20 years the power relations between art institutions and their sources of funding have become more complex. Museums used to be maintained either by public agencies—the tradition in Europe—or through donations from private individuals and philanthropic organizations, as has been the pattern in the United States. When Congress established the National Endowment for the Arts in 1965, US museums gained an additional source of

funding. In accepting public grants, however, they became accountable, even if in practice only to a limited degree, to government agencies.

Some public museums in Europe went the road of mixed support, too, although in the opposite direction. Private donors came on board with attractive collections. As has been customary in US museums, however, some of these donors demanded a part in policy making. One of the most spectacular recent examples has been the *de facto* takeover of museums (among others, museums in Cologne, Vienna, and Aachen) that received or believed they would receive gifts from the German collector Peter Ludwig.[3] As is well known in the Rhineland, Count Panza di Biumo's attempt to get his way in the new museum of Mönchen-gladbach, down the Rhine from Ludwig's headquarters, was successfully rebuffed by the director, Johannes Cladders, who is both resolute and a good poker player in his own right.[4] How far the Saatchis in London will get in dominating the Tate Gallery's Patrons of New Art—and thereby the museum's policies for contemporary art—is currently watched with the same fascination and nervousness as developments in the Kremlin. A recent, much-noticed instance of Saatchi influence was the Tate's 1982 Schnabel show, which consisted almost entirely of works from the Saatchis' collection. In addition to his position on the steering committee of the Tate's Patrons of New Art, Charles Saatchi is also a trustee of the Whitechapel Gallery.[5] Furthermore, the Saatchis' advertising agency has just begun handling publicity for the Victoria and Albert, the Royal Academy, the National Portrait Gallery, the Serpentine Gallery, and the British Crafts Council. Certainly the election victory of Mrs Thatcher, in which the Saatchis played a part as the advertising agency of the Conservative Party, did not weaken their position (and may in turn have provided the Conservatives with a powerful agent within the hallowed halls of the Tate).

If such collectors seem to be acting primarily in their own self-interest and to be building pyramids to them-selves when they attempt to impose their will on "chosen" institutions, their moves are in fact less troublesome in the long run than the disconcerting arrival on the scene of corporate funding for the arts—even though the latter

at first appears to be more innocuous.[6] Starting on a large
scale toward the end of the 1960s in the United States and
expanding rapidly ever since, corporate funding has spread
during the last five years to Britain and the Continent.
Ambitious exhibition programs that could not be financed
through traditional sources led museums to turn to corpora-
tions for support. The larger, more lavishly appointed these
shows and their catalogues became, however, the more
glamour the audiences began to expect. In an ever-advancing
spiral, the public was made to believe that only Hollywood-
style extravaganzas are worth seeing and give an accurate
sense of the world of art. The resulting box-office pressure
made the museums still more dependent on corporate
funding. Then came the recession of the 1970s and 1980s.
Many individual donors could no longer contribute at the
accustomed rate, and inflation eroded the purchasing power
of funds. To compound the financial problems, many
governments, facing huge deficits, often due to sizable
expansions of military budgets, cut their support for social
services as well as their arts funding. Again museums felt
they had no choice but to turn to corporations for a bailout.
Following their own ideological inclinations and making
them national policy, President Reagan and Mrs Thatcher
encouraged the so-called private sector to pick up the slack
in financial support.

 Why have business executives been receptive to
the museums' pleas for money? During the restive 1960s
the more astute ones began to understand that corporate
involvement in the arts is too important to be left to
the chairman's wife. Irrespective of their own love for or
indifference toward art they recognized that a company's
association with art could yield benefits far out of proportion
to a specific financial investment. Not only could such a
policy attract sophisticated personnel, but it also projected
an image of the company as a good corporate citizen and
advertised its products—all things that impress investors.
Executives with a longer vision also saw that the association
of their company, and by implication of business in general,
with the high prestige of art was a subtle but effective means
for lobbying in the corridors of government. It could open
doors, facilitate passage of favorable legislation, and serve as
a shield against scrutiny and criticism of corporate conduct.

Museums, of course, are not blind to the attractions for business of lobbying through art. For example, in a pamphlet with the telling title "The Business Behind Art Knows the Art of Good Business," the Metropolitan Museum in New York woos prospective corporate sponsors by assuring them: "Many public relations opportunities are available through the sponsorship of programs, special exhibitions, and services. These can often provide a creative and cost-effective answer to a specific marketing objective, particularly where international, governmental, or consumer relations may be a fundamental concern."[7]

A public relations executive of Mobil in New York aptly called the company's arts support a "goodwill umbrella," and his colleague from Exxon referred to it as a "social lubricant."[8] It is liberals in particular who need to be greased because they are the most likely and sophisticated critics of corporations, and they are often in positions of influence. They also happen to be more interested in culture than other groups on the political spectrum. Luke Ritter, who as outgoing director of the British Association of Business Sponsorship of the Arts should know, recently explained: "A few years ago companies thought sponsoring the arts was charitable. Now they realize there is also another aspect; it is a tool they can use for corporate promotion in one form or another." Ritter, obviously in tune with his Prime Minister, has been appointed as the new Secretary General on the British Arts Council.

Corporate public relations officers know that the greatest publicity benefits can be derived from high-visibility events, shows that draw crowds and are covered extensively by the popular media; these are shows that are based on and create myths—in short, blockbusters. As long as an institution is not squeamish about company involvement in press releases, posters, advertisements, and its exhibition catalogue, its grant proposal for such an extravaganza is likely to be examined with sympathy. Some companies are happy to underwrite publicity for the event (which usually includes the company logo) at a rate almost matching the funds they make available for the exhibition itself. Generally, such companies look for events that are "exciting," a word that pops up in museum press releases and catalogue prefaces more often than any other.

Museum managers have learned, of course, what kind of
shows are likely to attract corporate funding. And they also
know that they have to keep their institutions in the lime-
light. Most shows in large New York museums are now
sponsored by corporations. Institutions in London will soon
be catching up with them. The Whitney Museum has even
gone one step further. It has established branches—almost
literally a merger—on the premises of the two companies.[9]
It is fair to assume that exhibition proposals that do fulfill
the necessary criteria for corporate sponsorship risk not
being considered, and we never hear about them. Certainly,
shows that could promote critical awareness, present
products of consciousness dialectically and in relation to the
social world, or question relations of power have a slim
chance of being approved—not only because they are
unlikely to attract corporate funding, but also because they
could sour relations with potential sponsors for other shows.
Consequently, self-censorship is having a boom.[10] Without
exerting any direct pressure, corporations have effectively
gained a veto in museums, even though their financial
contribution often covers only a fraction of the costs of an
exhibition. Depending on circumstances, these contributions
are tax-deductible as a business expense or a charitable
contribution. Ordinary taxpayers are thus footing part of
the bill. In effect, they are unwitting sponsors of corporate
policies, which, in many cases, are detrimental to their
health and safety, the general welfare and in conflict with
their personal ethics.

Since the corporate blanket is so warm, glaring
examples of direct interference rare,[11] and the increasing
dominance of the museums' development offices hard
to trace, the change of climate is hardly perceived, nor is
it taken as a threat. To say that this change might have
consequences beyond the confines of the institution and
that it affects the type of art that is and will be produced
therefore can sound like over-dramatization. Through
naiveté, need, or addiction to corporate financing, museums
are now on the slippery road to becoming public relations
agents for the interests of big business and its ideological
allies. The adjustments that museums make in the selection
and promotion of works for exhibition and in the way
they present them create a climate that supports prevailing

distributions of power and capital and persuades the populace that the status quo is the natural and best order of things. Rather than sponsoring intelligent, critical awareness, museums thus tend to foster appeasement.

Those engaged in collaboration with the public relations officers of companies rarely see themselves as promoters of acquiescence. On the contrary, they are usually convinced that their activities are in the best interests of art. Such a well-intentioned delusion can survive only as long as art is perceived as a mythical entity above mundane interests and ideological conflict. And it is, of course, this misunderstanding of the role that products of the conscious-ness industry play, which constitutes the indispensable base for all corporate strategies of persuasion.

Whether museums contend with governments, power trips of individuals, or the corporate steamroller, they are in the business of molding and channeling consciousness. Even though they may not agree with the system of beliefs dominant at the time, their options not to subscribe to them and instead to promote an alternative consciousness are limited. The survival of the institution and personal careers are often at stake. But in nondictatorial societies the means for the production of consciousness are not all in one hand. The sophistication required to promote a particular interpretation of the world is potentially also available to question that interpretation and to offer other versions. As the need to spend enormous sums for public relations and government propaganda indicates, things are not frozen. Political constellations shift and unincorporated zones exist in sufficient numbers to disturb the mainstream.

It was never easy for museums to preserve or regain a degree of maneuverability and intellectual integrity. It takes stealth, intelligence, determination—and some luck. But a democratic society demands nothing less than that.[12]

[1] The Equitable Life Assurance Society bought and commissioned art works worth seven million dollars US for its new headquarters on New York's 7th Avenue. It also made space available for a branch of the Whitney Museum. Explaining this investment in art, Benjamin D. Holloway, the chairman of Equitable's Real Estate Group, declared: "We are doing these things because we think it will attract and hold tenants and that they will pay us rents we are looking for." Quoted in *The New Yorker*, April 14, 1988.

[2] This infusion of capital was insufficient to stem the decline of Mr Ludwig's chocolate empire. In 1988, he was forced to sell his license to produce and market Lindt chocolate in Germany and the Netherlands. Even more tranchant was the take-over of all of his non-German production facilities (St-Hyacinthe, Québec; St Albans, Vermont; Herentals, Belgium) including the van Houten label and distribution network by the Swiss Jacob Suchard AG. From first place, Mr Ludwig's chocolate company dropped to fourth among German chocolate manufacturers.

[3] In September 1985, the new building of the Ludwig Museum was opened in Cologne. At the occasion, Mr Ludwig presented to the public busts of himself and his wife, Irene, which he had commissioned from Arno Breker. Breker was the most celebrated artist of the Nazi regime. In interviews, Ludwig praised Breker and proposed that paintings and sculptures made under Hitler should be included in German museums.

[4] Dr Cladders, who for several years was in charge of the German Pavilion at the Venice Biennale, has since retired from the directorship of the Museum in Mönchongladbach, and Count Panza di Biumo has sold a major portion of his collection to the Museum of Contemporary Art in Los Angeles.

[5] During an exhibition of my works at the Tate Gallery in 1984, Charles Saatchi resigned from the Patrons of New Art committee of the Tate as well as from the Board of Trustees of the Whitechapel Gallery. Max Gordon, a friend of the Saatchis and the architect of the new Saatchi Museum in London, is still member of the Whitechapel Gallery where a retrospective of Julian Schnabel was mounted in 1986.

[6] The influence of the Saatchis has since grown considerably through a spectacular series of merges. They have become the largest advertising empire of the world, with amiable offshoots in public relations, lobbying, and management consulting. As experienced toilers in those branches of the consciousness industry, the Saatchis now seem to have an impact on the art world that matches or even exceeds that of other corporate art sponsors, particularly in regard to contemporary art. Carl Spielvogel, the head of one of the Saatchi & Saatchi subsidiaries in New York, is now the Chairman of the Metropolitan Museum's Business Committee, and Charles Saatchi is a Vice-Chairman of the Museum's International Business Committee.

[7] Already In 1971, C. Douglas Dylion, the recently retired Chairman of the Metropolitan's Board of Trustees, wrote in the *Columbia Journal of World Business* (September/October 1971): "Perhaps the most important single reason for the increased interest of international corporations in the arts is the almost limitless diversity of projects which are possible. The projects can be tailored to a company's specific business goals and can return dividends far out of proportion to the actual investment required."

[8] In an open page advertisement in the *New York Times* on October 10, 1985, Mobil explained under the headline: "Art, for the Sake of Business," the rationale behind its involvement in the arts In those words: "What's in it for us—or for your company? Improving—and insuring—the business climate." More extensive reasoning is given by Mobil Director and Vice-President of Public Affairs, Herb Schmertz, in the chapter "Affinity-of-Purpose Marketing: The Case of Masterpiece Theater," in his book *Goodbye to the Low Profile: The Art of Creative Confrontation*, Little, Brown & Co., Boston 1986.

[9] The headquarters of Philip Morris in New York and the headquarters of the Champion International Corporation in Stanford, Connecticut. An additional branch has since been opened at the new headquarters of the Equitable Life Assurance Society in New York. Benjamin D. Holloway, Chairman and Chief Executive Officer of the Equitable Real Estate Group, a subsidiary of the insurance company, has joined the Whitney Museum Board of Trustees. When he was queried about his relationship through the exhibition program of the Museum at the Equitable Center by Michael Brenson of the *New York Times* (February 23, 1986), he answered: "I would be the last person in the world to censor them, but I'm responsible for what I do and they are responsible for what they do and if they do something irresponsible, they have to take the consequences."

[10] Philippe de Montebello, Director of the Metropolitan Museum, is quoted in *Newsweek* (November 26, 1985): "It's an inherent insidious hidden form of censorship ... But corporations aren't censoring us—we are censoring ourselves."

[11] In 1984, Mobil threatened the Tate Gallery and the Stedelijk van Abbemuseum in Eindhoven with a lawsuit. The oil giant objected to the reproduction of several works I had made on the activities of Mobil in the catalogue, which was co-published by the two institutions on the occasion of a one-man show at the Tate Gallery. As a precautionary legal measure, the two museums suspended the distribution of the catalogue. They resumed distribution to the public after about a year.

[12] This is a slightly altered version of an essay that was originally delivered as a talk at the Annual Meeting of the Art Museum Association of Australia in Canberra, August 30, 1983, and published in *Art in America* in 1984. Photographs of volcanoes erupting and surfers surfing were taken from slides bought by Haacke in Hawaii en route to his lecture in Canberra; these slides were projected during the talk.

Painterly Bricolage. Art on Art:
The Question of Quoting
René Payant

Parachute, no. 16, Fall 1979

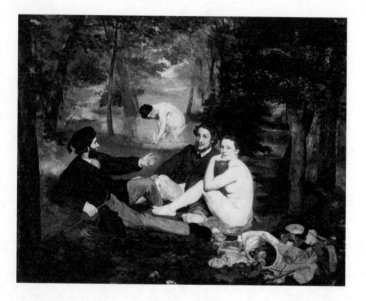

Édouard Manet
Le Déjeuner sur l'herbe (*Luncheon on The Grass*), 1863, oil on canvas, 208 × 264.5 cm

Quoting: Betwixt and Between

We could, from the outset, postulate the following: every painting quotes another (at least one). But the consequences of such a proposal are already great, for at least two reasons. First, because we would have to question the use of the expression "to quote." If this term should be reserved for the "work" of written or spoken language, then importing it into the realm of painting almost automatically implies that painting could, or even should, itself be considered a language. Unless, like all the other terminological borrowings from linguistics, its use is metaphoric and assumes only a vague resemblance between the two fields. I prefer to disregard this latter possibility, because to accept it would lead us onto the confused paths of a discourse on art that has become literary. As for considering painting as similar to a language, this too is not without problems.

Debates over the linguistic nature of painting (or of any other kind of image) have not yielded results impressive enough for us to continue quibbling over the hierarchy that should exist between linguistics and semiology (or semiotics).[1] What interests us here lies beyond this first level of distinction, because quoting belongs to the domain of the theory of discourse, which is a higher level of linguistic analysis. This does not mean that we can overlook the fundamental distinction between the minimal units of language, but— for the moment—we will not limit our analysis to this theoretical point.[2] I would like to suggest, rather, that we bracket this question and look at painting as a system of forms which are capable of signifying.[3] Our borrowings from linguistics, literary theory, or semiotics will thus serve only as theoretical tools to make it possible for us to designate more adequately one of the particulars of the signifying process. And, who knows, perhaps at the same time to determine a feature of the specificity of the "language of painting."

To grant our opening postulate would also oblige us, in another sense, to take into account at least two works at a time. This is not impossible, but it poses several difficulties: the quoted work is only partially present, while the quoting work does not, generally speaking, clearly indicate its source. This is one reason why Leo Steinberg came to resist the use of the term to describe the process of referencing that we might "discover" in a painting.[4] Locating an imported fragment in a painting, moreover, in no way guarantees that this element so distinguished in the eyes of the viewer-reader will have a referencing function. According to Steinberg, painting, up until the "revelatory" experiments of the 20th century, was more likely to mask its borrowings. We can thus understand the "pleasure" of the art historian who, tracking without respite the work's imported motifs (in the Panofskian sense), suddenly stumbles upon an unacknowledged refer-ence. Iconographic analysis already pushes the sense of this study a little further ahead. However, art historians (all too) often—because it is difficult to attain masterly erudition in the iconological method—are satisfied with the discovery alone. I do not at all feel that I have the spirit of Sherlock Holmes, but if I were to learn something from this famous detective, it would be his "logic"—the relationships that

push him, (almost) necessarily, to go where others do not, or at least to stop when others sketched out which paths to follow.

Whether camouflaged[5] or frankly acknowledged, the quotation remains, just the same, a formal feature of the work which refers us back to its genesis. We view the question of quoting in painting essentially from the point of view of its production. From this point of view, we might better be able to see that the degree of its manifestation is a question of its era, and represents a conception of painting rather than a simple definition of quoting alone. Quoting, which is a link between at least two works, interests us as a dynamic. I will thus consider it here as an act rather than as a product. Since quoting is an act of moving something from one space to another, which is to say of transporting (part of) a source work to a target work, the quote, as a part of the target work, necessarily refers to its original place. While it involves a choice on the part of the author of the target work—which is what Steinberg insists upon—it nevertheless, and above all, indicates a principle of "movability" within the source work, which is something Steinberg does not seem to acknowledge.[6] This principle, moreover, is linked to the principle of reproducibility. Indeed, despite the act of quoting, the source work remains intact, because the quote in the target work is only a representation. If the source work had been physically transported, the process would be more one of collage. This is a crueler act, because it creates holes and puts an end to any possible repetition. Transporting the work by proxy, however, can be repeated indefinitely: a quoted work is thus not quoted once and for all.

It would therefore be worthwhile to know what exactly is involved in the act of quoting. Let us think, first of all, of this: I am reading a text (for example, Steinberg's article) and, all of a sudden, or after re-reading it, I underline a passage (for example, the passage quoted above in note six). What has happened? Have I chosen to mark this section of the text, or, on the contrary, has it chosen me? Why all of a sudden? Was I seduced, or shocked? Why while re-reading it? To recover a lost thought or return to a passage that I understood only later on? Why quote it now? Because it suits me, because I found in it an idea I share? In which case, I was inside the text even before arriving at it: reading

as a mirror effect; Narcissus. Or, I underline in order to accuse, because I don't like the idea, and my gesture is cruel— the text is thus already against me, and I would inevitably exhaust myself trying to neutralize it. Because, by quoting it, I would only be attacking its/my representation: reading's Medusa effect. To write under the text (underlining) or in its margins (making note of) is already to put in motion a process of quoting: sooner or later we are going to write on what we have already chosen there. In other words, we are going to write on what is already-done (readymade), on a text that has already been worked by our annotations and which will find itself quoted, which is to say represented, in and by our future text. The quote always wins, because it distinguishes itself from the setting that frames it. It will thus always be at the center of representation, or in any event its value will be increased, because it is underlined, pointed out, framed, selected, and put into play from the beginning, in other words since we stopped there or it stopped us, in order to begin being by beginning to push us away, to push us off the stage, outside of the action.

I will not make the claim in as radical a fashion as Steinberg that an artist's decisions are not reactions to irresistible causes. Here, reason triumphs with too much facility. To choose to quote is perhaps to decide, at the same time, one's ruin. The source is like a condensation of energy; to touch it is like opening a breach through which its intensity escapes and enters into us. Quoting is thus to be carried away, or to let oneself be carried away, by an extraneous force. While it is true that, traditionally, painters sought to mask their borrowings, this was in order to guarantee their visibility and mastery of the language of painting, which they proved they could control. The uniform, flawless image that left no trace of its production (for which we imagine the classical painting sought to be a model) nevertheless runs the risk of being a perfect simulacrum and thus of making us forget the painter. On the contrary, the heterogeneous image that asserts itself without shame as including quotes, testifies by nature to the existence of the painter. But what this kind of image-construction truly represents is the source work's force which, through the painter's action, has shifted, and which is transformed by the target painting. If modernity is marked by the most

open manifestation of quoting, it is because it reveals the
autonomy of the language of painting, the working strength
that circulates within it through painters, who are its
transformers. If modernity represents artists' conquest of
the freedom of expression,[7] this is proportional to the
conquest of self-referencing (self-quoting) of the language
of painting.[8] Here we touch upon the paradox at the heart
of painting: the relationship between the force of objects
and the artist's resistance. Everything takes place between
these two poles: this is where desire circulates, whose
complexity creates the tension between the life force (Eros)
and the death wish (Thanatos). This, I believe, is where we
must locate the work of quoting, half way between the same
and the other.

Collage Effect

Of the numerous examples that Steinberg cites in passing,
we will examine here only Manet's famous *Déjeuner sur l'herbe*
(1863). It will help us establish more precisely the direction
our enquiry into painting will take and to distinguish our
position from Steinberg's. Steinberg first cites Manet's work
in a comparison of an engraving by Hans Sebald Beham and
other engravings by Marcantonio Raimondi. Like others
before him, he locates the motif of the central trio in *Déjeuner*
as deriving from Raphael's *Judgment of Paris* (ca. 1510–1520), of
which Raimondi had done an engraving.[9] In the case of this
example of borrowing, Steinberg's only further comments
are made in order to insist upon the "recycling" of motifs.

Some of the reactions to this painting at the 1863 Salon
des Refusés, however, already suggest one of the painting's
interesting features. The *Déjeuner* was without doubt one of
the least understood and most ridiculed paintings in the
Salon—which, in Zola's words, nevertheless emitted a "fine
fragrance of youth, bravura, and passion."[10] In the end, the
Emperor decreed that the painting offended the people's
sense of decency. It was not the woman's nudity that was at
issue, however, but rather the two men, who were dressed
in the style of the day. It was, therefore, a case of an excess
of realism—while the woman remained a part of a long
tradition in the history of painting, of which Ingres was a
good representative at the time. But this nude was not

entirely free of defects, and was capable of attracting the same reproaches that were made two years later against *Olympia* (1863), which was inspired by Titian's *Venus of Urbino* (1538). A-P. Martial accused Manet of neglecting reflections and counter-reflections, of making the shadows too sooty-looking, and of distancing himself too much from nature's innate harmony. T. Gauthier also called attention to the lack of relief. Even Courbet was shocked by this absence of relief. Numerous art historians have since echoed these negative remarks. Elie Faure, for example, even while granting this gesture a certain audacity, remarked that Manet almost completely ignored half tones, that he almost entirely suppressed any richness of form and contented himself with juxtaposing or superimposing splotches encircled by very firm lines. By not subscribing to the representation of "complicit shadows,"[11] Manet sacrificed in a sense the representation's realistic aspect. With the *Déjeuner*'s central trio we are, as a result, in the presence of a complex and somewhat paradoxical motif. The female nude is banal, but her plastic treatment is incongruous and detracts from the picture's representational realism; while within the group of completely dressed men, it is realism itself that makes the iconographic accuracy inadmissible. But between the excess of realism here and the absence of realism there, there is a slippage in the plastic treatment of the iconography that we must insist upon here. Indeed, here we touch upon a nuance that makes it possible to distinguish the stated object (what the painting represents or utters) from the way it is stated and the fact it is stated (the painting as representation or utterance). By creating a dichotomy within the motif, Manet created a fault in this painting's unity and thus directed the viewer's attention to two realities in opposition.

It is not only for this reason, no doubt, that Manet seemed to have "all the qualities needed to be unanimously rejected by every jury in the world."[12] John Rewald adds to this an observation that leads us back to the heart of our discussion: Manet demonstrates a strange lack of imagination in untiringly drawing on the work of other artists.[13] But this famous historian of Impressionism also plunges us into ambiguity when he refers, in the same breath, to the borrowing of themes, motifs, and styles, which are not exactly the same thing.

Whatever the fairness or accuracy of all these observations, we can make use of them for our own discussion. First of all, the central section of *Déjeuner* comes from a work by Raphael, but by way of an intermediary, Raimondi's engraving, or in other words by way of a reproduction that puts the original into circulation. On this first point, it remains to be determined if there is something within Manet's painting that signals the fact that the central motif was imported. In other words, whether we can recognize a formal mark—like the use of quotation marks, for example—that isolates the motif as an independent element of the landscape (the backdrop) and of the still life in the foreground. Second, the borrowed fragment is divided into two distinct parts through their different treatment. The chromatic quality, the design, and the brush strokes used to represent the men connects them quite well to the rest of the image. The female character, who is bright, outlined with a firm stroke and virtually without a model, thus stands out against the central trio and, as a result, from the entire image. Hence, third, the representation of the female nude is the least realist part of the painting. As a result, when all is said and done, the nude woman functions as a *mise en abîme* of the process of creating the painting: it is a fragment of a fragment displaced to the setting of Manet's painting. It is thus doubly framed, and put into play a process of the realistic representational system's degradation. In other words, by gradually isolating itself from the rest of the image, it has lost its volume; it has become flat and, in the end, "sticks" more to the plane of the canvas than to the scene depicted. Hence the effect of its superimposition on the entire image, its collage effect.[14]

Semiotic Rupture

Once again, we must take note of the semantic transformation that accompanies this spatial displacement. In the source work, Raphael's *Judgment of Paris*, as in Raimondi's engraving of it, the group of three figures is part of a mythological scene. In the target work, the quoted section is placed in a quite modern scene. Manet reproduced the arrangement and gestures of the characters as he found them,[15] but he dressed the men. The woman's nudity is thus doubly

peculiar and makes it possible to construct any number of
"little stories" about the scene. The Renaissance painting's
narrative closure has given way to an ambiguous scene that
presents the painting in a way that encourages connotations.
In short, Manet emptied the borrowed form of its content.
In the latter scene, the nude and flattened woman is even
indicated by the figure on the right, who has been stripped
of the reed he held in the original scene.[16] There is no doubt
that this woman is the principal subject of the painting, but
we do not know exactly what she is the principal subject
of, unless it is, precisely, the story of the painting itself. This
would mean that Manet turned the meaning of the scene
toward representation itself by indicating the space in which
it is produced: the surface of the canvas. In declaring
his borrowing from the Renaissance of one of its painterly
motifs and in (re)working it in another way to create
a contradiction within it, Manet has reversed the entire
project of the painting system established during the
Renaissance, because he draws the viewer's attention to this
system's hidden side. Here, quoting thus becomes critique.
The big "R" that was written on the stretchers used to
transport rejected canvases did not stand for "Revolution,"[17]
but this what was already in motion here, in the passage
from the masked quote to the unveiling of the act of quoting,
among other things.

We can conclude this initial setting out of a few questions
concerning quoting in painting by proposing the following
schema:

1. Complete quoting: form and content
2. Truncated quoting: a) form only
 b) content only

This schema, which is, without a doubt, still far too general,
will nevertheless make it possible for us to examine in
greater depth the various kinds of and intentions behind
quoting in painting. This quoting, as we will see, is not
always as direct; sometimes it is carried out obliquely (indirect
discourse). But, as an utterance within an utterance, a
message within a message, quoting (or the discourse quoted),
as Roman Jakobson reminds us, is "speech within speech, a

message within a message."[18] It is this circular effect—the message referring back to the message—which we began to perceive in *Le Déjeuner sur l'herbe.*

Bricolage and Co.

Before returning to the problems raised by Steinberg's article, I propose to re-read—because it is often alluded to but never really analyzed by anyone—the passage in Claude Lévi-Strauss' *The Savage Mind* in which he discusses bricolage.[19] It will then remain to be seen how this concept might connect with that of intertextuality, as proposed by Julia Kristeva,[20] so that, in the end, we can determine if it is appropriate or possible to link semiology and iconology in a study of the history of the "language of painting" which would take into account the new gaze that modernity has led us to cast on the works of the past.

> This orientation of production toward polyphony, dialogism, polysemy, and plurality ... could not fail to have effects on criticism. The unity of the work and its reading having now been lost, critics have been forced to reformulate their attitudes toward the work and their own activity as writers. To increasing degrees, critics confront the problem of the relationships between different discourses and, above all, the question of the relationship between their own discourse and the discourse of the work.
> —Leyla Peronne-Moisès, "L'intertextualité critique"[21]

Translated from the French by Timothy Barnard.

N.B. The preceding text is Part 1 of a two-part essay of the same title. Part 2, "L'art à propos de l'art. Citation et intertextualité," appeared in *Parachute*, no. 18, Spring 1980.

[1] See, among others, Umberto Eco, *La Structure absente*, Mercure de France, Paris 1972, in particular the chapter "Vers une sémiotique des codes visuels," p. 169–257; Georges Mounin, *Introduction à la sémiologie*, Minuit, Paris 1970, in particular the chapters "Les systèmes de communication non linguistiques et leur place dans la vie du XXe siècle," p. 17–39, and "Linguistique et sémiologie," p. 67–76. For a more recent introduction to semiology, see Jurgen Pesot, *Silence, on parle. Introduction à la sémiotique*, Guérin, Montreal 1979.

[2] Here I prefer to limit myself to the distinction between the form and substance of the expression and the form and substance of the content, as proposed by Louis Hjelmslev in *Prolegomena to a Theory of Language*, trans. Francis J. Whitfield, University of Wisconsin Press, Madison 1963. See also Louis Marin, "Éléments pour une sémiologie picturale," in *Études Sémiotiques*, Klincksieck, Paris 1971, p. 17–43.

[3] This is the very theme of iconology, as Erwin Panofsky describes in his book *Meaning in the Visual Arts*, Doubleday, New York 1955. As for this analytico-interpretative method, to which we will return later, Panofsky outlines its ends and means in the introduction to his *Essais d'iconolgie*, Gallimard, Paris 1967, p. 13–45.

[4] Leo Steinberg, "The Glorious Company," in J. Lipman and R. Marshall, *Art about Art*, Dutton/Whitney Museum of American Art, New York 1978, p. 6–31. This book was published on the occasion of an exhibition at the Whitney, from July 19–September 24, 1978, which was dedicated exclusively to American work from the second half of the 20th century. Steinberg's introduction is a general approach to the question, but his thesis remains somewhat ambiguous. We will discuss it throughout the present article.

[5] In this case, it possibly does not merit the same denomination. Steinberg underlines the problem; we will come back to this when we attempt to distinguish modalities of quotation.

[6] "Even the innocuous metaphor of the 'source' is insidious in that it suppresses the possibility of deliberateness. Things that spring from a source—such as rivers or rumors—have no power to choose from which source to flow. But artistic decisions are not reactions to irresistible causes; artists find serviceable material and put it to work." Steinberg, "The Glorious Company," p. 21.

[7] Which finds its accomplishment, in the quoting process, in the United States after 1950, according to Lipman and Marshall, *Art about Art*, p. 6–7.

[8] See Clement Greenberg, "Modernist Painting," in Gregory Battcock (ed.), *The New Art*, Dutton, New York 1965.

[9] Steinberg does not reproduce the Manet painting; but the Raimondi mentioned is figure 24 in the Steinberg text: *Passavant VI*, 137, copy a, p 17.

[10] The Zola quote and the references to Manet which follow are taken from M. and G. Blundem and J.-L. Duval, *Journal de l'Impressionnisme*, Skira, Geneva 1973, p. 53ff. [free translation].

[11] This beautiful expression, which describes well the trickery of representational painting, is Elie Faure's. See Duval, *Journal de l'Impressionnisme*, p. 55.

[12] An unsigned comment published at the time of the 1863 Salon des Refusés in *La Gazette de France*, July 21, 1863 [free translation].

[13] Steinberg quotes Rewald's *The History of Impressionism* when commenting on the recycling of motifs. Rewald, to buttress his argument on the lack of imagination in Manet, draws on Degas, who said: "Manet ... had no initiative ... and never did anything without thinking of Vélasquez and Hals." See Steinberg, "The Glorious Company," p. 31, note 17 [my translation; unable to locate original]. A critic of the 1864 Salon pointed out the numerous references in Manet's painting by ironically calling the painter "Don Manet y Courbetos y Zurbaran de los Batignolles." Duval, *Journal de l'Impressionnisme*, p. 56.

[14] We will not develop here the impact created by engraving as a translation system; only the loss of color and the emphasizing of the line should be noted.

[15] Except for the central character's head, which has gone from being in profile to being turned three-quarters forward.

[16] Unless the slightly turned index finger is pointing toward the viewer instead; see note 13 above. This would mean that everything now takes place on this side of the painting and no longer through it in the sense of it being conceived as a straight, transparent window.

[17] Duval, *Journal de l'Impressionnisme*, p. 54.

[18] Roman Jakobson, "Shifters, Verbal Categories, and the Russian Verb," in *Selected Writings, Vol. 2: Word and Language*, Mouton, The Hague 1971, p. 130.

[19] Claude Lévi-Strauss, *The Savage Mind*, University of Chicago Press, Chicago 1966, p. 16–36.

[20] Julia Kristeva, [*Séméiôtiké*]. *Recherches pour une sémanalyse*, Seuil, Paris 1969.

[21] Leyla Perrone-Moisès, "L'intertextualité critique," in *Poétique* 27 (1976), p. 372. This issue of the journal was dedicated to intertextuality [free translation].

Appropriation/Expropriation: Convention or Intervention?
Bruce Alistair Barber

Parachute, no. 33, Winter 1983–1984

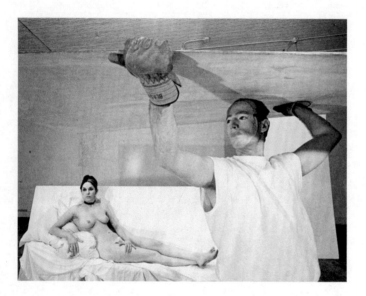

Robert Morris, *Site*, performance with Carolee Schneeman, 1964
Photograph by Hans Namuth

... as the traveler does not appropriate the route which he traverses, so the farmer does not appropriate the field which he sows.
—Pierre-Joseph Proudhon, *What is Property?* (1840)

Upon the different forms of property, upon the social conditions of existence, rises an entire superstructure of distinct and peculiarly formed sentiments, illusions, modes of thought, and views of life. The entire class creates and forms them out of its material foundations and out of the corresponding social relations. The single individual who derives them through tradition and upbringing, may imagine that they form the real motives and the starting point of his activity.
—Karl Marx, *The Eighteenth Brumaire of Louis Bonaparte* (1852)

There are several thousand words and innumerable phrases in the English language that refer either directly or indirectly to the acts of

taking or borrowing. Add to these the number of words and phrases relating to property and possession and we have a myriad of terms that convey meanings to these actions and behaviors that determine and are themselves determined by social relations, socio-economic and cultural conditions.

Convention

The term "appropriation" and its semantic correlative "expropriation,"[1] while relative newcomers to the discourse of high art,[2] are not unknown to culture at large, or the institution of art as it has been historically constituted. And if a certain semantic "sibling rivalry" accompanies the use of the terms in present discussions concerning the nature and function of art, the use of their linguistic equivalents in the written history of art is recondite, if not at times downright obscure. In the guise of quotation: derivation, imitation, copy, borrowing (the polite words of art historical discourse); filching, plagiarism, piracy, forgery, bastardization (the impolite words); and more recently, with diverse connotations— reproduction, representation, de- or re-contextualization, appropriation, and the somewhat comical representation-as- such,[3] the history of visual art, to name but one vector of cultural history, is littered with incestuous takings and borrowings—from the past to the present, from low culture to high, and from high culture to low.[4]

 The role and tasks of the connoisseur—the etymology of the name itself is interesting (from the Middle-French connoistre, now -aître, cf. reconnoistre)—are partially predicated upon discovering, uncovering, through sleuth- like behavior, cultural borrowings in order to ascertain the original, unique, and consequently valuable artwork from the mediocre, conventional, or academic works of cultural fellow-travelers. Copying or quoting from earlier cultural artifacts were the early approved methods of instruction for young visual artists before they were instructed to "look to nature" or " ... to themselves"[5] for "truth" and we can say, with some authority, that this was true of the other arts as well. Copying, the obvious point must be made, is one method, among others, of learning, of acquiring new knowledge and skills with which to gain control over one's world. However, copying as a *de jure* method of instruction

in the visual arts had other important results, atypical when viewed historically and especially when compared to the received knowledge assimilated to other areas of human experience and action. On these forms of instruction were constructed the codes for standards of quality and excellence which became the determining conditions for the entrance of the artist and his/her work into the annals of history. The originality, with respect to received ideas or forms, or uniqueness of the work, coupled with a real or constructed "otherness" for the personality of the artist according to the transcendental image of the artist as genius or creative magus,[6] privileged the product over the mode of learning. The principles of connoisseurship and the "ethicality" of art historical scholarship rests upon these assumptions. And these were further manifested in critical and aesthetic judgments and the criterion for taste, which provided the bases for the written construction of our "authentic" art history.

For the art historian/connoisseur, a particularly knotty and ultimately inconsequential problem in art history is the question of when life drawing became a standard (institutionalized) practice for the artist-in-training and *de rigueur* for the continuing competence and high performance of the professional. The so-called copy-books and casts from the antique for use as models for further (informed) production, were available and presumably consulted in the guilds of the Middle Ages and the first art academies of the late Renaissance.[7]

Produced in limited editions and before advanced methods of mechanical reproduction, often hand copied, their use continued in various forms for centuries. Today the "how-to" (draw) books and other visual drawings aids such as catalogues of old master drawings used by amateur and professional respectively, could be considered their modern equivalents. These standardized copies, if we can call a small number standardized, took away the necessity to study from nature—"from the life"—for any other reason than to deductively verify the "truth" of the historically given, the received model. A comparison could be made to the early, received models in science, the practice of alchemy, where the world view of those practitioners was so determined by the authority of the religious oligarchy, that to experiment inductively would have been to risk censuring for heresy.

From the late Renaissance through to Romanticism the practice of studying from life seemed and often was redundant, especially given the omnipotence of certain received models from the antique, tempered, and theologized for consumption by those working within the context of a society controlled by a less than benign ideology of religious humanism. The artists, with some notable exceptions, close approximation, and subtle extension of the received models, were the cardinal principle on which many staked their claims to success.

From our perspective the analysis of inventories and collections of 17^{th}-century drawings presents some problems with respect to the "from life" question. In examining *catalogues raisonnés* we may encounter entries such as these: "this study from the life," or "in this drawing executed from the life model," claims more often than not completely unsubstantiated. We know from contemporary literary sources that life models were active in Italian academies during the 17^{th} century. Important commentators of the time, Bellori and Malvasia, were both aware of the importance of training from the model and particularly of methods of instruction based on the standard practice of copying or quoting from antique reliefs, busts, and statues. Malvasia noted that in the Caracci Academy men and women of all types, shapes, and sizes were employed for the purposes of instruction.[8] We can safely assume from this and other contemporary evidence[9] that life drawings were produced. However, the question of whether this was mediated by a methodical and institutionalized instruction according to the appropriated (idealist) canons of the antique, especially when this itself was the result of obedience to the tenets of Neoplatonic theory and humanist ideology, is open to dispute.

The appropriation and subsequent academicization of the past was not lost on Denis Diderot and other critics of the late 18^{th} century. Diderot attacked the academic instruction of his time for its inherent mannerist and reactionary tendencies. He wrote:

> all these academic positions, strained, prepared, arranged, all these poses, coldly and awkwardly taken up by some poor devil, and always the same poor devil hired to come three times a week to undress

and let a professor set him up as a lay figure—what have these to do with the positions and actions of nature? [10]

Appropriation and the Origins of Visual Copyright

With the somewhat peripatetic development and refinement of various methods of mechanical reproduction from the early 15th century through to the mid-17th century the appropriation of literary and visual works began to control the shape of production and consumption. It is not surprising that some of our modern conceptions of private property, the legal definitions of the rights of ownership and copyright, should coincide with the development of individualism— the freedom of the—and the early origins of industrialism and mercantilism (entrepreneurial capitalism).

Contemporary scholars of copyright place the date of the first copyright laws to 1476, when Caxton established his printing press at Westminster. Certainly punishment had been meted out for copyright infringements well before this, and the documented case in Ireland (AD 561) of the unauthorized copying by hand of a prayer book led to the decision of King Diarmid, "to every cow her calf, to every book its copy." To quote from an essay by A.A. Keyes, an expert on Canadian and international copyright laws: "The action was, perhaps, the only known instance where a defendant, found to be a copyright infringer, was subsequently canonized (as St Columba)." [11] Caxton's press was controlled by de facto copyright laws until 1586 when the Crown, fearing political confrontation and theological heresy, decreed that it had the right to control, in fact censor and muzzle, any dissenting voices from the community and even, as the quote below indicates, from outside the Realm.

That no person or persons whatsoever shall presume to print, or cause to be printed, either in parts beyond the Seas or in this Realme ... any seditious, scismatical or offensive books or pamphlets, to the scandal of Religion or Church, or the Government or Governors of the Church or State ... [12]

Subsequent English copyright laws were the result of common petitions to the Crown, and in 1710 the "Act for the Encouragement of Learning" gave copyright for a period of 14 or 21 years to the author or bookseller. This act, however, did not refer to visual images and this omission proved to be a major problem for visual artists and particularly engravers and painters for the next 25 years.

The gradual stratification of the classes and the bourgeoisification of sections of the proletariat in France, Germany, and England in the early 18th century, caused by advances in agriculture, industrialization, and the subsequent urbanization accompanying the rural/urban drift, were to have a marked effect on the production and consumption of cultural products. With education, surplus earnings, and the desire for upward mobility, sections of the bourgeoisie began to consume those products originally the province of the aristocracy. The resulting increase in the number of actual or potential consumers led to the increase in production and mass marketing of books, small genre paintings and prints, portrait busts, and casts or copies from the antique. Coincident with the increase in production of these items was the decrease in the production of large-scale commissioned works for public institutions and homes of the landed gentry. The pace of these changes, while relatively slow at the outset, rapidly increased toward the end of the 18th century and the beginning of the 19th.[13] Another important result was the increase in visual plagiarization for profit, and this capitalizing of the present paralleled the colonialist adventures of the most advanced European countries in the East, Africa, North America, the Pacific, and Australia, and the plundering of objects of value from their past or "primitively" alien present.[14]

The anticipated result of cultural appropriation in the advanced countries was the introduction of visual copyright laws. Art historian David Kunzle, in an excellent essay on the English artist William Hogarth, has shown how the artist's paintings, and in particular his engravings, were often plagiarized within a few weeks of Hogarth's public announcements of their availability for sale. From 1727 to 1730, the appropriation and subsequent marketing of hack copies of his work made Hogarth leave the engraving process entirely to pursue the more private practice of

painting. Kunzle relates how the plagiarization (often by memory) by other engravers of Hogarth's work left him no other option than to protect himself by careful exposure of his works and to pursue the legal option—to petition the government for a change in the copyright law, in the company of other "Artists and Designers of Paintings and Original Prints." Hogarth finally submitted his brief to the parliament in February 1735, outlining the circumstances of the abuse of his and others' work; an appeal for a Bill to be passed, which would prevent,

> … such frauds and abuses for the future, and securing the properties of the Authors of Books; or in such other manner as by the house shall be thought fit.[15]

Appropriation and the Avant-Garde: Possession and False Consciousness

Quoting and copying for the purpose of instruction and/or pecuniary interest continued uninterrupted throughout the 18th and 19th centuries. While a major concession had been won by the introduction of visual copyright—The Engravers Act of 1735—and the passing of similar acts in other countries, the incentive "to take from one for one's own" and to thereby profit from it, was left intact. The methods of appropriation, particularly if from a contemporary source, were more likely to be obscured, or as a number of appropriators reasoned to their benefit, the taking had to be exact—forged—or totally appropriated—*expropriated*.

Economics aside, the other incentives: the status-seeking and *épater le bourgeois* strategies of avant-garde artists seeking to control the present through a disruption, negation, or "taking (making) over" of the past through parody or critique, were to become major aspects of cultural production—of re-invention—in the 19th and early 20th centuries. In the 19th century one standard of artistic excellence, much in evidence then and still very much in force today, was the visual conceit, the manner(s) in which the artists managed to consciously obscure their sources. The emphasis on progress, given the green light with the Enlightenment, the gradual secularization of the Church, and industrialization, gave to the concept of the avant-garde[16]

one major characteristic, decisive in its determination of the subsequent behavior and productions of artists—radicality. The avant-garde precepts associated with this, or better, subsumed under this central notion, became an excessive attention to the new, the fashionable, the outrageous; in fact anything that altered or presumed to alter the normative, the status quo. The parallel to agnosticism or atheism in the questioning of widely held and dominant ideas in the Church, became, within the domain of high art, the questioning of the authority of the past and of tradition. The character of this questioning or denial could be described as aesthetic heresy. And yet the dominance of the past, of convention, had etched itself indelibly on the present, and in order to deny the past it became incumbent on those artists of the avant-garde to consume it before they eliminated it.

This, in part, explains why the efforts of those artists working within the avant-garde still revealed the traces of the past. The determining power of the ideologies controlling social relations also controlled and determined the character of the artists' productions. Radicality, therefore, was softened by the power of convention. Major challenges to convention would have been subjected to abject dismissal or censure (which in some cases is what occurred). While many artists participating in the avant-garde maximized their alienation from the rest of society and suffered the derision of reactionaries with benign contempt, the conditions of their existence necessitated that they minimize those aspects of their behavior which would have totally excluded them from participating socially, even within a sub-group of like-minded individuals, determined to shake or shatter the status quo. What may be described as conventional non-conventionality was typical of those groups following Hugo's *La Bataille d'Hernani* (1830), the prototype of bohemian life through to the late decadents, the literary Symbolists of the 1880s. And one could say that this conventional/non-conventionality represents a form of false consciousness on the part of those members of the avant-garde, ironically conscious of their mission, yet tactically prescribing their commonality with those institutions and agents of the status quo; a gesture toward the minimizing of alienation and cultural disenfranchisement.

To give one example of a 19ᵗʰ-century artist whose avant-garde prevarication led him to appropriate the past and yet conceal his sources, we should examine the work of Édouard Manet, and in particular his painting *Olympia*, now considered one of the monuments of modernism in the visual arts. It took some 50 years for the connection that we take so much for granted today between Titian's *Venus of Urbino* (1538) and Manet's *Olympia* (1863) to be made. The sources, contemporary and past for some of his other paintings, were noted and derided[17] by many of his contemporaries, as were the "odalisque"-like traits of the reclining model in the Olympia—"what is this yellow bellied odalisque?" wrote one critic. The fact that Manet's entries to the Salon had been rejected many times perhaps sheds some light on his use of a classical painting for his model. We must, however, remember that it was not necessarily his "borrowings" that enraged his critics but the manner in which they were painted. If he were surreptitiously using a model from the past in order to maximize his chances of success in the Salon, why would he go to such lengths to "conceal" his parody? And would not his friend and champion Émile Zola have defended it later on these basic grounds? Whatever the reasons for Manet's careful appropriation of the past, his success at concealing his model was not lost on those artists who subsequently chose *Olympia* as their own model for "making over." Cézanne, without the knowledge of the debt to Titian, reproduced his own version of *Olympia* in 1873, and, later, Picasso, in 1901. Picasso placed himself in bed with the nude model, the little white dog (fidelity) from the Titian, and the (symbol of promiscuity) black cat.

More recently, American sculptor Robert Morris used the "Olympia" image in his minimal performance work *Site* (1965). In the Morris work, the artist, wearing a Jasper Johns' mask of his (Morris') face, moved back and forth carrying away plywood sheets from the tableau vivant of artist Carolee Schneeman reclining in the pose of "Olympia." These "homages" to the Manet serve to indicate the resilience of the received image within the telos of modernism, and particularly the importance later artists gave to monuments and the strategies of artists working within the avant-garde tradition. Another example of a non-conventional/conventional avant-garde false consciousness is the following

quotation, a statement made by another American sculptor, Carl Andre, in the context of a discussion concerning his row of bricks, *Leve* (1966).

> All I am doing is putting Brancusi's *Endless Column* on the ground instead of the sky.[18]

This convention is a form of ironic disavowal, an acceptance of radicality, and yet a backward glance; a nervous appropriation of history in order to deflect or minimize alienation. What these quotations evidence is a form of protectionism, a possession of history in order to ensure one's place in history.

The resilience of certain topoi (themes) throughout the history of art, as well as the omnipotence of convention, may speak far less of the unchanging peculiarities of the human condition—of universals—than the attention artists paid to each other's work. The reasons for this are varied— instruction, status seeking, homage, etc. What they reinforce is the determining power of ideology, and while individuals may assume that their actions represent a denial or departure from the past, their work is invariably tied to the ideologically instituted conditions of the present as these have been constituted from the past.

Holding Up the Mirror to Culture

> From a photographic negative, for example, one can make any number of prints; to ask for the "authentic" print makes no sense. But the instant the criterion of authenticity ceases to be applicable to artistic production, the total function of art is reversed. Instead of being based on ritual, it begins to be based on another practice-politics.
> —Walter Benjamin, "The Work of Art In the Age of Mechanical Reproduction" (1935)

With the introduction of photo-mechanical reproduction in France in the 1830s and the subsequent invention of modern processing techniques by Fox Talbot and Baynard in 1839, the possibilities for cultural producers to feed with greater voracity on the products of culture were enhanced.

Photography, as Susan Sontag has remarked, is a form of acquisition.[19] The act of taking a photograph allows the photographer to "possess" the subject. However, the act of possession is a de facto claim to the subject, not a right to its ownership. The acquisition metaphor is useful in that it allows some comparison to other forms of acquisition like stamp or book collecting. Like the philatelist, the photographer lays claim to the subject—the original—through its reproduction. And yet in the context of the inherent reproducibility of the reproduction, the laying of claims to the original, in Benjamin's terms—the authentic—makes no sense. We do know, however, that prints, first editions, and rare stamps acquire considerable value through time, and in so doing this defeats their inherent reproducibility. In this way the business of acquisition begins to take on the economic values of the market place.

In the early 19th century the logic of cultural consumption began to parallel and become further identified with the appropriation—the culturalization—of nature. The adventitious development of the market for the infinite variety of photographic subjects, among them portraits, landscape, pornography, military and police surveillance, medical and architectural uses, anthropological and archeological photo-documentation, etc., precipitated a crisis from which traditional visual culture has never recovered. The "crisis in representation" is well titled; but the crisis had other dimensions: photography, far from being a mere tool of representation, had become an apparatus for the control and subjugation of reality.

Under the power of photography, the control that visual artists had over the domain of mimetic production was eroded. It was not unusual for many artists to appropriate the means of those devices that had, within a few decades, challenged their superiority in the business of representation. The extent to which 19th-century artists from Daguerre and Nadar on participated in the development of photography has been discussed at length elsewhere.[20] Many artists not only took photographs, but actually used them as the basis for subsequent representation in other media. The reverse also happened with photographers aping the conventions of easel painting, from portraits, genre scenes, and landscape to history painting. The appropriation of photographic

prints, particularly the stereograph, by major 19th-century artists such as Delacroix, Courbet, and Manet, has received much attention in recent years. It has been noted as well, that Charles Baudelaire's softened attitudes to photography after his early vehement opposition to its use in art practice led to a general approbation in the late 1850s. However, there remained several taboo areas, which have recently been the subject of much debate in art historical circles. These discussions have centered on the use made of photography by the *plein air* painters of the Barbizon school and later the Impressionists, to uncover methods of de-naturization in their exemplary "from-nature" works.

After Corot's death, some three hundred photographs were found in his studio, two hundred described by his biographer Robaut as "different subjects after nature." It is known that Millet was acquainted with a number of photographers including Félix Nadar, Étienne Carjat, and Félix Feuardent. In discussion with Edward Wheelwright, a young American painter who visited him in 1855–1856, Millet revealed his thoughts on the use of photography for the production of his painting. To quote from Wheelwright:

> Millet thinks photography a good thing and would himself like to own a machine and take views. He would, however, never paint from them but would only use them as notes. Photographs, he says, are like casts from nature, which can never be equal to a good statue. No mechanism can be a substitute for genius. But photography as we use casts may be of the greatest service.[21]

It may be clear from the suggestion offered previously that Millet's thoughts on photography are close to those artists of the 17th century who went to nature with the object of identifying and reproducing the models of "truth" received from the antique. Millet's use of language is revealing. His own observations of nature are selective and interpretive: photography objectifies and is consequently of questionable use as a model for the representation of nature. Even Naturalism was tainted by the resilience of idealist Neoplatonic theories. Art should transcend life and photography was merely a crude device for reproducing material reality, not

a means of investing it with significance. To quote from
Alexander Pope's *Essay on Criticism*, this was "Nature still but
nature methodized." Ironically photography became chained
to the conventions of painting, and for some years the
discourse surrounding the appreciation of photography was
tainted by the discourse of high art.[22]

Reproducibility as the Criterion for Appropriation

We can possibly tie the first wrenching of photo theory from
general theories of art as a means of transcending reality to
the development of chrono-photography and probably more
precisely the cinema.

Relativism, one of the hallmarks of modernism and
modernity, is embedded in the moving picture. Of course
assaults on the logic and authority of causality had been
made well before the invention of film, particularly in the
writings of Nietzsche and Henri Bergson. Film allowed the
exploration of hitherto unreachable and unrepresentable
aspects of the natural and the social world. What this
means produced in the minds of the viewers was even more
extraordinary: it enabled the viewers to explore other
worlds, to passively consume the objects and actions of
realities separate from their own, as if they were participating
in those realities.

> ... the film, on the one hand, extends our compreh-
> ension of the necessities which rule our lives; on the
> other hand, it manages to assure us of an immense
> and unexpected field of action. Our taverns and
> our metropolitan streets, our offices and furnished
> rooms, our railroad stations and our factories
> appeared to have us locked up hopelessly. Then came
> the film and burst this prison-world asunder by the
> dynamite of the tenth of a second, so that now,
> in the midst of far-flung ruins and debris, we calmly
> and adventurously go traveling.[23]

What may be referred to as a form of "tourism of the con-
science" allows the viewer to acquire knowledge at a distance.
This attribute of film allowed Benjamin and others to sense
its potential for controlling the construction of consciousness

both positively and negatively. As an apparatus for producing both propaganda and the criticism of propaganda, film and now television have no equal in any of the processes, image- or language-based, for the representation of the external world.

Film allowed the constitution of new learning in more powerful ways than had previously been available. The quality of this learning is of course open to dispute; however the power of film to disrupt traditional manners of thinking about the world and one's place in it reproduced paradigmatically the central notion in Benjamin's theory of reproduction. The technique of film wrested the reproduced object and we might add subject, from tradition. And furthermore:

> To an ever greater degree the work of art reproduced becomes the work designed for reproduction.[24]

Authenticity ceases to be a criterion of value; reproducibility and with it consumability become the "governors of performance" in everyday life. As Benjamin wrote, "mass reproduction is aided especially by the reproduction of the masses."

The Readymade and Montage: Appropriation and the Critique of Culture

Examples of (proxy) readymades and montages are to be found in culture long before Duchamp and Heartfield (with George Grosz), in 1913 and 1916 respectively, introduced their critical versions into the domain of culture. In the history of visual art, examples of framed sequences of images appear in late Medieval and early Renaissance woodcuts of dramatic spectacles. These forms of continuous representation, in the company of others, contain a matrix of information not unlike that displayed in some forms of additive montage.

Prior to the Dada "explosion" of 1916, the concepts of simultaneity and synthesis had been fully articulated in the work of the literary Symbolists and, later, the Futurists. Premised on Baudelaire's correspondences and Bergson's metaphysics, the concepts of synthesis and simultaneity

provided the basis for the history of work which took from life to construct art and which made of art an approximation of the fortuitousness and gratuitousness of life experience. The compounding of image to image and of text to text to elicit new and extraordinary meanings became the mode of operation of virtually all of the avant-garde groups before the Second World War.

In literature the examples of the "play-within-a-play" genre may be offered as types of readymades: Sophocles' *Antigone*, Shakespeare's *Coriolanus* through to Brecht's appropriation of Kipling's colonialist verses in *A Man's a Man*. The list could go on, for the strategy of appropriating for the purpose of exposing, criticism, or the allegorical reconstituting of the past in the context of the present, has, within literature, a long and venerable history. Similarly, the list-making of writers such as Walt Whitman (an early influence on the work of the literary Symbolists, Moréas, Mallarmé, et al.), James Joyce, William Faulkner, Ezra Pound, and many others is close to and in many cases pre-dates the anesthetic appropriation from everyday life which gave to Duchamp's actions such sacreligious authority in the world of art.

The case of Duchamp, however, is instructive in the context of recent discussions concerning appropriation for the purpose of cultural criticism. In 1913, when the artist had his "happy idea" to upturn a bicycle wheel onto a kitchen stool and watch it turn, he set in motion an unending cycle of dispute within the institution of art about the extent to which the artist may literally take from life to produce art. Duchamp's "blague" was the consequence of an art of extreme willfulness—a form, almost, of willful infantilism (Ortega). And to borrow an appropriate metaphor from Artaud, Duchamp had unleashed a virus within the system, which, having consumed its host, would move on to the infection of others.[25] Artaud, the author of several theatrical treatises including one which Duchamp would probably have identified with, "No More Masterpieces" (1938), is an unlikely choice given the extreme differences in the projects and temperaments of the two men, but the manner in which Duchamp's idea has been assimilated and reproduced since its conception can only be described as a veritable infection—the plague.

Duchamp's readymade, readymades-aided, and the reciprocal readymade (the reverse of the readymade) all question the nature, status, and function of visual art. In fact, the claim is stronger than this; Duchamp's readymade questioned the institution of visual art in the same manner as Mallarmé's *Un Coup de dés* or Joyce's *Ulysses* questioned the institutions of poetry and the novel.

Duchamp's intentional yet "anaesthetized" choice of an object and the final conferring of the status of art through the nominating power—the signature—of the artist allowed the primary interrogatives: "What is the status of this object if not by my hand, if not unique, if an object originally of functional use value?" and "How is it that this can come up for the count as art?" Duchamp's questioning of the ontological and epistemological status of the art object called into question the whole status of art, and if only for a brief, yet important moment in history, the institution of art and those administrators of the institution: the artist, critic, curator, gallery director, art historian, etc. The "happy idea" has had of course profound repercussions in the total management, administration, and education of artists and lay public alike since then. It is impossible to confront the appropriating and recontextualizing strategies of contemporary artists without acknowledging the debt to Duchamp.

The resurgence in interest in and subsequent promotion of Duchamp's work in the 1950s[26] allowed it to re-enter, in the company of other Dada work (Man Ray, Schwitters, Heartfield, Picabia), into the discourse of high art once again. The readymade examples from the *Bicycle Wheel* of 1913, *Bottle Rack* (1914), the moustachioed Mona Lisa—*L.H.O.O.Q.* (1915) to the *succès de scandale*, R. Mutt's *Fountain* (1917), gave license to the work of British and American Pop artists from the mid-1950s to the early 1960s. The Pop artists' ironic appropriation and remaking of the images of the consciousness industry—advertising— reproduced some of the earlier strategies of Duchamp. The re-contextualizing of familiar advertisements or imagos from popular culture by Warhol, Rosenquist, Hamilton, et al., and the appropriation and re-inventing of comic strip imagery as high art by Lichtenstein, provided the ground for the critical appraisal of mass culture and the increasing commodification of daily life under the dominant ideology

of advanced capitalism. However, the criticism of advertising rarely advanced beyond the ironical—or the parodistic. The cynical detachment of the Pop artists allowed them to disengage their means of representation from the real world of politics. This became obvious by the speed with which the objects produced themselves entered the market, often to be bought by the owners of the subjects of the parody.

There were cases of Pop artists who infringed the copyright of advertisers. However, in the spirit of free enquiry and fair use they usually evaded prosecution. An unusual result of the "assault" on popular culture was the manner in which the works of the Pop artists were co-opted and re-used by the producers of popular culture. In many instances the work of high culture appropriators like Warhol and Lichtenstein was re-appropriated for further use in the domain of popular culture, thus completing the dialectic of production/consumption/production. This is an important point to note; as a toothless form of criticism—an almost ideologically neutral criticism—parody reproduces rather than reveals. As Duchamp's critique of art was appropriated by the art institution, so too was the work of the Pop artists taken over by those institutions at which it was aimed.

By contrast, the critical work of John Heartfield could never have been appropriated by the Nazi ideologues of the Third Reich for use as promotional propaganda for their regime. Propaganda is invariably partisan, and while it methods may be ironical and parodistic, its forms and objectives are rarely confused. An interesting example in this respect is a cultural production from the other side—the case of German filmmaker Leni Riefenstahl's film *Triumph of the Will* (1933)—a monument of Nazi propaganda. In the early stages of the Second World War a copy of Riefenstahl's film was obtained by the allies; it was given to film director Luis Buñuel, who was instructed to re-edit it to turn it into a potent piece of anti-Nazi propaganda. Buñuel changed the film substantially, turning Hitler into a puppet figure of grotesque proportions. It was shown to several other filmmakers and government heads, with conflicting responses. The final consensus was that the original was also crafted as a piece of propaganda and that the Buñuel parody could not disturb the strength of the Riefenstahl version. The final decision was made by President Roosevelt, and he put the lid on the can.

Work that is committed, partisan, has the capacity to sustain its critique through time. The principle and procedures of both additive and dialectical montage, the collapsing or confrontation of two or more separate and usually appropriated images or ideas so that new meanings may be constituted from the resulting conflict or contradictions, allow for a more perspicuous confrontation with the subject(s) used. In the most successful montages (Heartfield's remain the best examples), the incipient conflict of interpretation is minimized. Moreover, the work is ordered by the commitment of the artist to the representation of his own ideology, which necessarily comes into competition with that of the subject. The power of the work is further developed by its means of reproduction and transmission—in Heartfield's case the *AIZ* (Workers' Illustrated Paper—*Arbeiter Illustrierte Zeitung*). The mode of transmission in company with texts printed with the photo-montaged images (Heartfield's montaged works rarely operate effectively without texts) completes the dialectic and enables the work to successfully intervene in the passive consumption or construction of fascist ideology. This form of intervention is akin to the Brechtien strategy of interruption for the purpose of instruction.

Appropriation and Cultural Hegemony—Expropriation

Another relational element to the taking/borrowing and property/possession "homologues," one that relates to some recent discussion, is the question of what happens outside of the petty system of internalized production and consumption. Since the 1950s and in many instances before this, there has been a developing consciousness among a growing sector of the artist population and those participating in the critical discourse surrounding the production of high art, that the commodity status of the work, as determined initially by the producer and later compounded *in extenso*, by those operating in the marketplace, has assisted in its appropriation for use (capitalization) by the ruling classes.

The origins of this growth in consciousness are difficult to find. For some, however, it coincided with the programmatic marketing on an international scale of

national culture, which began after the Second World War and was, for the most part, dominated by the United States. The appropriation of culture by those holding the reins of social and economic power, while allowing a minimum conferment of economic power and social prestige on those artists whose work was taken for such use, was perceived by some as undermining the authentic status and autonomy of art. The replacement became the service to the interests of the state of a particular class. The autonomy of art—its necessary degree of autonomy from the social and political context within which it was produced—its transvaluative and transcultural character, persuasively argued by theories from Schiller and Kant to Greenberg, ironically began to crumble under the weight of contradictions within capitalist ideology, the very ideology which had kept art's autonomy alive. Capitalism's appropriation of culture allowed it to paradigmatically represent (re-create) and sustain two of its central mythologies—the sanctification of the individual and the necessary "evil" of capital as the engine of productive life. Examples cited in the art world included the internationalizing of the art market for the ultimate benefit of the marketeers, the establishment of a tiered system of economic value for artworks, and the consolidation of the "star" system.

In the early 1950s, Abstract Expressionism was "marketed" with the kind of entrepreneurial aggressiveness usually associated with Disney merchandise, Hollywood movies, Coca Cola, and other products of Americana. Culture was sold on the basis of "cultural exchange" to countries outside the United States. Recent discussions[27] have revealed the true nature of these exchanges. The massive touring exhibition of Abstract Expressionism destined to become the model for subsequent exhibitions has been discussed as an attempt on the part of the US government and its institutions including The Museum of Modern Art, the USIS [United States Information Service] and the CIA to promote and sustain the understanding in host countries of American cultural power and freedom. Above all, the work of the Abstract Expressionists presented an aesthetic paradigm of social freedom—democracy. Dubbed in some of the recent critical literature as co-optation, this form of appropriation was generally perceived to be undermining the status or potential function of art and, worse,

of exploiting the artist's labor for the ultimate purpose of maintaining myths about the nature of capitalist enterprise. Artists were not willing to participate in America's imperialist desires, though many of them quietly condoned cultural hegemony.

The corollary to the gradual comprehension among culture producers that they were producing within an increasingly bureaucratized and alienating world was the notion that their work, far from decreasing the reificatory mechanisms in the "outside" world, was reproducing some of the salient and most objectionable features of life under capitalism. As argued insistently by Marx and later by members of the Frankfurt School (Horkheimer, Adorno, Marcuse, and Reich), the pre-eminence given to consumption under capitalism had led irrevocably to the impoverishment of social and cultural life, and culture producers were rapidly losing the effective means to combat it.

The critique of social relations under capitalism has been located in the analysis of the fetishization of commodities, the division of labor, and the subsequent alienation of the producer working within a society dominated and determined by capitalist (patriarchal) ideology. The response to these conditions and their critique has been varied within the art world.

For some artists it initiated the need to politicize one's life and work, to actively demonstrate one's opposition to the controlling institutional structures within the art world and outside. For others, it allowed a further retreat into the nether worlds of their own subjectivity, which usually culminated in an alliance with those who maintained the ruling ideology. The range of responses from the radical left to the affirmative right may be found in the behavior and work of the participants in all of the art "movements" from the end of the Second World War to the present. The most obvious prototypes may be seen in the political prevarication of the pre-war avant-gardes, Dada and Surrealism.

In the late 1950s and early 1960s, Fluxus, Happening, and "event" artists, those whose work located itself in opposition to the dominant mode of expression in the work of the Abstract Expressionists, sought to undermine the rigid and reactionary structuring of the postwar avant-garde.

Their attempts to counter the commodification of art and to criticize the dominant mode of expression often resulted in the further commodification of art and the deification of the artist as "star." With late Minimal, Process and Body art, Conceptualism, Arte Povera, ecological and performance art throughout the "pluralized" 1970s, the artwork and artist as consumable "objects" again came into question. The so-called "de-materialization" of the art object (Lippard/ Chandler) was presented as a *coup de grâce* to the art world. The putative death of the author (Barthes) and many, many statements of the order "I do not wish to add any more objects to the world" (Huebler), almost consummated the act. With no objects to consume, and just work—critical work—to be undertaken, the art world seemed ready to cast its net properly in the direction of life.

The first art world stirrings of feminism[28] assisted in the realization that the various institutions of art were but microcosms of those "outside" structures that oppressed ethnic minorities, members of the working class, and women. The conditions seemed ripe for a general critique of the structures and mechanisms of culture. But the last few years have revealed to us that this is a project still in its infancy. Few artists have marginalized their work to the extent that it begins to operate successfully outside of the institutions of art. Within the art world itself, critical work has generally taken the forms of fellow travelerism and radical chic approximations and reworkings of "productive" and "operative" work of the past. It takes its forms in the nostalgia for the past, the appropriation of low cultural work to the realm of high culture, museological critiques, the placing of work of high culture artists in low cultural domains. The list could go on. The gains: in some cases a positive reinvestigation of the past, a new-found consciousness that many artists are part of the oppressed majority and that collective struggle is the only means to oppose the authoritarian and self-serving institutions of monopoly capitalism. The extended critique of culture is a necessary, yet early, stage in the general critique and transformation of society.

Low Culture's Critique of High Culture: Two Examples from the Disney Studios

If there has been some inconsistency in high culture's critique of itself over the past 60 or so years, no such critical inconsistency has marked the work of low (mass) culture producers, especially when their work attempts to undermine high culture's hegemony[29] over low culture. The history of low culture work, of popular or mass culture[30] is now being given the attention which is its due. However, few studies have been published on the propagandistic function of popular parodies of high culture, their success or lack of it in the debunking of the authority and legitimacy of high culture's claim to historical and ideological pre-eminence.[31]

Comic strips, cartoons, and caricatures have often become the vehicles for low culture critiques of high art. There are few simpler ways of producing propaganda or seeing ideology at work than in the comic strip and its surrogate forms.[32] In passing I should note that some excellent work has been accomplished in this field by Californian art historian David Kunzle,[33] and Kunzle himself found his models in the ideological analysis of Armand Mattelart and Ariel Dorfman in their classic piece of anti-imperialist writing, *How To Read Donald Duck* (1973). Kunzle translated and wrote the introduction to the English edition.[34]

One of the obvious points to be made about high and low culture, particularly under capitalism, is how they feed and gain sustenance from one another. This is a consistent theme in the literature from Leo Löwenthal (1961), Theodor Adorno (1967), and Dwight MacDonald (1961), to Kunzle (1973), Raymond Williams (1974), Pierre Bourdieu, and J.-C. Passeron (1977), among others. With advertising, television, and other new technologies including computer technology, the trafficking from one to the other has gained in urgency. Under capitalist relations, high, being more dynamic, usually appropriates from low, which, by comparison, remains stable and unchanging. Inventive, progressive cultures need revitalizing from time to time and in societies where this takes the form of market expansionism, or alternatively, capturing the market through acts of entrepreneurial skillfulness; appropriation, the taking from one to nourish the other, even when this necessarily leads to the

impoverishment of the appropriated, becomes the order of the day. Most recent studies have focused on these appropriations, particularly where these allow for the critical rejuvenation of the avant-garde. Few studies have been done on the obverse tendency: the move from high to low has similar characteristics.

We shall attempt to explore here this phenomenon through the analysis of two Walt Disney comic strips (c. 1966–1972) as these exemplify, in the context of a wide selection of similar popular cultural forms, an attack on the work of high culture producers.[35]

The comic strips illustrated from the studios of Walt Disney (c. 1966 and 1972 and reprinted in 1978, 1979), reveal the taking from high to low for the purpose of critical "instruction." It is important to note that the Disney Corporation usually takes from the public domain and from other sources of popular culture, i.e. Walt Disney "presents Winnie the Pooh," (after A.A. Milne), Walt Disney's Pinocchio (after Collodi), and Disney's Christmas Story (after Dickens), among countless other examples. The examples used here are more contemporary and unusual in respect to the total output of Disney productions. It is somewhat ironic that while Disney's army of lawyers is constantly engaged in litigations against abusers of their copyright, the reverse instance rarely occurs. Disney's plagiarizing from the public domain allows them to negotiate the taking for pecuniary interest with ease. The sources for these examples are obscured by the narrative format and the overlaying of the Walt Disney stock characters, thus making the task of bringing successful litigations against Disney, if this was desired by the original producers, an extremely difficult (and costly) legal procedure.

The first example appeared in Walt Disney's *Uncle Scrooge*, no. 170, November 1979, and is titled, "Gyro Gearloose—The Sculptinker." The title conveniently collapses the terms "amateur" and "professional," "low" and "high." The extraordinary artist/inventor genius figure is coupled with the tinkerer, handyman, or bricoleur. The apotheosis of both sculptor and tinkerer is revealed in this absurd, fable-like, perhaps even Faustian sketch of Gyro, who once again manages to outwit his principal competitor, the devilish Emil Eagle. Totemically, goose and bald eagle are

interesting birds to assume an anthropomorphic cast; a
structuralist would have no difficulty in approaching the
topsy-turvy world of the comic strip armed with Lévi-Strauss'
"iron triangle of the culinary." However, the strip's critique
of high art can be more readily understood in terms of
its vulgar and not necessarily its "allegorical" content.

Gyro is seen entering a new "invention" in the local
museum's art show—art show denoting competition, which
is not so very far from the truth of exhibiting. And Gyro
as the able competitor is reproducing a central theme of
Disney's world; for all of the Disney characters, in good
capitalist fashion, are actively engaged in competition with
one another. Dorfman and Mattelart describe this in the
more extreme examples as a form of Social Darwinism.
They also point to the proliferation of negative character
types which are coupled to more positive types distinguished
by their virtues and these according to a normative
success rated model of personality and behavior: Gyro has
Emil, Scrooge McDuck, the Beagle Boys, unusually unlucky
Donald Duck, and his unusually lucky cousin Gladstone
Gander, et al.

In the Sculptinker strip, inventor Gyro assumes the
artist identity but maintains his original role previously
established in the series. This new "dual" role is actualized
in the reader's mind by Emil's curiosity—"since when has
Gyro been an artist?" Gyro's contribution to modern art
is his "Sculptinker Piece" described by Evil Emil Eagle as a
"moving, mechanical masterpiece." In this exhibition of
the elite avant-garde artists we have transposed the actually
intelligent statements made by the "dumb" museum
assistants who are shown moving the Gearloose work into
the museum—"Symbolical of symbolism, huh?" ventures
one of them casually. It should be noted that members
of the working class, when represented in Disney strips, are
usually portrayed, along with peoples from third world
countries, as dumb, ignorant savages.

Emil is bent on making Gyro's masterpiece work for
him as well. True to his nature, he has projected heavily onto
Gyro's ambitions for the work and responds with his own
nefarious intentions. Enter the Culture Vulture and exhibition
judges looking somewhat like their counterparts from
19ᵗʰ-century salon exhibits. Their acclamations, "wow, look

at that," and "zounds," cue Gyro to set his machine in motion.
His carefully drawn expression reveals the real intentions
behind his work. The machine self-destructs in the viewers'
faces. Emil, who has been using the shelter of the machine
to pursue his petty criminal activity of picking pockets, is
caught unawares by the blast and is catapulted into the long
arm of the law. When asked to explain his "creation," Gyro
lets loose a tirade against the "alienating" conditions
of modern sculpture and reveals his attempted parodistic
critique of modern art; "Yes," he says, "it symbolizes that
modern-type sculptoring is a big bust. I hate the no talent
stuff." The double irony is confirmed when Gyro is awarded
first prize (a sports trophy no less) for his "explosion art."
Gyro, defeated, clasps his head with horror and disclaims,
"Oh, no. My wreckage won!"

This strip is actually based on a real work by Swiss
Kinetic artist Jean Tinguely, whose famous *Hommage à New
York* (1960) self-destructed to the critical acclaim and horror
of New York's press outside The Museum of Modern Art.
Gyro's masterpiece receives the response all genuinely avant-
garde work receives, sooner or later, from the bourgeoisie—
co-optation. Like Tinguely's aestheticized anarchic gesture,
the "moving mechanical masterpiece" becomes cloaked
with the progressive, innovative values of bourgeois ideology.
Gyro, like the hapless Emil, receives his (unanticipated)
due—institutional incarceration. The status quo is secured
not, however, without first undergoing an attack on its
superstructure.

The second example is more contemporary and less
subtle in its critique of the avant-garde. Its subject is body
and performance art of the mid-1960s to the early 1970s.
The Beagle Boys comic (Walt Disney, no. 43, August 1978)
is in all probability also a reprinted version of an earlier
edition, as Body art was well past being a vanguard
phenomenon by 1972–1973. It is safe to assume that Disney's
artists were up-to-date with the latest high cultural trends,
as they were with political events. Dorfman and Mattelart
confirm in their study that Disney was producing anti-North
Vietnamese propaganda at the height of the US involvement
in Vietnam, as well as strips aimed at undermining the
Popular Unity government of Salvador Allende in Chile
before the CIA's initiated coup of 1973.

In *A Bad Day with Buttinski*, the Disney version of common criminals, the Beagles are up to their usual inept plotting and planning of their illegal activities. Buttinski Beagle (possibly a name suggestive of a Polish joke) enters the narrative and in two of the strip's frames we are introduced to his major personality flaw, his "buttin' in." After causing some trouble on the street by interfering with the Beagles' innocent request to an officer of the law for directions to the bank they are planning to rob, Buttinski toes a ride on the back of the Beagles' Al Caponish sedan. Alighting at the Crim's country lair, Buttinski pads up to the doorway only to have the exasperated Beagles slam the door in his face. The stupidity of Buttinski and the liability of his personality flaw are revealed when he intervenes in a cat fight and comes off, as one Beagle relates, "much the worse for his buttin' in." The Beagles celebrate and set to work, planning their next bank heist, deciding quickly on a novel getaway vehicle, easily identifiable for majority group readers, the skateboard.

Meanwhile Buttinski is buttin' in on a building painter and while attempting to give the painter a few tips on the correct handling of the brush, he fortuitously upsets three paint cans onto the unsuspecting Beagles skating below. This is good Keystone Cop's stuff and the creator of the strip deftly uses Buttinski again to turn the disaster (the bank job has been foiled by his good intentions) into a success. Buttinski leads the paint splattered Beagles to a contest being held in the Art Center Square. The bohemian-looking judge passes them the prize (again a trophy and dollar bills) and proclaims them the "new Body art winners," while one of Beagles remarks with a sigh, "it's messy but lots safer than robbin' banks." Buttinski revealing aside, "now where would you boys be without me buttin' in," completes the narrative and validates his philanthropy.

Whatever psychological motivations allowed the cartoonist(s) to address the avant-garde, their intentions are clear; Body art is as illegitimate a pursuit as a life of crime and both activities are less legitimate, though perhaps more exciting, than house painting or drawing comic strips as a career. Buttinski is the real winner here, always managing to turn misfortune into fortune. As the proto-typical stooge or "fall guy," he wins by having his essential

character remain intact, while the Beagles accept the "booby" prize for being in the wrong place at the right time.

We can possibly compare the Beagle Buttinski strip to Yves Klein's 1960 performance of his *Monotone Symphony* and simultaneous demonstration of his Anthropometry "painting," where nude models, under the direction of the artist, literally paint with their bodies to the accompaniment of a string quartet playing a single note for the duration of the performance. More recently, New York artist Vito Acconci's *Run Off* (1973) could have served as the comic strip's model. In his work Acconci rubs his nude body against a freshly painted (Kleinian International Blue) wall, reversing the instrumentality of the tool to surface support, the brush to the canvas. In this case Acconci's body becomes the canvas; his movements allow the wall to become the "applicator" of the paint to his body. Acconci's work is a parody of the correct "investiture of the self" in the work of the Abstract Expressionists, particularly Jackson Pollock. It also acts as a reversal of the models' roles in the Klein Anthropometries; Acconci is the male demonstrator and initiator of the work, the director and performer/subject. His body itself becomes the paradigmatic exhibitable work, for there is nothing else, save the documentation of the event, to show.

Both the Klein and the Acconci works, in the company of many examples using the body as both subject and object of the work (Adrian Piper, Gilbert and George, Michel Journiac, Bruce Nauman, Carolee Schneemann, et al.) are calculated slaps in the faces of the bourgeoisie and the artist heroes are applauded and rewarded for their efforts at undermining the status quo through an innovative continuance of the critical avant-garde. In the Beagle strip, the bourgeoisie fights back. It is ironic that the agents of the critique become the Beagles, members of the lumpen proletariat, and that the anti-social characteristics of robbing banks are channeled paradigmatically into the "messier but lots safer" critique of high culture.

In the Gearloose strip, Gyro, the eccentric loner, is represented to us as a figure from a bygone age. His good-old Yankee know-how and entrepreneurial skills are revealed to us as more authentic than this aberrant world of art, where to the outsider, decisions are made at the highest

level in the most blatantly irrational and fortuitous manner. Paradoxically, the refuge of individual creative behavior and "Yankee know-how," in a society dominated by corporate and bureaucratic institutions, becomes the role of the artist, and in particular the sanctified freedom that the artist's role allows.

To different degrees of complexity, both the Gyro and the Beagle comic strips parody contemporary art as meaningless quackery. It would be too simplistic to say that these comics reveal the "sour grapes" alien status of the popular media artist working anonymously for the Disney machine, or that they operate in the same manner as cartoons of monkey's doing Abstract Expressionist paintings in the early 1950s where the message is "a mere animal without human intelligence could do this," or "my kid could do that." As forms of propaganda, these examples are both crude and yet still intelligent critiques of high culture. In the context of the comics' readership, these critiques have a didactic function which attempts and is probably successful in undermining, for a largely neophyte audience, the significance of the avant-garde.

Addendum—A Note on Copyright

It may be said that a generalized approach to the critique of culture and the institutions of culture, television, film, advertising, etc., cannot be undertaken with any degree of authenticity without "taking from one for one's own (use)," the objects of culture. Much of the work in the exhibition *Appropriation/Expropriation* (Mount Saint Vincent University Art Gallery, March 11–April 3, 1983) presented potential or actual copyright problems because of this fact. Because culture is produced by individuals who sell their labor, the illicit taking of the products of that labor necessarily conflicts with the ownership of the object(s) in question. The centrality of ownership and property to our society is such that any questioning of the products of society brings into question the rights of ownership.

Prior to the change in copyright law in the United States in 1976, the First Amendment establishing the right to "Freedom of Speech" had always come into conflict with the right to ownership.[36] Litigations were defended

on the principles of "fair use and free enquiry," but the
established guidelines were never clear and were subject to
wide interpretation in courts of law. Precedent-setting cases
were the only means to establish and interpret the laws
protecting ownership and the freedom of speech. The major
argument leading a conviction of the defendants in copyright
litigations was the proof of intent to profit from the act(s)
of taking. The wheels that set in motion the need to change
the existing law established in 1904 were the introduction
of new technologies, video and tape recorders, xerox and
satellite transmission. In Canada fair use (dealing) in respect
to copyright is still in the process being revised. It remains
to be seen what effect the placement of the Constitution
has on the legalities and interpretability of existing copy-
right laws.

The principal defense for scholars and artists who
appropriate for the purpose of instruction or critique is
"fair use." However, the nature and extent of profitability
for fair users is clearly interpretable. Profiting can cover the
range of meanings from excessive monetary gain from the
commercialization of a product (or even idea), to a "mere"
elevation of status for the successful appropriator.

Legislators in both Canada and the United States
have found it impossible to adequately define "fair use"
and it is "questionable, therefore, whether fair dealing can
be usefully defined to provide certainty in determining
what can or cannot be done in particular cases." The rule
of thumb prevails. In a democratic society, testing is
the only manner in which revision can be accomplished.

[1] Both words share the same Latin root; from proprium—property. Appropriation—the act of taking to oneself, for one's own. Expropriation—to dispossess. Chambers Twentieth Century Dictionary Edinburgh 1975.

[2] See the recent issues of *October, Artforum, Parachute,* and *Art in America*. Articles which expressly deal with appropriation include: Craig Owens, "The Allegorical Impulse: Toward a Theory of Postmodernism," Parts I & II, *October* 12 (Spring 1980); *October* 13 (Summer 1980). Douglas Crimp, "Pictures," *October* 8 (Spring 1979): and "The Photographic Activity of Postmodernism," *October* 15 (Winter 1980); Benjamin Buchloh, "Allegorical Procedures: Appropriation and Montage," *Artforum* (September 1982).

[3] See Douglas Crimp, "Pictures." Crimp's use of the form is informed by Walter Benjamin's thinking in the "Doctrine of the Similar" (1933). See *New German Critique* 17 (Spring 79). This essay develops Benjamin's theory of language and the ideas were first presented in his essay "On Language as Such and on the Language of Man" (1916). For further discussion on Benjamin's aesthetic and language theories see Richard Wolin, *Walter Benjamin: The Aesthetic of Redemption,* Columbia University Press, New York 1982.

[4] This refers to the co-optation of images from high culture such as those produced by the Pop artists of the 1960s, which were re-used to sell commodities. Numerous instances of this form of "taking-back" may be found in the design catalogues for window dressers and advertising agencies where the models of high art provide designs for popular culture.

[5] The range of movements here would include Mannerism through to Romanticism and beyond. For an extensive discussion of some of these issues see Ernst Gombrich, *Art & Illusion,* Pantheon Books, New York 1961.

[6] See Geraldine Pelles, *Art, Artists and Society; Origins of a Modern Dilemma. Painting in England and France 1750–1850,* Prentice Hall, New Jersey 1963.

[7] For an authoritative study on the academies of the Renaissance see Nikolaus Pevaner, *Academies of Art, Past and Present,* Cambridge University Press, Cambridge 1940.

[8] Joseph Meder, *Die Handzeichung; ihre Technik und Entwicklung,* Anton Schroll & co., Vienna, 1919.

[9] See Elizabeth Holt, *Documentary Sources in the History of Art,* vol. II, Doubleday Anchor, New York 1947.

[10] Denis Diderot, "My Eccentric Thoughts on Drawing," chapter 1, from *An Essay on Painting,* Paris, 1781 requoted in Holt, *Documentary Sources in the History of Art,* p. 312.

[11] A.A. Keyes, "Copyright and Fair Dealing in Canada," in J.S. Lawrence and B. Timberg (eds.), *Fair Use and Free Enquiry: Copyright Law and the New Media,* Ablex, New Jersey 1980, p. 212.

[12] Cited in J.S. Shelton, "Copyright Law. Fair Use and the Academy: An Introduction," in Lawrence and Timberg (eds.), *Fair Use and Free Enquiry,* p.4.

[13] See Arnold Hauser, *The Social History of Art,* vol. II & III, Vintage, New York, 1958, for an outline of these changes in their social context.

[14] See Karl Ernest Meyer, *The Plundered Past,* Atheneum, New York, 1977, for an informed discussion of cultural imperialism and colonialist practices.

[15] Chad in Ronald Paulson, *Hogarth: His Life, Art, and Times,* Yale University Press, New Haven 1971, vol. I, p. 361, requoted in Kunzle, "Hogarth: Miracles and the Origin of Visual Copyright," in Lawrence and Timberg (eds.), *Fair Use and Free Enquiry,* p.21.

[16] For some useful discussions on the avant-garde see Renato Poggioli, *The Theory of the Avant-Garde,* trans. G. Fitzgerald, Harvard University Press, Cambridge Massachusetts 1968; Matei Calinescu, *Faces of Modernity: Avant-Garde, Decadence, and Kitsch,* Indiana University Press, Bloomington 1977;

Hans Magnus Enzensberger, "The Aporias of the Avant-Garde," in *The Consciousness Industry,* Seabury, New York 1974.

[17] See George Heard Hamilton, *Manet and His Critics,* W.W. Norton, New York 1965.

[18] Cited in David Bourdon, "The Razed Sites of Carl Andre," *Artforum* (October 1966), reprinted in Gregory Battcock, *Minimal Art: A Critical Anthology,* Dutton, New York 1968.

[19] Susan Sontag, *On Photography,* Dell, New York 1973, p. 155–161.

[20] See Aaron Scharf, *Art and Photography,* Penguin, Harmondsworth 1968; and Gisele Freund, *Photography and Society,* Godine, Boston 1980.

[21] Scharf, *Art and Photography,* p.92.

[22] This is still the case. See J., Szarkowski, *Looking at Photographs. 100 Pictures from the Collection of The Museum of Modern Art,* The Museum of Modern Art, New York 1973.

[23] Walter Benjamin, "The Work of Art In The Age of Mechanical Reproduction," in *Illuminations,* ed. Hannah Arendt, Schoken Books, New York 1969, p. 236.

[24] Ibid.

[25] In Artaud's collection of essays, *The Theatre and its Double.* (1938), Grove Press, New York 1994

[26] With the publication of Robert Motherwell's *The Dada Painters and Poets,* Wittenborn, New York 1951.

[27] See Max Kozloff, "American Painting During the Cold War," *Artforum* (May 1973).

[28] For an analysis of the process of quotation and appropriation as it relates to recent work, see Martha Rosler, "Notes on Quotes," *Wedge,* vol. 1, no. 2 (Fall 1982).

[29] The distinction made in this section between high culture and low, has its roots in the Frankfurt School, particularly in the work of Löwenthal, Adorno, Marcuse, as well as Walter Benjamin, while the Frankfurt theorists tend to concentrate on their critiques on the debilitating effects of mass culture on culture. In general, more recent studies have tended to differentiate between the types of culture and the diversity of their effects in response both to the economic dominance of popular culture and to the ideological and historical dominance of high culture. This opposition itself is not as absolute as this statement would suggest, for the patterns of dominance clearly shift depending on the nature and context of the material examined. Generally speaking high culture's hegemony over low culture is historical, class based, though not necessarily economically based.

[30] There exists a burgeoning field of literature, on the Sociology of Art and the Sociology of Culture. Kroeber and Kluckhohn (1952) and R. Williams (1958, 1976) have investigated the complexity of the terms, especially culture as these have been used in various disciplines, in particular Literature, Anthropology, and Sociology.

[31] While the author recognizes the urgency of admitting low or popular culture to the general history of social movements, cultural forms, and the history of ideas, the negative debasement of an authentic, radical high culture to secure a status quo of ignorance within the low cultural domain is as dangerous a project as a high culture cantrism, or worse, negative propagandizing of popular culture from the other side. This section reveals some ambivalence with respect to the ultimate cultural value of the popular cultural critiques examined. At this stage it is enough to recognize them as critiques. From a Marxist perspective, the "ruling ideas" of capitalism may be found in both popular and high culture. It is those progressive, and within capitalist culture, radical, elements within the two that must be sustained if culture and society are to be transformed. The partitioning off of certain sections of culture for their reactionary tendencies is a necessary

strategy, for through this, contradictions are isolated and
subjected to further critical analysis and this process may
allow judgments to be made.

[32] Syndicated newspaper strips, which may be either thematic
or serialized. Television and film series based on comic
strips or newspaper publications. The history of caricatures
and cartoons must also be placed within that group of
visual forms, which actively critique high culture.

[33] David Kunzle, *History of the Comic Strip*, vol. 1, "The Early
Comic Strip," UCLA Press, 1974.

[34] In the study of comic strips and popular culture a few
other texts stand out, most for their attachment to his-
tory, few for the rigor of their analysis: Russel B. Nye, *The
Unembarrassed Muse* (1970); Rual Donney, *The Astonished Muse*
(1957); Reinhold Reitberger and Wolfgang Fuchs, *Comics: An
Anatomy of a Mass Medium* (1973): and some useful antholo-
gies including *The Funnies: An American Idiom*, ed. David
Manning White and Robert H. Abel (1983); *Mass Culture:
The Popular Arts in America* (1957), ed. White and Bernard
Rosenberg; *Popular Culture and Expanding Consciousness*, ed.
Ray B. Browne (1973).

[35] For this analysis a certain "currency" in terms of the
literature of mass communications and popular culture,
a thorough survey of the material available, historical and
contemporary, would have to be undertaken, including
analyses of the institutions which produce these forms.
The intentionality of the producers involved should also be
investigated as well as the usual content and, where possible,
effects analysis. With the distinctive modes of qualitative
and quantitative study and their criticism allowed for, a
thorough investigation may lend more credibility to the
statements made—that there are "few simpler ways of
seeing ideology at work than in the comic strip and its
surrogate forms" and that these examples truly represent
an attack on high culture.

[36] See J.S. Lawrence, "Copyright Law, Fair Use, and the
Academy: An Introduction," in Lawrence and Timberg
(eds.), *Fair Use and Free Enquiry*, p. 3–17. This essay was also
published in a special issue of *Open Letter: Essays on "Perfor-
mance" and Cultural Politization*, ed. Bruce Barber (Fall 1983).

Most of this essay was first published under the same title
for the exhibition *Appropriation/Expropriation, Recent Works
from the Halifax Community* organized with the Mount
St. Vincent University Art Gallery by Bruce Alistair Barber
and Jan Peacock.

A revised version of the original essay was published in
a special double issue of *Open Letter: Essays on (Performance)
and Cultural Politicization*, ed. Bruce Barber, *Open Letter*,
5th series, no. 5 (Summer 1983), and no. 6 (Fall 1983),
Coachhouse Press, Toronto.

RE: POST
Hal Foster

Parachute, no. 26, Spring 1982

Laurie Anderson
United States Part II, performance, 1984

"Postmodernism" is a term used promiscuously in art criticism, often as a mere sign for not-modernism or a synonym for pluralism. As such, it means little—only, perhaps, that we are in a reactionary period in which modernism as such is distant and modernist revivals all too near. Yet there are critics who use the term with rigor, who define postmodernism as a theory and ground it in specific works. I have chosen to discuss the writings of, in particular, three critics associated with *October*: Rosalind Krauss, Douglas Crimp, and Craig Owens.

What postmodernism is depends largely on what modernism is, i.e. how it is defined. As a chronological term, modernism is often restricted to the period 1880–1930 or thereabouts, though many extend it to postwar art or "late modernism." As an epistemological term, modernism is even harder to specify (e.g. ought one to accept the break between classicism and modernity as defined by Foucault? Ought one

to refer to Kantian self-criticism as Greenberg does?). In any case, postmodernism, articulated in relation to modernism, tends to reduce it. Is there a modernism that can be so delimited? If so, what would constitute a break with it?

Postmodernism's Modernism

Tactically, modernism is regarded as distilled in late modernism, the ideology of which is extracted from the critical writings of Clement Greenberg and Michael Fried. It is defined as "the point of view which sees art as the mastery of purity"[1]; it holds that "the concept of art itself ... (is) meaningful, or wholly meaningful, only with the individual arts,"[2] and that "the art object itself can be substituted (metaphorically) for its referent."[3] It is said to prescribe "specific areas of competence," and to foster, in the artist, a self-critical formalism in which the inherited "code" of the medium is manipulated and, in the critic, an historicism that "works on the new and the different to diminish newness and mitigate difference."[4] Painting, sculpture, and architecture are thus distinct, and art exists properly only within them; each art has a code or nature, and art proceeds as the code is revealed, the nature purged of the extraneous.

Such, (simplified), is the aesthetic of postmodernism's modernism, distilled in the term *purify*. Once, this will-to-purity was subversive: it rendered art critical, and the artist autonomous. Conventions—social ones encoded in the aesthetic—were excised, and the artist was immersed in artistic practice, his or her true history. In retrospect, such a strategy seems decorous and politically retrograde. "Purity" abets a division of labor within culture, which, as a result, comes to partake of both the special professionalism of the academy and the commercial commodity-production of industry.[5] It also abets the idea of art as its own issue, engendered from a special history: this is the line (often one of *post hoc propter hoc*) of historicism, the genealogy of modern art history.

Curiously, historicism is seen as the critical operation of modernism. Even to the intellectual historian Renato Poggioli, the avant-garde is "the artistic equivalent of a transcendental historicism."[6] The term "transcendental historicism" seems a contradiction, but it is one basic to

modernism—no matter how "transcendental" or radically new the art, it is recouped, rendered familiar by historicism.[7] Late modernism only reworks the contradiction: art is avant-garde insofar as it is radically historicist—the artist delves into art-historical conventions in order to break out of them.[8]

Such historicism (the New as its own Tradition) is both an origin and an end to the avant-garde; and one aim of postmodernism is to sever the two—to retain radicality but be rid of historicism.[9] For as the discourse of the continuous, historicism recoups inherently; it conceives time as a totality (whereby "revolutions are never more than moments of consciousness"[10]) and man as the only subject (i.e. historicism at once posits and reveals human consciousness as sovereign). Discontinuity is resisted, as is any decentering (whether of class, family or language). In art, of course, historicism's subject is the artist and historicism's space is the museum—history is presented as a narrative, continuous, homogenous, and anthropocentric, of great men and master works.

Modernism's Postmodernism

Purity as an end and decorum as an effect; historicism as an operation and the museum as the context; the artist as original and the art work as unique—these are the terms which modernism privileges and against which postmodernism is articulated. To postmodernism, they inform a practice now exhausted, whose conventionality can no longer be inflected. Pledged to purity, the mediums have reified— hence, postmodernist art exists between, across, or outside them, or in new or neglected mediums (like video or photography). Historicized by the museum, commodified by the gallery, the art object is neutralized—hence, postmodernist art first occurred in alternative spaces and/ or in many forms. As the place of art is re-formed, so too is the role of the artist, and the values that heretofore authenticated art are questioned. In short, the cultural field is transformed, aesthetic signification opened up.

The field transformed is the first condition of postmodernism. In "Sculpture in the Expanded Field," Rosalind Krauss details how modern sculpture entered a condition of

"pure negativity: the combination of exclusions ... (it) was now the category that resulted from the addition of the *not-landscape* to the *not-architecture*."[11] These terms, she notes, are simply the terms "architecture" and "landscape"; set with the others, they form a "quaternary field, which both mirrors the original opposition and opens it."[12] It is in this "logically expanded field," suspended between these terms, that the postmodernist forms—"site-construction," "axiomatic structures," and "marked sites"—exist with sculpture. To Krauss, they break with modernist practice, and so cannot be thought of in terms of historicism. Here, art-historical context will not suffice as meaning, for postmodernism is articulated not within the mediums but in relation to cultural terms. These forms are conceived logically, not derived historically, and so must be regarded in terms of structure. To be seen as such, postmodernism must posit a break; this one, with the mediums and with historicism, is crucial—it seals modernism and opens the cultural space of postmodernism. Crimp and Owens also posit a rupture, though, focused on other artists, they detail its advent somewhat differently. If, for Krauss, the signal is an expanded field, for Crimp it is a return of "theater" (tabooed by late modernism), and for Owens an "eruption of language" (also "repressed") and, more importantly, a new postmodernist impulse, "allegorical" or deconstructive in nature.

Again, these critics first pose postmodernism against late modernism, whose classic text is seen as the essay "Art and Objecthood" by Michael Fried.[13] Therein, Fried objects to the implicit "theater" of Minimalist sculpture: "art degenerates as it approaches the condition of theater," runs the often-quoted line, with "theater" defined as "what lies between the arts." To Crimp, this intuition signals modernism's demise: the important work of the 1970s, he notes, exists precisely between the arts; moreover, such work—especially video and performance—exploits the very "theater" (a "preoccupation with time—more precisely, with the duration of experience") that Fried deemed degenerate. In effect, Minimalism's implicit "theater" became post-minimalism's explicit "theater." Extrapolated, much contemporary art can be derived, or so Crimp writes in the essay "Pictures":

If many of these artists can be said to have been apprenticed in the field of performance as it issued from minimalism, they have nevertheless begun to reverse its priorities, making of the literal situation and duration of the performed event a tableau whose presence and temporality are utterly psychologized; performance becomes just one of a number of ways of "staging" a picture.[14]

Owens also cites the Fried dictum as late modernist law, which he relates as a "belief in the absolute *difference* of verbal and visual art," to the neoclassical order (i.e. the temporal arts, poetry, etc., *over* the spatial arts, painting, etc.).[15] Such a hierarchy, Owens writes, is based on a "linguistic criterion," one that the modernist visual arts repressed. The emergence of time, intuited by Fried, is then marked by an "emergence of discourse":

[T]he eruption of language into the aesthetic field—an eruption signaled by, but by no means limited to, the writings of Smithson, Morris, Andre, Judd, Flavin, Rainer, LeWitt—is coincident with, if not the definitive index of, the emergence of postmodernism. This "catastrophe" disrupted the stability of a modernist partitioning of the aesthetic field into discrete areas of specific competence; one of its most deeply felt shocks dislodged literary activity from the enclaves into which it had settled only to stagnate—poetry, the novel, the essay—and dispersed it across the entire spectrum of aesthetic activity.[16]

Owens regards much of the work that ensued (e.g. Conceptual, story, even site-specific art) as *textual*[17]; here he quotes Barthes: "a text is not a line of words releasing a single 'theological' meaning (the 'message' of the Author-God), but a multi-dimensional space in which a variety of writings, none of them original, blend and clash."[18] Such "textuality" is a poststructuralist notion, based on the idea that the sign is not stable, i.e. that it does not enclose one signifier and signified as such. Similarly, the postmodernist work is seen less as a "book" sealed by one original author and final meaning than as a "text" read as a polysemous tissue of

codes. So, as Barthes writes of "the death of the author," the postmodernists infer "the death of the artist" (and hence, the death of the subject) at least as originator of unique meaning.

Posts

To an extent, the postmodernist line retraces the poststructuralist line.[19] Both reflect upon a culture that is utterly coded.[20] "[W]ithin the situation of postmodernism," Krauss writes, "practice is not defined in relation to a given medium—sculpture—but rather in relation to the logical operations on a set of cultural terms, for which any medium—photography, books, lines on walls, or sculpture itself—might be used."[21] In effect, the postmodernist manipulates old signs in a new logic: he or she is a rhetorician who transforms rhetoric (even the mediums are often readymades to be reinscribed). To Crimp, the postmodernist is concerned not with modernist autonomy but with "strata of representation"—"we are not in search of origins," he writes, "but of structures of signification: underneath each picture there is always another picture."[22] In such "pictures," modes (e.g. performance) may be transposed, signs or types collided, so that aesthetic limits are transgressed as cultural codes are opened up. Crimp cites these tactics: "quotation, excerptation, framing, and staging."[23] To Owens, not only are mediums collided, but levels of representation and reading are too: an "allegorical impulse" deconstructs the symbol-paradigm of modernism. "Appropriation, site-specificity, impermanence, accumulation, discursivity, hybridization—these diverse strategies characterize much of the art of the present and distinguish it from its modernist predecessors."[24]

Much Minimal art is based on a given form or public sign. Of the star and cross paintings of Frank Stella, Krauss once wrote, "The logic of the deductive is shown ... to be inseparable from the logic of the sign."[25] This is not the case with much postmodernist art: the sign's stability, the medium's code, are rendered problematic.[26] For example, the expanded field is "generated by problematizing the set of oppositions between which the modernist category *sculpture* is suspended."[27] Signification is thus opened: the

work is freed of the term "sculpture" ... but only to be bound by other terms, "landscape," "architecture," etc. Though no longer defined in one code, practice remains within a field. Decentered, it is recentered: the field is (precisely) "expanded," more than "deconstructed." The model for the field is a structuralist one, as is the activity of the essay: "to reconstruct an 'object' in such a way as to manifest thereby the rules of functioning (the 'functions') of this object."[28] "The Expanded Field" thus posits a logic of cultural oppositions questioned by poststructuralism—and also, it seems, by postmodernism (at least as articulated by Owens and Crimp).

Rather than "map" a "field," Douglas Crimp uncovers "strata" of "pictures." This recalls Barthes, for whom the cultural type or "myth" is a composite of signs, and in fact Crimp notes how these pictures often re-present types in a way that "subverts their mythologies."[29] But to Crimp they do more, as they must, really, for, as Barthes later noted, demystification is now mythological too (a "doxa" of its own).[30] Not only do they question the "ideological signified," but they also "shake" the sign itself (the picture-underneath-the-picture thus has more to do with Derrida's grammatology: the notion that the sign is always already articulated by another sign). Such, at least, is the claim.

To change the object itself: this, to Craig Owens, is the mandate of postmodernism. To Owens, postmodernist art is contingent: it exists in (or as) a web of references, not necessarily located in any one form, medium, or even spot. Thus, as the object is destructured, so is the subject, or viewer, dislocated.[31] In this postmodernism, the aesthetic field is more than "logically expanded"—its logic is deconstructed. As noted, the modernist order of the arts was, to Owens, decentered by an "eruption of language": the resultant work (often of a "writing composed of concrete images")[32] is "allegorical" in nature.[33] Temporal and spatial at once, it dissolves the old order; so too, it opposes the "pure sign" of late modernist art and plays, instead, on the "distance which separates signifier from signified, sign from meaning."[34] Whereas the symbol-paradigm of modernism proposes that "the art object itself can be substituted (metaphorically) for its referent," the allegorical impulse of postmodernism may effect a "structural interference of two

distinct levels or usages of language, literal and rhetorical (metaphoric), one of which denies precisely what the other affirms."[35]

Figures and Fields

Krauss, Crimp, and Owens all pose postmodernism as a rupture with the aesthetic order of modernism. And yet the concept of the field remains—even if only as a term to define its own dispersal. That is, postmodernism is seen within a given problematic of representation—in terms of types and codes, rhetorical figures, and cultural fields. As a discourse in a space. Its very "illegibility" is "allegorical," its very schizophrenia is strategic. Is it necessary to think in terms of fields and figures of representation? No doubt: what else is there (but the pragmatics of "Energism" or the vacuity of pluralism?) And yet criticism thereby remains recuperative. As a textual practice, postmodernist art cannot be translated: criticism, then, would not be its supplement. But then, what would it be? What *does* criticism do vis-à-vis art perceived as critical? Does it enter as another code in the text of the art? Or does it initiate the very play of signs that is the text? It is "the failure of contemporary theory," Owens writes, not to "see its own realization in Smithson's practice."[36] But have the postmodernist critics interiorized this practice? Do they engage the art as its textual nature would demand? "[A]s soon as one attempts to show ... " Derrida writes, "that there is no transcendental or privileged signified and that at that point the field or play of signification knows no limit, then one ought—but this is exactly what one cannot do—to refuse the very concept and word sign."[37] But this is exactly what one cannot do—such is the epistemological bind of poststructuralism and postmodernism.

To Owens, postmodernism, as a deconstructive enterprise, enfolds a contradiction—namely, "the methodological necessity of preserving as an instrument a concept whose truth value is being questioned."[38] As an example, he notes that as "sites" for images, Rauschenberg's "paintings" refer to the very term that they contest: the museum.[39] Such complicity is a conspiracy, for a convention, form, tradition, etc., is only deconstructed from within. Deconstruction, then, is reinscription: there is no "outside" (except in the

positivist sense of "outside the mediums"—a transgression
that reasserts the limit). Which is to say, there is no way *not*
to be in a field of cultural terms, for these terms (e.g. the
museum) inform us presumptively.

Much postmodernist art, then, is referential, yet it
refers only "to problematize the activity of reference."[40] For
example, Crimp and Owens stress art that "steals" types
and even actual images, an "appropriation" that is seen as
critical—both of a culture in which images are commodities
and of an aesthetic practice that holds (nostalgically) to an
art of originality. And yet, can a critique be articulated
within the very forms under critique? Again, yes: how else
could it be articulated? (Such a critique cannot hope,
however, to displace these forms: at best, it indicts them as
"given" or "natural" and stresses the need to think and
represent otherwise.) Another question is not so obvious:
are the given mediums *not* mediated? That is to say, is a
medium such as painting given as static and neutral, or is it
in fact re-formed, re-presented, in and by the very forms
that it mediates?

Postmodernism

Appropriation, textuality ... these tactics seem to preclude
mediums whose logic is based on authenticity and originality.
Painting in particular is problematic to the postmodernist
critics, and even photography is seen to hold a vestige of
aura—an aura that is elaborated or expunged (in oddly "pure"
fashion?) by many artists today. (Indeed, a certain aura or
even cult of inauthenticity is active today: the purloined
image is now almost the law.). Moreover, to these critics, the
value of art as expression, as craft, etc., is complicitous with
a dated ideology and even political economy.[41] To think of
art and artists in these terms can only mystify.

Today, there is, of course, a resurgence in painting,
not only a revival of old modes as if they were new, but also
a retreat to old values as if they were necessary. Much of it is
regressive—or rather, defensive. In the midst of a society
suffused with "information," many seem to regard painting—
its specificity—as critical. The old avatars (creative artists,
authentic art) are returned, precisely because they are
untimely, as forces to resist complete mediation (which is to

say, complete absorption in the consumerist program of mass media). Such a position, a nostalgic one, would regard postmodernism as complicitous with, not critical of, the media forms that engulf us.[42]

To a different degree, both these positions simplify. That is, they both seem to imply that art mediums as representations or institutions are somehow apart from other representations or institutions, and so unable to engage them in any critique.[43] In the postmodernist critics, this is seen in a tendency to reduce painting to "pure" painting, now regarded as reified and, in general, in a tendency to rehearse the "positivism of the medium" of late modernism and so to seal a formalist image of modernism that is relatively easy to displace.

Postmodernism does exploit late modernist dogma, only to reconfirm its reduction, to which late modernism is then subjected. This is clearest as regards the mediums: identified with modernism, they are foreclosed with it. Clearly, mediums, or forms thereof, are "historically bounded"[44]; but to derive a logic of a medium from historical examples and then to see it (the logic) apart from the examples as somehow essential—this seems fallacious. A formalism of sorts, it first asserts the immanence or mediation of art, only to deny it later. And, in practical terms, it runs awry of the many modernist displacements of the mediums.

To expand the aesthetic field, to transgress formal closures, to steal images, to denature given signs, to question cultural myths, to problematize the activity of reference, etc., how alien are these tactics to modernism? Picasso, Pollock, and Smithson all destructure the modes of signification that they inherit. Magritte, Johns, and Laurie Anderson all pose forms of rhetorical interference. They cannot all be recouped as postmodernist or proto-postmodernist. The strategy of appropriation, as seen in Duchamp and again in Rauschenberg, is modernist in origin, as is the deconstructive impulse—we are told often that modern art arose in metaphysics' fall (the only question is, did art then serve as a substitute?).

"[T]he deconstructive impulse," Craig Owens writes, "must be distinguished from the self-critical tendency of modernism."[45] This is crucial to the postmodernist break, and no doubt the two operations are different: self-criticism,

centered on a medium, does tend (at least under the aegis of formalism) to the essential or "pure"; whereas deconstruction, on the contrary, decenters and exposes the "impurity" of meaning. And yet unlike self-reflexivity (with which it is often conflated), self-criticism does not enforce a closure. It may, in fact, issue in deconstruction (such is really the recent history of critical theory), so that if postmodernism is truly deconstructive of modernism, it would seem to be a discursivity within it.

Certainly, to be regarded as an epistemological break (and not merely a chronological term), postmodernism must be based on a form of knowledge—and thus on material conditions—substantially different from modernism's. (A new technique, for example, may enable—but not initiate—a new way of seeing.) Perhaps such a form does exist: to know it will require a Foucaultian archaeology—to posit it now, on the basis of aesthetic effects, seems precarious. Recent practice has effected a defamiliarization, an estrangement (quintessentially modernist terms) that, in turn, stresses the historical, i.e. conditional, nature of art. And it is no doubt important to insist upon the cultural specificity of modern- ism (for it is determinate). But again: to delimit it now seems problematic.

And yet postmodernism is defined as a rupture. In this it is like modernism, which, despite historicism, speaks a rhetoric of discontinuity. Like modernism too, postmod- ernism is posed against a past perceived as inert: terms like "reified categories" and "exhausted conventions" punctuate its discourse, as do "radical innovation" and "advanced aesthetic practice." The postmodernists thus rely on the old historical imperative of the avant-garde: theirs is a language of crisis in the sense of both judgment and separation. As noted above, these crises in art tend to be recouped institu- tionally (in the museum and in art history), and such recuperation, along with pluralism, is the main problem of contemporary art: how to retain avant-garde radicality, which is a crucial criterion of value, and be rid of the historicism that recoups and reduces even as it provokes the extreme? (It may be that a revision of historicism is necessary, one in which the series of breaks, characteristic of modernism, are "not seen as an avant-garde succession— in which an evolution of discontinuity is substituted for an

evolutionism of continuity—but in the form of a problematic constellation, whose systemic set off the 20th century as a deconstructive synchrony."[46])

Postmodernism is highly conscious of historical moment: in effect, it displaces modernism as the next (necessary) term. Pushed back into the book of culture, modernism is posed in its own reduction, foreclosed more than deconstructed. Rather than reduction, what is needed is a revision of modernism: an opening of its supposed closure. And perhaps postmodernism is this too. Though it reconfirms late modernist dogma, it also reorders other modernist discourses (for example, artists like Duchamp and Klee are favored, as are critics like Baudelaire and Benjamin). As such, it may be less a break with modernism than an advance in a dialectic in which modernism is reformed. Certainly, the postmodernists, nearly alone among critics today, are committed to a high seriousness; and as a theoretical enterprise, postmodernism does seem proffered on the conviction "that a system calling for corrections, translations, openings, and negations is more useful than an unformulated absence of system—one may then avoid the immobility of prattle and connect to the historical chain of discourses, the progress (*progressus*) of discursivity."[47]

[1] Donald B. Kuspit, "The Unhappy Consciousness of Modernism," *Artforum* (January 1981), p. 53.

[2] Michael Fried, "Art and Objecthood," *Artforum* (Summer 1967), p. 21 (italics in the original); cited by Douglas Crimp in "Pictures," *October* 8 (Spring 1979), p. 76.

[3] Craig Owens, "The Allegorical Impulse: Toward a Theory of Postmodernism (Part 2)," *October* 13 (Summer 1980), p. 79.

[4] Rosalind Krauss, "Sculpture in the Expanded Field," *October* 8 (Spring 1979), p. 31.

[5] Marxist critics (e. g. Peter Fuller) have even related the "pure sign" of modernist art (the object as its own referent) to the monolithic nature of monopoly capitalism. Others (e. g. T. W. Adorno) see the "purity" of modernist art as a negativity—an abstraction posed against the totalizing abstraction of capital.

[6] Renato Poggioli, *The Theory of the Avant-Garde*, Harper & Row, New York 1971, p. 103.

[7] See Krauss, p. 31–33.

[8] See Kuspit, p. 53.

[9] It is ironic (but not unexpected) that, in an age like the modern that so valorizes breaks and ruptures, the primary critical model would be historicism—whose job it is to recoup breaks and ruptures.

[10] Michel Foucault, *The Archeology of Knowledge*, Harper & Row, New York 1976, p. 12.

[11] Krauss, p. 36 (her italics).

[12] Ibid., p. 37.

[13] This essay was and is of prime importance—a catalyst. (For Smithson's reaction, see "Letter to the Editor," *Artforum*, October 1967, reprinted in *The Writings of Robert Smithson*, ed. Nancy Holt, The New York University Press, New York 1979, p. 38.) Fried objected to the "perversity" of minimalism—its deviation from the late modernist will to "purity." Other, less perspicacious critics regard Minimalism as the *nec plus ultra* of modernist reductionism. That it should enfold such a contradiction—the modernist impulse to the thing-itself and the postmodernist impulse toward "theatricality" or "perversity" might in fact make Minimalism the scene of a shift in sensibility as the postmodernists seem to suggest. See also Michael Fried, *Absorption and Theatricality; Painting and Beholder in the Age of Diderot*, University of California Press, Berkeley 1980.

[14] Crimp, "Pictures," p. 77. Here, Crimp retains an (oblique) historicism, though the passage shows that it need not be centered on any one medium.

[15] Craig Owens, "Earthwords," *October* 10 (Fall 1979), p. 125–126. And yet modernism is seen, at least originally, as a revolt *against* the Neo-Classical order as it congealed in the academy. Romantic confusion of genres, Symbolist syncretism, Surrealism ... Granted that these are episodes, they nevertheless question any characterization of modernism as a doctrine of decorum.

[16] Ibid., p. 126–127.

[17] Smithson is one exemplar: Of *Spiral Jetty* Owens writes: "The work is henceforth defined by the position it occupies in a potentially infinite chain extending from the site itself and the associations it provokes—'in the end I would let the site determine what I should build' (p. 111)—to quotations of the work in other works." Ibid., p. 128.

[18] Roland Barthes, "The Death of the Author,"in *Image/Music/Text*, trans. Stephen Heath: Hill & Wang, New York 1977, p. 146; quoted by Owens in "Earthwords," p.127.

[19] See Frederic Jameson, *Fables of Aggression: Wyndham Lewis, the Modernist as Fascist*, University of California Press, Berkeley 1979, p. 20. " ... the contemporary poststructuralist aesthetic ... signals the dissolution of the modernist paradigm—with its valorization of myth and symbol, temporality, organic form and the concrete universal, the identity of the subject and the continuity of linguistic expression—and foretells the emergence of some new, properly postmodernist or schizophrenic conception of the cultural artifact—now strategically reformulated as 'text' or *écriture*, and stressing discontinuity, allegory, the mechanical, the gap between signifier and signified, the lapse in meaning, the syncope in the experience of the subject."

[20] Not only is the present generation of artists the first (to a great degree) to attend college and even graduate school, it is the first born into a totally (mass) mediated world (TV, etc.)—the first to be immersed in its particular representations, stereotypes, etc. This has affected many of today's artists, no less than many of today's film directors. Indeed, the first field of reference for these artists is often these media, not art history.

[21] Krauss, "Sculpture in the Expanded Field," p. 42.

[22] Crimp, "Pictures," p. 87.

[23] Ibid.

[24] Craig Owens, "The Allegorical Impulse: Toward a Theory of Postmodernism (Part 1)," *October* 12 (Spring 1980), p. 75.

[25] Rosalind Krauss, "Sense and Sensibility: Reflections on Post '60s Sculpture," *Artforum* (November 1973), p. 47.

[26] Though much late modernist and postmodernist art is similarly materialistic, i.e. meaning is conceived as external, not expressive of an "inner self." See Krauss, "Sense and Sensibility," *passim*.

[27] Krauss, "Sculpture in the Expanded Field," p. 38.

[28] Roland Barthes, "The Structuralist Activity," trans. Richard Howard, *Partisan Review*, vol. 34, no. 1 (Winter 1967).

[29] Crimp, "Pictures," p. 85.

[30] Roland Barthes, "Change the Object Itself," in *Image/Music/Text*, p. 166–167. This is a danger of critical "doxa" in general. Though poststructuralism is now under attack, it remains a privileged discourse, one which, in turn, privileges the texts that it engages. One senses this often in Crimp's and Owens's criticism. See also, Jacques Derrida, *Of Grammatology*, trans. Gayatari Spirak, Johns Hopkins University Press, Baltimore 1976.

[31] Again on Smithson Owens writes: "Unintelligible at close range, the spiral form of the *Jetty* is completely intuitable only from a distance, and that distance is most often achieved by imposing a *text* between viewer and work. Smithson thus accomplishes a radical dislocation of the notion of point-of-view, which is no longer a function of physical position, but of *mode* (photographic, cinematic, textual) of confrontation with the work of art." "Earthwords," p. 128.

[32] Owens, "Allegorical Impulse (Part 2)," p. 74.

[33] This is not, of course, the allegory of levels of reading (literal, allegorical, moral, anagogic) ordered by a logos, Christian or otherwise. That transcendental signified is precisely what is lacking. As a result, the "levels" collide— no total reading is possible. Here, Owens and Crimp are quite close: "In allegorical structure, then, one text is *read through* another, however fragmentary, intermittent or chaotic their relationship may be; the paradigm for the allegorical work is thus the palimpsest." Owens, "Allegorical Impulse (Part 1)," p. 69.

[34] Owens, "Allegorical Impulse (Part 2)," p. 63.

[35] Ibid. However, formulated differently, this contradiction can be seen as crucial to modernism. See Kuspit, *passim*.

[36] Owens, "Earthwords," p. 130.

[37] Jacques Derrida, "Structure, Sign, and Play," *Writing and Difference*, trans. Alan Bass, The University of Chicago Press, Chicago 1978, p. 281.

[38] Owens, "Allegorical Impulse (Part 2)," p. 71.

[39] Ibid. See also Douglas Crimp, "On the Museum's Ruins," *October* 13 (Summer 1980), p. 41–57.

[40] Ibid., p. 80.

[41] Craig Owens has suggested such an argument vis-à-vis Daniel Bell, *The Coming of Post-Industrial Society*, Basic Books, New York 1973; and Jean Baudrillard, *The Mirror of Production*, trans. Mark Poster: Telos Press, St. Louis, 1975. See also, Walter Benjamin, "The Work of Art in the Age of Mechanical Reproduction," in *Illuminations*, trans. Harry Zohn, Schocken Books, New York 1969.

[42] This remark is representative: "That art which commits itself self-consciously to radicality—which usually means the technically and materially radical, since only technique and not the content of the mind advances—is a mirror of the world as it is and not a critique of it." Barbara Rose, *American Painting: The Eighties*, Thorney-Sidney Press, Buffalo 1979.

[43] This may not even be true to "pure" painting. The will to purity is not merely about autonomy—it also serves to denature essences that are mere conventions. As such, it is at least an analogue to a much broader critique (it may even be argued that aesthetic conventions encode social ones and thus that the will to purity actually partakes in this critique). In late modernist art, the critique centers on each medium less by any imperative of decorum than by the necessity of a received language. For, again, without such, how can any critical or deconstructive enterprise be articulated? Again, it is a question of field or arena.

[44] Krauss, "Sculpture in the Expanded Field," p. 33.

[45] Owens, "Allegorical Impulse (Part 2)," p. 79.

[46] Jean-Claude Lebensztejn, "Star," *October* 1 (Spring 1976), p. 101.

[47] Roland Barthes, "Writers, Intellectuals, Teachers," in *Image/Music/Text*, 1977, p. 200.

Modern Art in the Common Culture
Thomas Crow

Parachute, no. 30, Spring 1983

Claude Monet
Régates à Argenteuil (Regattas at Argenteuil), c. 1872, oil on canvas, 48 × 75 cm

What is to be made of the continuing involvement between modernist art and the materials of low or mass culture? From its beginnings, the artistic avant-garde has discovered, renewed, or re-invented itself by identifying with marginal, "non-artistic" forms of expressivity and display—forms improvised by other social groups out of the degraded materials of capitalist manufacture. Manet's *Olympia* [1863] offered a bewildered middle-class public the flattened pictorial economy of the cheap sign or carnival backdrop, the pose and allegories of contemporary pornography superimposed over those of Titian's *Venus of Urbino* [1538]. For both Manet and Baudelaire, can their invention of powerful models of modernist practice be separated from the seductive and nauseating image the capitalist city seemed to be constructing for itself? Similarly, can the Impressionist discovery of painting as a field of both particularized and diffuse sensual play be

imagined separately from the new spaces of commercial
pleasure the painters seem rarely to have left, spaces whose
packaged diversions were themselves contrived in an
analogous pattern? The identification with the social practices
of mass diversion—whether uncritically reproduced,
caricatured, or transformed into abstract Arcadias—remains
a durable constant in early modernism. The actual debris of
that world makes its appearance in Cubist and Dada collage.
And even the most austere and hermetic of 20ᵗʰ-century
abstractionists, Piet Mondrian, anchored the culmination
of decades of formal research in a delighted discovery of
American traffic, neon, and commercialized Black music.
In recent history, this dialectic has repeated itself most
vividly in the paintings, assemblages, and Happenings of the
artists who arrived on the heels of the New York School:
Jasper Johns, Robert Rauschenberg, Claes Oldenburg, and
Andy Warhol.

How fundamental is this repeated pattern to the
history of modernism? Yes, it has to be conceded, low-cultural
forms are time and again called upon to displace and estrange
the deadening givens of accepted practice, and some
residuum of these forms is visible in many works of modern-
ist art. But might not such gestures be little more than
means to an end, weapons in a necessary, aggressive clearing
of space, which are discarded when their work is done? This
has indeed been the prevailing argument on those occasions
when modernism's practitioners and apologists have
addressed the problem, even in those instances where the
inclusion of refractory material drawn from low culture
was most conspicuous and provocative. In the early history
of modernist painting, Manet's images of the 1860s represent
one such episode, matched two decades later by Seurat's
depiction of the cut-rate commercial diversions of Paris.
And each of these confrontations between high and low
culture was addressed in a key piece of writing by an artistic
peer who assigned the popular component to a securely
secondary position.

In the case of Manet, the argument came from
Stéphane Mallarmé writing (in English) in 1876.[1] It was true,
he wrote, that the painter began with Parisian lowlife:
"Captivating and repulsive at the same time, eccentric, and
new, such types as were needed in our ambient lives."[2] But

the poet, in the most powerful reading of Manet's art produced in the 19th century, regarded these subjects as merely tactical and temporary. He was looking back at the work of the 1860s with relief that the absinthe drinkers, dissolute picnics, and upstart whores had faded from view. Left in their place was a cool, self-regarding formal precision, dispassionate technique as the principal site of meaning, behind which the social referent had retreated; the art of painting had overtaken its tactical arm and restored to itself the high-cultural autonomy it had momentarily abandoned. The avant-garde schism had, after all, been prompted in the first place by the surrender of the academy to the philistine demands of the modern marketplace—the call for finish, platitude, and trivial anecdote. The purpose of modernism was to save painting, not to sacrifice it to the degraded requirements of yet another market, this time one of common amusement and cheap spectacle. For Mallarmé, Manet's aim "was not to make a momentary escapade or sensation, but … to impress upon his work a natural and general law."[3] In the process, the rebarbative qualities of the early pictures—generated in an aggressive confrontation with perverse and alien imagery—were harmonized and resolved. His essay ends in the voice of an imaginary Impressionist painter who flatly states the modernist credo:

> I content myself with reflecting on the clear and durable mirror of painting … when rudely thrown, at the close of an epoch of dreams, in the front of reality, I have taken from it only that which properly belongs to my art, an original and exact perception which distinguishes for itself the things it perceives with the steadfast gaze of a vision restored to its simplest perfection.[4]

Despite the distance that separated their politics, a parallel argument to Mallarmé's was made by "an Impressionist comrade" in 1891 in the pages of the journal *La Révolte*. Entitled "Impressionists and Revolutionaries," his text was intended as a political justification of the art of Seurat and his colleagues to an anarchist readership—and the anonymous Impressionist comrade has been identified as painter Paul Signac.[5] Like Mallarmé's 1876 essay, this was another

account by an avant-garde initiate that addressed the relationship between iconography drawn from cheapened urban experience and a subsequent art of resolute formal autonomy. And, similarly, it marked the former as expedient and temporary, the latter as essential and permanent. The Neo-Impressionists, he stated, had at first tried to draw attention to the class struggle through the visual discovery of industrial work as spectacle, and "above all" through portraying the kinds of proletarian pleasure that are only industrial work in another guise: in Seurat's *La Parade* [1889] for example, the joyless and sinister come-on for Ferdinand Corvi's down-at-heels circus, or in the Pavlovian smile of the music-hall patron who anchors the mechanical upward thrust of the dancers in *Le Chahut* [1890].[6] As Signac expressed it:

> with their synthetic representation of the pleasures
> of decadence: dancing places, music halls, circuses,
> like those provided by the painter Seurat, who had
> such a vivid feeling for the degradation of our epoch
> of transition, they bear witness to the great social
> trial taking place between workers and Capital.[7]

But this tactic was to be no more permanent than the impulse that in 1890 sent optical theorist Charles Henry, armed with Signac's posters and charts, off to impart avant-garde ideas about color to the furniture workers of the Faubourg Saint-Antoine.[8] The continuing oppositional character of Neo-Impressionist painting does not derive, the artist was quick to say, from those earlier, keen perceptions of the injuries of social class; instead, it consisted in an aesthetic developed in their making, one that now can be applied to any subject whatever. The liberated sensibility of the avant-gardist would stand as an implicit exemplar of revolutionary possibility, and the artist would most effectively perform this function by concentration on the self-contained demands of his medium. Signac refused any demand that his group continue

> a precise socialist direction in works of art, because
> this direction is encountered much more strongly
> among the pure aesthetes, revolutionaries by temper-
> ament, who, striking away from the beaten paths,

paint what they see, as they feel it, and very often
unconsciously supply a solid axe-blow to the creaking
social edifice.[9]

Four years later, he summed up the progress of Neo-
Impressionism in a pithy sentence: "We are emerging from
the hard and useful period of analysis, where all our studies
resembled one another, and entering that of varied and
personal creation."[10] By this time Signac and his followers
had left behind the subjects and people of the Parisian
industrial suburbs for the scenic pleasures of the Côte d'Azur.

For both these writers the relationship between pain-
ting and the ordinary diversions of urban life moved from
wary identity to determined difference. At the beginning,
"rudely thrown, at the close of an epoch of dreams, in
the front of reality," as Mallarmé put it, vernacular culture
provided by default the artist's only apparent grasp on
modernity. Even this notoriously hermetic and withdrawn
poet, like the anarchist-socialist Signac, held that the
advanced artist was necessarily allied with the lower classes
in their struggle for political recognition: "The multitude
demands to see with its own eyes ... the transition from
the old imaginative artist and dreamer to the energetic
modern worker is found in Impressionism."[11] But it went
without saying, for both, that emancipated vision would
not come from imitating the degraded habits induced in the
multitude by its currently favored amusements. Mass
political emancipation occasioned a "parallel" search in
the arts—now, thanks to politics, rid of an oppressive,
authoritarian tradition—for ideal origins and purified
practice. The alliance between the avant-garde and popular
experience remained in place, but came to be expressed
in negative terms.

The self-conscious theories of modernism formulated
in the 20th century ratified this position and made its terms
explicit. In an essay that stands as one of Clement Greenberg's
most complete statements of formal method, "Collage"
of 1959, he put the "intruder objects" of Cubist *papiers collés*
firmly in their place.[12] He belittled the view of some early
commentators, like Guillaume Apollinaire and Daniel-Henry
Kahnweiler, that the technique represented a renewed
vision outward, its disruptions sparking attention to a

"new world of beauty" dormant in the littered commercial landscape of wall posters, shop windows, and business signs:

> The writers who have tried to explain their intentions for them speak, with a unanimity that is suspect in itself, of the need for renewed contact with "reality" [but] even if these materials were more "real," the question would still be begged, for "reality" would still explain next to nothing about the actual appearance of Cubist collage.[13]

The word "reality" stands in this passage for any independent significance the bits of newspaper or wood grain might retain once inserted into the Cubist pictorial matrix. Nowhere in the essay is this even admitted as an interpretative possibility. Collage is entirely subsumed within a self-sufficient dialogue between the flat plane and sculptural effect, the artist's worry over the problem of representation in general precluding representation in the particular. Thus, as the theory of modernism took on independent life, the dislodged bits of commercial culture came to appear, even more drastically, as the means to an end.

The testimony of the most articulate modernists would appear thoroughly to deny that debts to the vernacular in advanced art pose any particular problem—or perhaps to indicate that its solution must be pursued in another critical language entirely. Certainly, to the many partisans of a postmodernist present, who dismiss Greenberg's model as an arbitrary and arid teleology, it would appear foolish to look to the theory of modernism for any help whatsoever on this issue. Avant-garde borrowing from below necessarily involves questions of heterogeneous cultural practice, of transgressing limits and boundaries. The postmodernists, who celebrate heterogeneity and transgression, find modernist self-understanding utterly closed to anything but purity and truth to media.[14]

The critique of Greenbergian modernism is now well advanced, and its defenders are scarce. His present-day detractors have found their best ammunition in the prescriptive outcome of his analysis as it congealed after 1950. But the later Greenberg has thereby come to obscure the earlier and more vital thinker, his eventual modernist triumphalism

pushing aside the initial logic of his criticism and the particular urgency that prompted it. His first efforts as a critic in fact offered an explanation for the enforcement of cultural hierarchy as carried out by a Mallarmé or a Signac. At that point he was able to place the idealism of the former's mirror of painting and the latter's liberated consciousness in an historically analytical frame.

What worried Greenberg most in 1939 was not the picture plane. The founding essay of his enterprise as a critic, "Avant-Garde and Kitsch," begins with a flat rejection of the limited frame of formal aesthetics: "It appears to me it is necessary to examine more closely and with more originality than hitherto the relationship between aesthetic experience as met by the specific—not the generalized— individual, and the social and historical contexts in which that experience takes place."[15] This preamble was mildly stated but deeply meant; what was occupying his attention was nothing less than a material and social crisis that threatened the traditional forms of 19th-century culture with extinction. This crisis had resulted from the economic pressure of an industry devoted to the simulation of art in the form of reproducible cultural commodities, that is to say, the industry of mass culture. In search of raw material, mass culture had progressively stripped traditional art of its marketable qualities, and had left as the only remaining path to authenticity a ceaseless alertness against the stereotyped and pre-processed. By refusing any other demands but the most self-contained technical ones, the authentic artist could protect his or her work from the reproduction and rationalization that would process its usable bits and destroy its inner logic. From this resistance came the necessity for modernism's inwardness, self-reflexivity, "truth to media."

Greenberg made this plain in "Towards a Newer Laocoon," [1940] the essay in which he drew out the largely unstated aesthetic implications of "Avant-Garde and Kitsch." "The arts, then," he stated, "have been hunted back to their mediums, and there they have been isolated, concentrated and defined ... To restore the identity of an art, the opacity of the medium must be emphasized."[16] This conclusion was provisional and even reluctant, its tone far removed from the complacency of his later criticism. The formative theoretical moment in the history of modernism

in the visual arts was inseparably an effort to come to terms
with cultural production as a whole under the conditions of
consumer capitalism. Because of this—and only because
of this—it was able temporarily to surpass the idealism of
the ideologies generated within the avant-garde, an idealism
to which it soon tacitly succumbed. In Greenberg's early
analysis, mass culture is never left behind in modernist
practice, but persists as a constant pressure on the artist,
which severely restricts creative "freedom." "Quality," it is
true, remained in his eyes exclusively with the remnant
of traditional high culture, but mass culture was prior and
determining: modernism was its effect.

　　While interdependence between high and low lay at
the heart of his theory, Greenberg nevertheless could admit
no positive interdependence between the two spheres because
of the rigid distinction he drew between popular culture and
the modern phenomenon of kitsch. The former was for him
inseparable from some integrated community comparable to
the kind that sustained traditional high art; the latter was
peculiarly modern, a product of rural migration to the cities
and the immigrants' eager abandonment of the folk culture
they brought with them. Expanded literacy and the demarca-
tion of assigned leisure outside the hours of work, with the
promise of heightened diversion and pleasure within that
leisure time, set up pressure for a simulated culture adapted
to the needs of this new clientele. Kitsch had emerged to fill
a vacuum; the regimented urban worker, whether in factory
or office, came to compensate for the surrender of personal
autonomy through an intense development of the time left
over, transferring the search for individual identity into the
symbolic and affective experiences now defined as specific to
leisure. But because the ultimate logic of this re-creation
(the hyphen restoring the root meaning of the term) was the
rationalized efficiency of the system as a whole, these needs
were met by the same means as material ones: by culture
recast as reproducible commodities. Among those of his
contemporaries whose cultural horizons were limited to
kitsch, Greenberg saw subjectivity as mirrored and trapped
in the lifeless logic of mass production: imagining, thinking,
feeling all performed by the machine long before the indi-
vidual consumer encountered its products in the tabloids,
pop tunes, pulp novels, and melodramas of stage and film.

For this reason, the artist—in any genuine sense of
the term—could expect no audience outside those cultivated
members of the privileged classes who maintain in their
patronage a pre-modern independence of taste. He could
state categorically,

> The masses have always remained more or less
> indifferent to culture in the process of development
> … No culture can develop without a social basis,
> without a source of stable income. And in the case
> of the avant-garde, this was provided by an elite
> among the ruling class of that society from which it
> assumed itself to be cut off, but to which it has always
> remained attached by an umbilical cord of gold. [17]

In light of this analysis, it is not surprising that he should
have posited the relationship between modernism and mass
culture as one of relentless refusal. The problem remained,
however, that the elite audience for modernism endorsed, in
every respect but its art, the social order responsible for the
crisis of culture. The implicit contention of early modernist
theory—and the name of T.W. Adorno for modern music
can be joined to that of Greenberg for the visual arts—was
that the contradiction between an oppositional art and a
public with appetite for no other kind of opposition could
be bracketed off, if not transcended, in the rigor of austere,
autonomous practice.

If the art of Manet is taken to mark the beginning of modern-
ism, it would be hard not to admit the general accuracy of
Greenberg's attachment to an elite. The impulse that moved
Signac momentarily to make an audience of Parisian furni-
ture workers stands out in its extreme rarity in the history of
the avant-garde. The fleetingness of those efforts in Berlin,
Cologne, or Vitebsk after World War I to redefine avant-garde
liberation in working-class terms tells the same story. But
oppositional art did not begin with Manet and did not, before
him, always opt for detachment.

The two artists together most responsible for defining
advanced art in terms of opposition to established conven-
tion, making painting a scene of dispute over the meaning of
high culture, were Jacques-Louis David and Gustave Courbet;

and the art of each, at least in the critical moments of 1785 and 1850, was about a redefinition of publics. The formal qualities that are rightly seen as anticipating fully fledged modernism—the dramatic defiance of academic compositional rules, technical parsimony, and compressed dissonance in the *Oath of the Horatii* [1784] or the *Burial at Ornans* [1849–1850]—were carried forward in the name of another public, excluded outsiders, whose characteristic means of expression these pictures managed to address. In the process, "Rome" or "the countryside" as privileged symbols in a conflict of social values were turned over to the outsiders. The antagonistic character of these pictures can thus be read as duplicating real antagonisms present within the audience assembled at the public exhibitions. Already perceived oppositions of style and visual language, drawn from the world outside painting, were thrust into the space of art and put to work in a real interplay of publics. The appeal of each artist to the excluded group was validated by the hostility exhibited by the established, high-minded art public; that hostility was redoubled by the positive response of the illegitimate public; and so on in a self-reinforcing way.[18]

But with the installation of oppositional art within a permanent avant-garde, that group itself comes to replace the oppositional public precariously mobilized by David or Courbet; antagonism is abstracted and generalized; and only then does dependence on an elite audience and luxury-trade consumption become a given. One writer of Greenberg's generation, rather than bracketing off this dependence, made it central to his analysis: this was Meyer Schapiro. In his little-known but fundamental essay of 1936, "The Social Bases of Art," and in "The Nature of Abstract Art," published the following year in the independent *Marxist Quarterly*, he argued in an original and powerful way that the avant-garde had habitually based its model of artistic freedom on the aimlessness of the middle-class consumer of packaged diversion.[19] The complicity between modernism and the consumer society is clearly to be read, he maintained, in Impressionist painting:

> It is remarkable how many pictures we have in early
> Impressionism of informal and spontaneous sociability,
> of breakfasts, picnics, promenades, boating trips,

holidays, and vacation travel. These urban idylls
not only present the objective forms of bourgeois
recreation in the 1860s and 1870s; they also reflect
in the very choice of subjects and in the new aesthetic
devices the conception of art solely as a field of
individual enjoyment, without reference to ideas and
motives, and they presuppose the cultivation of these
pleasures as the highest field of freedom for an
enlightened bourgeois detached from the official
beliefs of his class. In enjoying realistic pictures of his
surroundings as a spectacle of traffic and changing
atmospheres, the cultivated rentier was experiencing
in its phenomenal aspect that mobility of the envi-
ronment, the market, and of industry to which he
owed his income and his freedom. And in the new
Impressionist techniques which broke things up into
finely discriminated points of color, as well as in the
"accidental" momentary vision, he found, in a degree
hitherto unknown in art, conditions of sensibility
closely related to those of the urban promenader
and the refined consumer of luxury goods.[20]

Schapiro's contention was that the advanced artist, after
1860 or so, succumbed to the general division of labor as a
full-time leisure specialist, an aesthetic technician picturing
and prodding the sensual expectations of other, part-time
consumers. The above passage is taken from the 1937 essay;
in its predecessor Schapiro offered an extraordinary thematic
summation of modernism in a single paragraph, one in which
its progress is logically linked to Impressionism's initial alliance
with the emerging forms of mass culture. In the hands of the
avant-garde, he argued, the aesthetic itself became identified
with habits of enjoyment and release produced quite con-
cretely within the existing apparatus of commercial enter-
tainment and tourism—even, and perhaps most of all, when
art appeared entirely withdrawn into its own sphere, its
own sensibility, its own medium. If only because of the
undeserved obscurity of the text, it is worth quoting at length:

Although painters will say again and again that content
doesn't matter, they are curiously selective in their
subjects. They paint only certain themes and only in a

certain aspect ... First, there are natural spectacles, landscapes, or city scenes, regarded from the point of view of a relaxed spectator, a vacationist, or a sportsman, who values the landscape chiefly as a source of agreeable sensations or mood; artificial spectacles and entertainments—the theater, the circus, the horse race, the athletic field, the music hall—or even works of painting, sculpture, architecture, or technology, experienced as spectacle or objects of art ... symbols of the artist's activity, individuals practicing other arts, rehearsing, or in their privacy; instruments of art, especially of music, which suggest an abstract art and improvisation; isolated intimate fields, like a table covered with private instruments of idle sensation, drinking glasses, a pipe, playing cards, books, all objects of manipulation, referring to an exclusive, private world in which the individual is immobile, but free to enjoy his own moods and self-stimulation. And finally, there are pictures in which the elements of professional artistic discrimination, present to some degree in all painting—the lines, spots of color, areas, textures, modeling—are disengaged from things and juxtaposed as "pure" aesthetic objects.[21]

Schapiro would one day become a renowned and powerful apologist for the avant-garde, but his initial contribution to the debate over modernism and mass culture squarely opposed Greenberg's conclusions of a few years later: the 1936 essay was, in fact, a forthright anti-modernist polemic, an effort to demonstrate that the avant-garde's claims to independence, to disengagement from the values of its patron class were a sham; "in a society where all men can be free individuals," he concluded, "individuality must lose its exclusiveness and its ruthless and perverse character."[22] The social analysis underlying that polemic, however, was almost identical to Greenberg's. Both saw the modern marketing of culture as the negation of the real thing, that is, the rich and coherent symbolic dimension of collective life in earlier times; both believed that the apparent variety and allure of the modern urban spectacle disguised the "ruthless and perverse" laws of capital; both posited modernist art as a

direct response to that condition, one that would remain in
force until a new, socialist society was achieved.[23] Given
these basic points of agreement and the fact that both men
were operating in the same intellectual and political milieu,
how can the extent of their differences be explained?

One determining difference between the two theorists
lay in the specificity of their respective understandings
of mass culture: though the analysis of each was summary
in character, Greenberg's was the more schematic. His use
of the term "kitsch" encompassed practically the entire
range of consumable culture, from the crassest proletarian
entertainments to the genteel academicism of much "serious"
art: "all kitsch is academic; and conversely, all that's academic
is kitsch," was Greenberg's view in a pithy sentence.[24]
Schapiro, on the other hand, was less interested in the
congealed, inauthentic character of cultural commodities
taken by themselves than he was in behavior: what, he asked,
were the characteristic forms of experience induced by
these commodities? In his discussion of Impressionism, this
line of inquiry led him to the historically accurate perception
that the people with the time and money able fully to occupy
the new spaces of urban leisure were primarily middle class.
The weekend resorts and *grands boulevards* were, at first,
places given over to the conspicuous display of a brand of
individual autonomy specific to that class. The correct
clothes and accessories were required, as well as the correct
poses and attitudes. The new department stores, like
Boucicaut's Au Bon Marché, grew spectacularly by supplying
the necessary material equipment and, by their practices of
sales and promotion, effective instruction in
the more intangible requirements of this sphere of life. The
economic barriers were enough, in the 1860s and 1870s,
to ward off the incursion of other classes of consumer. Even
such typically working-class diversions of the present day
as soccer and bicycle racing (Manet planned a large canvas
on the latter subject in 1870) began in this period as
enthusiasms of the affluent.[25]

In Schapiro's eyes, the avant-garde merely followed a
decentering of individual life, which overtook the middle
class as a whole. It was, for him, entirely appropriate that the
formation of Impressionism should coincide with the
Second Empire, that is, the period when acquiescence to

political authoritarianism was followed by the first spectacu-
lar flowering of the consumer society. The self-liquidation
after 1848 of the classical form of middle-class political cult-
ure prompted a displacement of traditional ideals of individual
autonomy into spaces outside the official institutions of
society, spaces where conspicuous styles of "freedom" were
made available. That shift was bound up with the increasingly
sophisticated engineering of mass consumption, the internal
conquest of markets, required for continuous economic
expansion. The department store, which assumed a position
somewhere between encyclopedia and ritual temple of
consumption, is the appropriate symbol for the era. It served
as one of the primary means by which a middle-class public,
often deeply unsettled by the dislocations in its older
patterns of life, was won over to the new order being wrought
in its name.[26]

These early essays of Greenberg and Schapiro, which
took as their common subject the sacrifice of the best
elements in bourgeois culture to economic expediency, were
both visibly marked by the classic interpretation of the 1848–
1851 crisis in France: that of Marx in *The Eighteenth Brumaire
of Louis Bonaparte*.[27] There Marx described the way in which
the forcible exclusion of oppositional groups from the
political process necessitated a kind of cultural suicide on
the part of the propertied republicans, a willed destruction
of their own optimal institutions, values, and expressive
forms:

> While the parliamentary party of Order, by its clamor
> for tranquility, as I have shown, committed itself
> to quiescence, while it declared the political rule of
> the bourgeoisie to be incompatible with the safety
> and existence of the bourgeoisie, by destroying with
> its own hands in the struggle against other classes
> in society all the conditions for its own regime, the
> parliamentary regime, the extra-parliamentary mass
> of the bourgeoisie, on the other hand, by its servility
> toward the President, by its vilification of parliament,
> by its brutal treatment of its own press, invited
> Bonaparte to suppress and annihilate its speaking and
> writing section, its politicians and its literati, its
> platform and its press, in order that it might be able

to pursue its private affairs with full confidence in the protection of a strong and unrestricted government. It declared unequivocally that it longed to get rid of its own political rule in order to get rid of the troubles and dangers of ruling.[28]

When Schapiro spoke of the "enlightened bourgeois detached from the official beliefs of his class," he sought to go a step beyond Marx, to describe the concrete activities through which that detachment was manifested. Out of the desolation of early 19th-century forms of collective life, which affected all classes of the city, adventurous members of the privileged classes led the way in colonizing the one remaining domain of relative freedom: the spaces of public leisure. There, suppressed community was displaced and dispersed into isolated acts of individual consumption; but those acts could in turn coalesce into characteristic group styles. Within leisure, a sense of solidarity could be recaptured, at least temporarily, in which individuality was made to appear embedded in group life: the community of fans, aficionados, supporters, sportsmen, experts. Lost possibilities of individual effectiveness within the larger social order were re-presented as a catalogue of leisure-time roles. Another contributor to this extraordinary theoretical moment of the later 1930s, Walter Benjamin, made this point plainly in his study of Baudelaire and Second-Empire Paris. Speaking of the privileged class to which the poet belonged, he wrote:

> The very fact that their share could at best be enjoyment, but never power, made the period which history gave them a space for passing time. Anyone who sets out to while away time seeks enjoyment. It was self-evident, however, that the more this class wanted to have its enjoyment in this society, the more limited this enjoyment would be. The enjoyment promised to be less limited if this class found enjoyment of this society possible. If it wanted to achieve virtuosity in this kind of enjoyment, it could not spurn empathizing with commodities. It had to enjoy this identification with all the pleasure and uneasiness that derived from a presentiment of its destiny as a class. Finally, it had to approach this destiny with a

sensitivity that perceives charm even in damaged and
decaying goods. Baudelaire, who in a poem to a
courtesan called her heart "bruised like a peach, ripe
like her body, for the lore of love," possessed this
sensitivity. To it he owed his enjoyment of this society
as one who had already half withdrawn from it.[29]

In his draft introduction to the never-completed Baudelaire
project, Benjamin wrote, "In point of fact, the theory of *l'art
pour l'art* assumes decisive importance around 1852, at a time
when the bourgeoisie sought to take its 'cause' from the
hands of the writers and poets."[30] In *The Eighteenth Brumaire*
Marx recollects this moment ... Modernism, in the conven-
tional sense of the term, begins in the forced marginalization
of the artistic vocation. And what Benjamin says of literature
applies as well, if not better, to the visual arts. The avant-
garde left behind the older concerns of official public art not
out of any special rebelliousness on the part of its members,
but because their political representatives had jettisoned
as dangerous and obstructive the institutions and ideals
for which official art was metaphorically to stand. David's
public, to cite the obvious contrasting case, had found
in his pictures of the 1780s a way imaginatively to align itself
with novel and pressing demands of public life; his *Horatii*
and *Brutus* resonated as vivid tracts on individual resolve,
collective action, and their price. Oppositional art meant
opposition on a broad social front. Until 1848, there was at
least a latent potential for a middle-class political vanguard
to act on its discontent, and an oppositional public painting
maintained itself in reserve. This was literally the case with
the most powerful attempt to duplicate David's early tactics,
Géricault's *Raft of the Medusa* (1818–1819), which failed to find
an oppositional public in the politically bleak atmosphere
of 1819.[31] But when the Revolution of 1830 roused Delacroix
from his obsession with individual victimization and sexual
violence, he reached back to his mentor's great prototype.
The barricade in his *Liberty Leading the People*, heaving up in
the foreground, is the raft turned ninety degrees; the bodies
tumble off its leading rather than trailing edge (Delacroix
shifts the sprawling, bare-legged corpse more or less intact
from the right corner to the left, precisely marking the way
he has transposed his model); the straining pyramid of

figures now pushes toward the viewer rather than away. In the first days of 1848 the republican Michelet employed the Géricault painting in his oratory as a rallying metaphor for national resistance. And after the February uprising, *Liberty* emerged briefly from its captivity in the store-rooms.[32]

The events of 1851 ended all this, denying, as they did, any ambition Courbet had entertained to shift the address of history painting to a new outsider public, an opposition based in the working classes. For a middle-class audience, the idea of a combative and singular individuality, impatient with social confinement, remained fundamental to a generally internalized sense of self—as it still does. But that notion of individuality would henceforth be realized in private acts of self-estrangement, distancing and blocking out the gray realities of administration and production in favor of a brighter world of sport, tourism, and spectacle. This process was redoubled in the fierce repression that followed the uprising of the Commune 20 years later; between 1871 and 1876, the heyday of Impressionist formal innovation, Paris remained under martial law.

If the subjective experience of freedom became a function of a supplied identity, one detached from the social mechanism and contemplating it from a distance, then the early modernist painters—as Schapiro trenchantly observed in 1936—lived that role to the hilt. That observation might well have led to a dismissal of all avant-garde claims to a critical and independent stance as so much false consciousness (as it does for some today). But in his essay of the following year, Schapiro himself came to resist such a facile conclusion. The basic argument remained in place, but "The Nature of Abstract Art" deploys without irony terms like "implicit criticism" and "freedom" to describe modernist painting. Of the early avant-garde, he wrote,

> The very existence of Impressionism which trans-
> formed nature into a private, unformalized field
> of sensitive vision, shifting with the spectator, made
> painting an ideal domain of freedom; it attracted
> many who were tied unhappily to middle-class jobs
> and moral standards, now increasingly problematic
> and stultifying with the advance of monopoly

capitalism ... in its discovery of a constantly changing phenomenal outdoor world of which the shapes depended on the momentary position of the casual or mobile spectator, there was an implicit criticism of symbolic and domestic formalities, or at least a norm opposed to these.[33]

Added here was a recognition of some degree of active, resistant consciousness within the avant-garde. And this extended to his valuation of middle-class leisure as well. He spoke of an Impressionist "discovery" of an implicitly critical, even moral, point of view. This critical art had not been secured through withdrawal into self-sufficiency, but had instead been grounded in existing social life outside the sphere of art.

Schapiro created a deliberate ambiguity in the second essay, in that it offered a qualified apology for modernism without renouncing his prior dismissal of the reigning modernist apologetics.[34] "The Nature of Abstract Art" is an inconclusive, "open" text, and it is just this quality, its unresolved oscillation between negative and affirmative positions, that makes it so valuable.[35] By 1937 Schapiro had ceased to identify the avant-garde with the outlook of a homogeneous "dominant" class. So, while Impressionism did indeed belong to and figured a world of privilege, there was, nevertheless, disaffection and erosion of consensus within that world. The society of consumption as a means of engineering political consent and socially integrative codes is no simple or uncontested solution to the "problem of culture" under capitalism. As it displaces resistant impulses, it also gives them a refuge in a relatively unregulated social space where contrary social definitions can survive, and occasionally flourish. Much of this is, obviously, permitted disorder: managed consensus depends on a compensating balance between submission and negotiated resistance within leisure. But once that zone of permitted freedom exists, it can be seized by disaffected groups in order to articulate for themselves a counter-consensual identity, an implicit message of rupture and discontinuity. From the official point of view, these groups are defined as deviant or delinquent; following contemporary sociological usage, they can be called resistant subcultures.[36]

In one of the founding formulations of cultural studies, Stuart Hall and Tony Jefferson set out the traits of such subcultures in a way that can serve with little modification to characterize the early avant-garde as a social formation:

> They cluster around particular locations. They develop specific rhythms of interchange, structured relations between members: younger to older, experienced to novice, stylish to square. They explore "focal concerns" central to the inner life of the group: things always "done" or "never done," a set of social rituals which underpin their collective identity and define them as a "group" instead of a mere collection of individuals. They adopt and adapt material objects—goods and possessions—and reorganize them into distinctive "styles" which express the collectivity of their being-as-a-group. These concerns, activities, relationships, materials become embodied in rituals of relationship and occasion and movement. Sometimes, the world is marked out, linguistically, by names or an argot, which classifies the social world exterior to them in terms meaningful only within their group perspective, and maintains its boundaries. This also helps them to develop, ahead of immediate activities, a perspective on the immediate future—plans, projects, things to do to fill out time, exploits ... They too are concrete, identifiable social formations constructed as a collective response to the material and situated experience of their class.[37]

To make the meaning of that last sentence more precise, the resistant subcultural response is a means by which certain members of a class "handle" and attempt to resolve difficult and contradictory experience common to their class but felt more acutely by the subcultural recruits.

It was the work of community activist Phil Cohen (now scandalously unrecognized in the ascendancy of cultural studies as a field) that made the breakthrough, joining an empirical sociology of deviance to systematic visual aesthetics. No one before him had seen past the stereotypes of adolescent deviance even to think that the menacing particulars of the original skinhead style in London's East

End—the boots and braces, the shaved scalps and selective racial marauding—might reward the sort of interpretation practiced by art-historical iconographers. What he found was a precisely coded response to the changes in the city's economy and land use that had eroded beyond recovery the neighborhood life that the skinheads' parents had known. Where the mods of the 1960s had articulated—through sharp, Italian-style suits and gleaming Vespas—an imaginary relation to the closed option of upward mobility, the skinheads turned around and fashioned a similarly imaginary relation to the downward option of rough manual labor, an identity that had become equally inaccessible to them in the wake of the closing of the East End's docks and industries. An imaginary belonging to a lost local culture, a refusal to assent to fraudulent substitutes for community, were figured in the dress, speech, and rituals of enforced idleness that so alarmed outsiders.

Though this in no way redeemed the racism, ignorance, and apathy on view, what Cohen decoded at least amounted to an eloquence in choices of style and imagery. Battered and marginalized by economic rationalizations, working-class community could only be recovered as an imaginary solution in the realm of style, one limited further to the temporary, inherently ambiguous phase of "youth." Cohen's stress on the symbolic and compensatory rather than activist function of subcultures, along with the shift from blocked verbal facility to high competence in visual discrimination, fits the pattern of the early artistic avant-garde movements just as well.[38] By the later 19th century, an artistic vocation, in the sense established by David, Goya, Géricault, Delacroix, or Courbet had become so problematic as to require similar defense. With the emergence of a persistent avant-garde, a small, face-to-face group of artists and supporters became their own oppositional public, one socially grounded within structured leisure. The distinctive point of view and iconographic markers of the subculture came to be drawn from a repertoire of objects, locations, and behaviors supplied by other colonists of the same social spaces; avant-garde opposition was and is drawn out of inarticulate and unresolved dissatisfactions which those spaces, though designed to contain them, also put on display.

At this point, clearer distinctions need to be drawn between kinds of subcultural response. There are those that are no more than the temporary outlet of the ordinary citizen; there are those that are merely defensive, in that the group style they embody, though it may be central to the social life of its members, registers externally only as a harmless, perhaps colorful enthusiasm. But the stylistic and behavioral maneuvers of certain subcultures will transgress settled social boundaries. From the outside, these will be read as extreme, opaque, inexplicably evasive and, for that reason, hostile. The dependable negative reaction from figures in authority and the semi-official guardians of propriety and morality will then further sharpen the negative identity of the subculture, help cement group solidarity, and often stimulate new adherents and imitators.

The required boundary transgression can occur in several ways. Where different classes meet in leisure-time settings, objects, styles, and behaviors with an established significance for one class identity can be appropriated and repositioned by another group to generate new, dissonant meanings. This shifting of signs can occur in both directions on the social scale (or scales). Another means to counter-consensual group statement is to isolate one element of the normal pattern of leisure consumption, and then exaggerate and intensify its use until it comes to signify the opposite of its intended meaning.

It is easy to think of examples of such semiotic tactics in present-day subcultures; our model of subversive consumption is derived from the analysis of these deviant groups. But the same tactics can just as easily be seen at work in the early avant-garde, where a dissonant mixing of class signifiers was central to the formation of the avant-garde sensibility. Courbet's prescient excursion into suburban pleasure for sale, the *Young Ladies on the Banks of the Seine* of 1856, showed two drowsing prostitutes in the intimate finery of their betters, piled on past all "correct" usage of fashionable underclothing.[39] And Manet would exploit similar kinds of dissonance in the next decade. It showed up in his own body; his friend and biographer Antonin Proust speaks of his habitual imitation of the speech patterns and peculiar gait of a Parisian street urchin.[40] The subject of both the *Déjeuner sur l'herbe* and *Olympia* is the

pursuit of commercial pleasure at a comparably early stage
when it necessarily involved negotiation with older, illicit
social networks at the frontier between legality
and criminality.[41]

Establishing itself where Courbet and Manet had led,
"classic" Impressionism, the sensually flooded depictions
of weekend leisure in which Monet and Renoir specialized
during the 1870s, opted for the second tactic. The life
they portray was being lived entirely within the confines
of real-estate development and entrepreneurial capitalism;
these are images of provided pleasures. But they are images
that alter, by the very exclusivity of their concentration
on ease and uncoerced activity, the balance between
the regulated and unregulated compartments of experience.
They take leisure out of its place; instead of appearing
as a controlled, compensatory feature of the modern social
mechanism, securely framed by other institutions, it stands
out in unrelieved difference from the denial of freedom
that surrounds it.

It is in this sense that Schapiro could plausibly speak
of Impressionism's "implicit criticism of symbolic and
domestic formalities, or at least a norm opposed to these."
But what Schapiro did not address was how this criticism
came to be specifically articulated as criticism: a difference
is not an opposition unless it is consistently legible as such.
This raises once again the question of modernism in its
conventional aesthetic sense—as autonomous, self-critical
form. The "focal concern" of the avant-garde subculture
was, obviously, painting conceived in the most ambitious
terms available. It was in its particular opposition to the
settled discourse of high art that the central avant-garde
group style gained its cogency and its point. They were able
to take their nearly total identification with the uses of
leisure and make that move count in another, major arena,
where official beliefs in cultural stability were particularly
vulnerable. The *grands boulevards* and suburban regattas
may have provided the solution, but the problem had been
established elsewhere: in the hollowing out of artistic
tradition by academic eclecticism, pastiche, the manipulative
reaching for canned effects, all the played-out maneuvers
of Salon kitsch. Almost every conventional order, technique,
and motif that had made painting possible in the past had, by

this point, been fatally appropriated and compromised by a decayed academicism. And this presented immediate, practical difficulties for the fundamental process of making pictures: how do you compose, that is, construct, a pictorial order of evident coherence, without resorting to any pre-fabricated solutions? The unavailability of those solutions inevitably placed the greatest emphasis—and burden— on those elements of picture-making that seemed unmediated and irreducible: the single vivid gesture of the hand by which a single visual sensation is registered. As tonal relationships belonged to the rhetoric of the schools—rote procedures of drawing, modeling, and chiaroscuro—these gestural notations would be of pure, saturated color.

The daunting formal problematic that resulted was this: how to build from the independent gesture or touch some stable, overarching structure which fulfilled two essential requirements: firstly, it had to be constructed only from an accumulation of single touches and could not appear to subordinate immediate sensation to another system of cognition; and, at the same time, it had to close off the internal system of the picture and invest each touch with consistent descriptive sense in relation to every other touch. Without the latter, painting would have remained literally pre-artistic, an arbitrary section out of an undiffer-entiated field of minute, equivalent, and competing stimuli. Impressionism, quite obviously, found ways around this impasse, discovered a number of improvised, ingenious devices for making its colored touches jell into a graspable order: disguised compositional grids, sophisticated play within the picture between kinds of notation and levels of descriptive specificity, motif selection in which the solidity of larger forms is inherently obscured, and, finally, the fabrication of the picture surface into a tangibly constructed wall or woven tissue of pigment. The persuasiveness of these solutions, however, depended to a great degree on the built-in orders of the places they painted. The aquatic resort or dazzling shopping street offered "reality" as a collection of uncomposed and disconnected surface sensations. The disjunction of sensation from judgment was not the invention of artists, but had been contrived by the emerging leisure industry to appear as the more natural and liberated moment of individual life. The structural demarcation of leisure

within the capitalist economy provided the invisible frame that made that distracted experience cohere as the image of pleasure.

The most provocative and distinctive pictorial qualities of early modernism were not only justified by formal homologies with its subject matter as an already created image, they also served to defend that image by preserving it from inappropriate kinds of attention. So that the promises of leisure would not be tested against too much contrary visual evidence—not only dissonant features of the landscape, like the prominent factories of Argenteuil, but also the all-too-frequent failure of the promise of happiness—the painters consistently fixed on optical phenomena that are virtually unrepresentable: rushing shoppers glimpsed from above and far away, the disorienting confusion of the crowded café-concert, smoke and steam in the mottled light of the glass-roofed railway station, wind in foliage, flickering shadows, and, above all, reflections in moving water. These phenomena have become, thanks largely to Impressionism, conventional signs of the spaces of leisure and tourism, of their promised vividness and perpetual surprise, but as optical "facts" they are so changeable or indistinct that one cannot really hold them in mind and preserve them as a mental picture; and therefore one cannot securely test the painter's version against remembered visual experience. The inevitably approximate and unverifiable registration of these visual ephemera in painting makes large areas of the canvas less descriptive than celebratory of gesture, color, and shape—pictorial incidents attended to for their own sake.

The passage from deliberate evasiveness and opacity to insistence on material surface—to modernist abstraction, in short—has been admirably articulated in an essay on Monet by the novelist Michel Butor (in effect taking up the matter where Mallarmé had left it a century before). Speaking of *Regattas at Argenteuil* of 1872, a picture dominated by broadly rendered reflections of sailboats and shoreline villas, he writes,

> It is impossible to interpret the reflected part as the simple notation of what lay before the painter's eyes. How can one suppose that Monet would have chosen any one of the millions of images that the camera

might have registered? He constructed an image, animated by a certain rhythm, which we may imagine as conforming to that of the liquid surface (yet there is nothing to confirm even this), based on real objects.

The semantic relation of above and below obviously works in both directions: a) the upper names the lower: this aggregate of blotches which means nothing to you is a tree, a house, a boat; b) the lower reveals the upper: this boat, this house, which may seem dull to you contains secret congruences of color, elementary images, expressive possibilities.

The upper part corresponds to what one recognizes, the reality one is used to; the lower, which leads us toward the houses and boats, corresponds to the painter's act. The water becomes a metaphor for painting. The very broad strokes with which these reflections are indicated are vigorous assertions of material and means. The liquid surface provides an instance in nature of the painter's activity.[42]

Monet used the artifice of painting to make his scene better, more congruent and formally satisfying, than it could ever be in life. Impressionism's transformation of leisure into an obsessive and exclusive value, its inversion of the intended social significance of its material, necessitated special painterly means, which in turn inverted the intended social significance of its medium.

Nineteenth-century high culture was nothing if it did not embody the permanent, indisputable, and ideal; the avant-garde appropriated the form of high art in the name of the contingent, unstable, and material. To accept modernism's oppositional claims, one need not assume that it somehow transcended the culture of the commodity; it can rather be seen as having exploited to critical purpose contradictions within and between distinct sectors of that culture. Validated fine art, the art of the museums, is that special preserve where the commodity character of modern cultural production is sealed off from apprehension. There the aggressively reiterated pretense is that traditional forms have survived unaltered and remain available as an experience outside history. Marginal, leisure-time subcultures perform

more or less the same denial of the commodity, using the objects at their disposal. Lacking legitimating institutions, their transformation of the commodity must be activist and improvisatory: thus, their continual inventiveness in displacing provided cultural goods into new constellations of meaning. The most powerful moments of modernist negation have occurred when the two aesthetic orders, the high-cultural and subcultural, have been forced into scandalous identity, each being continuously dislocated by the other.

The repeated return to mass-cultural material on the part of the avant-garde can be understood as efforts to revive and relive this strategy—each time in a more marginal and refractory leisure location. Seurat, when he conceived *Sunday Afternoon on the Island of the Grande Jatte* as the outsize pendant to his *Bathers at Asnières* in the 1880s, pointedly placed an awkward and routinized bourgeois leisure in another context, that of exhausted but uncontrived working-class time off.[43] His subsequent figure painting, as Signac pointed out, drew upon the tawdriest fringes of Parisian commercial entertainment, the proletarianization of pleasure for both consumer and performer alike. This scene was dissected according to the putatively objective and analytic system of Charles Henry. But according to the first-hand testimony of Emile Verhaeren, Seurat was moved to the artifice and rigidity imposed by Henry's emotional mechanics through identifying an analogous process already at work in his subject.[44] Art historians have long noted the appearance in Seurat's later paintings of the exaggerated angular contours that were the trademark of the poster artist Jules Chéret.[45] As much as the circus or the café-concert, Seurat's material was the advertisement of pleasure, the seductive face it puts on; he spoke of that face in a deferential tone and pushed his formal means in an attempt to master it. As Verhaeren put it: "The poster artist Chéret, whose genius he greatly admired, had charmed him with the joy and gaiety of his designs. He had studied them, wanting to analyze their means of expression and uncover their aesthetic secrets."[46] These last words are significant for the present argument, indicating as they do that the artist begins with an already existing aesthetic developed in the undervalued fringes of culture. In its marginality is its secret allure, one which is not so much the promise of pleasure—

from the evidence, Seurat was cool and critical in his attitude—as the simple existence of a corner of the city that has improvised an appropriate and vivid way to represent itself. The sophisticated and self-conscious artist, intent on controlling the artifice and abstraction that have irrevocably overtaken his art, on keeping it in contact with an appropriate descriptive task, finds subject matter in which this connection has already been made.

Cubism secured its critical character through a repositioning of even more exotically low-brow goods and protocols within the preserve of high art. The iconography of café table and cheap cabaret mark out its milieu with significant precision. The correct brand name on a bottle label was as significant for Picasso and Braque as it had been to Manet in the Bar at the Folies Bergère. The handbills, posters, packs of cigarette papers, department-store advertisements, are disposed in the pictures with conscious regard for the specific associations of each item and the interplay between them. The Cubists proceeded in the manner of mock conspirators, or Poe's sedentary detective Dupin, piecing together evidence of secret pleasures and crimes hidden beneath the apparently trivial surface of the popular media. Picasso for one could also take the measure of rival groups seeking identity in distraction. The provincial and chauvinist *Midi* displayed in his *Aficionado* of 1912 stands in pointed contrast to the idyllic south of France embraced by the established avant-garde. Given the associations of French bullfighting, the figure in the painting—the stuffed shirt in a Nîmes café, arrayed in his shoddy enthusiasm for the second-rate local bullring—stands as an enemy pleasure seeker. In addition to the comedy so apparent to an expert Spanish observer, there is a likely political subtext to the theme, the corrida being traditionally linked to parties of the extreme Right and having served as a rallying point for anti-Dreyfusard agitation in the south.[47]

The principle of collage construction—which entered Cubist practice around the same date as *The Aficionado*—further collapsed the distinction between the masterly and the burlesque, by turning pictorial invention into a fragmented consumption of manufactured images. Collage does its work within the problematic of pictorial modernism, dramatizing the literal support while preserving representation, but it is

a solution discovered in a secretly coded world describable by means of these literal surfaces. And Cubism is readable as a message from the margins not only in the graphic content of the intruder objects, but in their substance and organization as well. The ersatz oilcloth and wallpaper substitutes for solid bourgeois surfaces, supplied originally by Braque from his provincial decorator's repertoire, are determinedly second-rate—in present-day terms, the equivalent of vinyl walnut veneers or petrochemical imitations of silk and suede. As such surfaces soon degrade, peel, flake, and fade, as newsprint and handbills turn brown and brittle, so collage disrupts the false harmonies of oil painting by reproducing the disposability of the most ordinary consumer goods.

> Today, every phenomenon of culture, even if a model of integrity, is liable to be suffocated in the cultivation of kitsch. Yet, paradoxically, in the same epoch it is to works of art that has fallen the burden of wordlessly asserting what is barred to politics ... This is not a time for political art, but politics has migrated into autonomous art, and nowhere more so than where it seems to be politically dead.—T.W. Adorno, 1962[48]

Of the surviving contributors to the theory of modernism and mass culture that coalesced in the 1930s, Adorno alone was able to preserve its original range of reference and intent. One purpose of the present discussion of the avant-garde as a resistant subculture has been to lend historical and sociological substance to Adorno's stance as it pertains to the visual arts. In that light, the formal autonomy achieved in early modernist painting should be understood as a mediated synthesis of possibilities derived from both the failures of existing artistic technique and a repertoire of potentially oppositional practices discovered in the world outside. From the beginning, the successes of modernism have been neither to affirm nor to refuse its concrete position in the social order, but to represent that position in its contradiction, and so act out the possibility of critical consciousness in general. Even Mallarmé, in the middle of his 1876 defense of Impressionism as a pure art of light and air, could speak of it also as an art "which the public, with rare prescience, dubbed, from its first appearance,

intransigent, which in political language means radical and democratic."[49]

In the examples cited above, a regular rhythm emerges within the progress of the Parisian avant-garde. For early Impressionism, early Neo-Impressionism, and Cubism before 1914, the provocative inclusion of materials from outside-validated high culture was linked with a new rigor of formal organization, an articulate consistency of attention within the material fact of the picture surface; joining the two permitted the fine adjustment of this assertive abstraction to the demands of description—not description in the abstract, but of specific enclaves of the commercial city. The avant-garde group enacted this engagement itself, in an intensification of collective cooperation and interchange, individual works of art figuring in a concentrated group dialogue over means and criteria. But in each instance, this moment was followed by retreat—from specific description, from formal rigor, from group life, and from the fringes of commodity culture to its center. And this pattern marks the inherent limitations of the resistant subculture as a solution to the problematic experience of a marginalized and disaffected group.

Monet's painting after the early 1880s can be taken as emblematic of the fate of the Impressionist avant-garde. The problem of verifiable description was relaxed when the artist withdrew to remote or isolated locations to paint: the difficulty of improvising pictorial orders appropriate to a complex and sensually animated form of sociability was obviated by concentration on stable, simplified, and depop-ulated motifs (one knows this is a cathedral, a stack of grain, a row of poplars; the painting does not have to work to convince). In the process, the broad and definite touch of the 1870s, held between structure and description, was replaced by a precious, culinary surface, which largely gives up the job of dramatizing constructive logic. Not coinciden-tally, the 1880s was the period when Monet, thanks to Durand-Ruel's conquest of the American market, achieved secure financial success. Pissarro dismissed it all in 1887 as showy eccentricity of a familiar and marketable kind:

> Monet plays his salesman's game, and it serves him;
> but it is not in my character to do likewise, nor is it in

my interest, and it would be in contradiction above all
to my conception of art. I am not a romantic![50]

Pissarro had by this time thrown in his lot with the Neo-
Impressionists, for whom Monet's "grimacing" spontaneity
was precisely a point at issue. Monet had transformed
Impressionism from a painting about play to a variety of play
in itself (this is the sense in which modernist painting
becomes its own subject matter in a regressive sense). The
Neo-Impressionists moved back to the actual social locations
of play—and once again put squarely in the foreground
the formal problem of single touch/sensation versus larger
governing order. The result of Seurat's laborious method
was drawing and stately composition assertively made out of
color alone. As the group carried on following his premature
death, however, the pointillist touch expanded, became
freer and more expressive in itself, worked with its neighbors
less within finely adjusted relationships of color than as part
of a relaxed, rhythmic animation of flat areas. This "varied
and personal creation," as proclaimed by Signac in 1894,
also entailed a retreat from hard urban subjects in favor of
a repertoire of stock tourist vistas: sunsets, Côte d'Azur
fishing villages, Mont Saint-Michel, Venice. As in the
Impressionism of the 1880s, making the single gesture with
the brush now advertised itself as a kind of play within
an unproblematic playground, provided simultaneously by
motif and picture surface alike.

 This tendency was pushed even further in the hands
of the younger painters soon to be called Fauves. Derain
and Matisse, who came to artistic maturity in the late Neo-
Impressionist milieu in southern France, used the liberated
pointillist gesture as their point of departure. The result was
painting built from loose sprays and spreading patches of
saturated color, the descriptive function of which is casually
loose and unsystematic. Conventionalized landscape motifs
do much of that work and license the free abstraction of
surface effects. Derain's dealer Ambroise Vollard knew his
business when, having in mind the success of Monet's
London pictures of the 1890s, he dispatched the young artist
to England. Derain duly returned with a collection of
postcard views: Big Ben, Westminster Abbey, Tower Bridge.[51]
The Fauve "movement" was practically appropriated even

before it gained its public identity in the exhibitions of the
Indépendants and the Salon d'Automne in 1906: collectors
had spoken for major pictures; Vollard was buying out their
studios; the critic Louis Vauxcelles, who supplied them
with their supposedly derisive sobriquet, was in fact lyrically
suppportive. The Fauves came close to being the first
pre-sold avant-garde.[52]

But with that success came the sort of indeterminacy
that Pissarro had decried in Monet. Derain, writing from
L'Estaque in 1905, expressed his eloquent doubts to Maurice
Vlaminck:

> Truly we've arrived at a very difficult stage of the
> problem. I'm so lost that I wonder what words I
> can use to explain it to you. If we reject decorative
> applications, the only direction we can take is to
> purify this transposition of nature. But we've only
> done this so far in terms of color. There is drawing as
> well, so many things lacking in our conception of art.
> In short, I see the future only in terms of
> composition, because in working in front of nature
> I am the slave of so many trivial things that I lose the
> excitement I need. I can't believe that the future will
> go on following our path: on the one hand we seek
> to disengage ourselves from objective things, and on
> the other we preserve them as the origin and end
> of our art. No, truly, taking a detached point of view,
> I cannot see what I must do to be logical.[53]

With assimilation into a more or less official modernism
came the felt loss of a descriptive project and the corollary
erosion of pictorial logic. A useful contrast can, in fact, be
drawn between the work of Derain or Matisse at that
moment, and the contemporaneous work of Vlaminck, who
remained in the semi-industrialized suburban ring of Paris.
In the latter's paintings of 1904–1905, like *Houses at Chatou*,
Fauve color and gesture work against their expected conno-
tations of exuberance and ease; the deliberate instability of
the technique is instead made to stand for the raw, unsettled
quality of this particular landscape. In formal terms as well,
this painting is one of the most uncompromising and unified
Fauve works, and the artist's blunt confidence, his ability to

use the brightest colors to convey bleakness and dereliction, may well have intensified Derain's anxieties about his own direction.

A child of the suburban working class, Vlaminck in these paintings was no tourist, and this set him apart from his colleagues. Braque, who had taken liberated gesture and color the furthest toward surface abstraction, made the most decisive break with the short-lived Fauve idyll a few years later; he withdrew with Picasso from the exhibition and gallery apparatus during the crucial years of Cubist experimentation, renewing the old avant-garde commitment to collaborative practice. Even if the collectivity was reduced to the minimum number of two, the effacement of creative personality was all the greater. And that combined withdrawal and commitment to reasoned, shared investigation was tied down to specific representation—and celebration—of a compact, marginalized form of life.

Modernist practice sustains its claim to autonomy by standing, in its evident formal coherence, against the empty diversity of the culture industry, against market expediency, speculative targeting of consumers, and hedging bets. But it has achieved this contrast most successfully by figuring in detail the character of the manufactured culture it opposes. Picasso's *Aficionado* twisted the south of France idyll into an embarrassing leisure-time pose. The Dadaists of Berlin were most attentive to this potential in Cubism, seeking in their own work to expose the debility of life in thrall to industrial rationality. Raoul Haussmann wrote in 1918: "In Dada, you will find your true state: wonderful constellations in real materials, wire, glass, cardboard, cloth, organically matching your own consummate, inherent unsoundness, your own shoddiness."[54] But the example of Berlin Dada serves to demonstrate that to make this kind of meaning unmistakable was to end all of art's claims to resolve and harmonize social experience. The Cubist precedent, by contrast, had been an effort to fend off that outcome, to articulate and defend a protected aesthetic space. And because it was so circumscribed, it was overtaken, like every other successful subcultural response.

Collage—the final outcome of Cubism's interleaving of high and low—became incorporated as a source of excitement and crisp simplification within an undeflected

official modernism. In the movement's synthetic phase, translation of once-foreign materials into painted replications resolved the noisy and heterogeneous scene of fringe leisure into the sonority of museum painting. Critical distance was sacrificed further in 1915 when Picasso, in the wake of Braque's departure for the army, returned to conventional illusionism and art-historical pastiche while at the same time continuing to produce Cubist pictures. That move cancelled Cubism's claim to logical and descriptive necessity, and acknowledged that it had become a portable style, one ready-to-wear variety among many on offer. The critic Maurice Raynal, writing admiringly in 1924 of Picasso's *Three Musicians*, said more than he knew when he called it "rather like magnificent shop windows of Cubist inventions and discoveries."[55] The subject matter of that painting and others before it tells the same story: after 1914, virtually on cue, the raffish contemporary entertainers who populated previous Cubist painting gave way to Harlequins, Pierrots, and Punchinellos—sad clowns descended from Watteau and the pre-industrial past, the tritest metaphors for an alienated artistic vocation.

The basic argument of the present essay has been that modernist negation—which is modernism in its most powerful moments—proceeds from a productive confusion within the normal hierarchy of cultural prestige. Advanced artists repeatedly make unsettling equations between high and low, which dislocate the apparently fixed terms of that hierarchy into new and persuasive configurations, thus calling it into question from within. But the pattern of alternating provocation and retreat indicates that these equations are, in the end, as productive for affirmative culture as they are for the articulation of critical consciousness. While traditionalists can be depended upon to bewail the breakdown of past artistic authority, there will always be elite individuals who will welcome new values, new varieties and techniques of feeling. On the surface, this is easy to comprehend as an attraction to the glamour of marginality, to poses of risk and singularity. But there is a deeper, more systematic rationale for this acceptance, which has ended in the domestication of every modernist movement.

The context of subcultural life is the shift within a capitalist economy toward consumption as its own justification.

The success of this shift—which is inseparably bound up with the developing management of political consent—depends on expanded desires and sensibilities, that is, the skills required for an ever more intense marketing of sensual gratification. In our image-saturated present, the culture industry has demonstrated the ability to package and sell nearly every variety of desire imaginable, but because its ultimate logic is the strictly rational and utilitarian one of profit maximization, it is not able to invent the desires and sensibilities it exploits. In fact, the emphasis on continual novelty basic to that industry runs counter to the need of every large enterprise for product standardization and economies of scale. This difficulty is solved by the very defensive and resistant subcultures that come into being as negotiated breathing spaces on the margins of controlled social life. These are the groups most committed to leisure, its pioneers, who for that reason come up with the most surprising, inventive, and effective ways of using it. Their improvised forms are usually first made salable by the artisan-level entrepreneurs who spring up in and around any active subculture. Through their efforts, a wider circle of consumers gains access to an alluring subcultural pose, but in a more detached and shallow form, as the elements of the original style are removed from the context of subtle ritual that had first informed them. At this point it appears to the large fashion and entertainment concerns as a promising trend. Components of an already diluted stylistic complex are selected out, adapted to the demands of mass manufacture, and pushed to the last job lot and bargain counter.

The translation of style from margin to center depletes the form of its original vividness and subtlety, but a sufficient residue of those qualities remains such that audience sensibilities expand roughly at the rate the various sectors of the culture industry require and can accommodate. What is more, the success of this translation guarantees its cyclical repetition. While it is true that the apparatus of spectacular consumption makes genuine human striving—even the resistance it meets—into salable goods, this is no simple procedure. Exploitation by the culture industry serves at the same time to stimulate and complicate those strivings in such a way that they continually outrun and surpass its programming. The expansion of the cultural economy continually creates new fringe areas, and young and more extreme members of assimilated subcultures will regroup with new recruits at still more marginal positions. So the process begins again.

Elements of this mechanism were in place by the mid-19th century, and the rest of the century saw its coming to maturity in sport, fashion, and entertainment.[56] The artistic avant-garde provides an early, developed example of the process at work. In fact, because of its unique position between the upper and lower zones of commodity culture, this group performs a special and powerful function within the process. That service could be described as a necessary brokerage between high and low, in which the avant-garde serves as a kind of research and development arm of the culture industry.

To begin with its primary audience, the fact that the avant-garde depends on elite patronage—the "umbilical cord of gold"—cannot be written off as an inconsequential or regrettable circumstance. It must be assumed that so durable a form of social interchange is not based merely on the indulgence or charity of the affluent, but that the avant-garde serves the interests of its actual consumers in a way that goes beyond purely individual attraction to "quality" or the glamour of the forbidden. In their selective appropriation from fringe mass culture, advanced artists search out areas of social practice that retain some vivid life in an increasingly administered and rationalized society. These they refine and package, directing them to an elite, self-conscious audience. Certain played-out procedures within established high art are forcibly refused, but the category itself is preserved and renewed— renewed by the aesthetic discoveries of non-elite groups.

Nor, plainly, does the process of selective incorporation end there. Legitimated modernism is in turn repackaged for consumption as chic and kitsch commodities. The work of the avant-garde is returned to the sphere of culture where much of its substantial material originated. It was only a matter of a few years before the Impressionist vision of commercial diversion became the advertisement of the thing itself, a functioning part of the imaginary enticement directed toward tourists and residents alike.[57] In the 20th century this process of mass-cultural recuperation has operated on an ever-increasing scale. The Cubist vision of sensory flux and isolation in the city became in Art Deco a portable vocabulary for a whole modern "look" in fashion and design. Cubism's geometricization of organic form and

its rendering of three-dimensional illusion as animated patterns of overlapping planes were a principal means by which modernist architecture and interior design were transformed into a refined and precious high style. Advertised as such, now through the powerful medium of film costume and set decoration, the Art Deco stamp was put on the whole range of 20s and Depression-era commodities: office buildings, fabric, home appliances, furniture, crockery. (The Art Deco style was also easily drawn into the imagery of the mechanized body characteristic of proto-Fascist and Fascist Utopianism.)

The case of Surrealism is perhaps the most notorious instance of this process. Breton and his companions had discovered in the sedimentary layers of an earlier, capitalist Paris something like the material unconscious of the city, the residue of forgotten repressions. But in retrieving marginal forms of consumption, in making that latent text manifest, they provided modern advertising with one of its most powerful visual tools: that now familiar terrain in which commodities behave autonomously and create an alluring dreamscape of their own.

This essay has not aimed to supply a verdict on modernism in the visual arts. Recent discussion of the issue has suffered from a surplus of verdicts. Typically, one moment of the series of transformations described above is chosen as the definitive one. The social iconographers of modernism (the most recent trend in art history) largely limit them-selves to its raw material. The aesthetic dialecticians, Adorno holding out until the end, concentrate on the moment of negativity crystallized in form. The triumphalists of modernism—the later Greenberg and his followers, for example—celebrate the initial recuperation of that form into a continuous canon of value. Finally, that recuperation is the object of attack from two contradictory strains of postmodernism: the version offered by the Left sees in this moment a revelation that modernist negation was always a sham, never more than a way to refurbish elite commodities; that offered by the Right, advancing a relaxed and eclectic pluralism, sees this recuperation as insufficient and resents the retention of any negativity even if it is sublimated entirely into formal criteria.

The purpose of the present essay has been to widen discussion to include, or rather re-include, all the elements present in the original formulation of modernist theory. One motivation for writing came from reflection on the fact that the founding moments for subsequent discourses on both modernist art and mass culture were one and the same. Current debates over both topics invariably begin with the same names—Adorno, Benjamin, Greenberg (less often Schapiro, but that should by now be changing). Very seldom, however, are these debates about both topics together. But at the beginning they always were. The theory of one was the theory of the other. And in that identity was the realization, occasionally manifest and always latent, that the two were in no fundamental way separable. Culture under conditions of developed capitalism displays both moments of negation and an ultimately overwhelming tendency toward accommodation. Modernism exists in the tension between these two opposed movements. And the avant-garde, the bearer of modernism, has been successful when it has found for itself a social location where this tension is visible and can be acted upon.

[1] "The Impressionists and Edouard Manet," *Art Monthly Review* (September 30, 1876), p. 117–122; made conveniently available since the first publication of the present essay in Charles S. Moffett (ed.), *The New Painting: Impressionism 1874–1876*, Fine Arts Museum of San Francisco, San Francisco 1986, p. 28–34.

[2] Mallarmé, "Impressionists," in Moffett, *New Painting*, p. 30.

[3] Ibid.

[4] Ibid., p. 34.

[5] [Paul Signac], "Impressionistes et révolutionnaires," *La Révolte*, IV (June 13–19, 1891), p. 4; quoted in Robert and Eugenia Herbert, "Artists and Anarchism: Unpublished Letters of Pissarro, Signac and Others," *Burlington Magazine*, CII (November 1960), p. 692.

[6] For a contemporary description of the spectator in *Le Chahut*, see Gustave Kahn, "Seurat," *L'Art moderne* (April 5, 1891), p. 109–110. On Corvi and the connection to Seurat, see Robert Herbert, "'La Parade du cirque' de Seurat et l'esthétique scientifique de Charles Henry," *Revue de l'Art*, 50 (1980), p. 9–23. A monumental and maudlin depiction of the same dispirited location by Fernand Pelez was exhibited at the Salon in 1888: see Robert Rosenblum, "Fernand Pelez, or the Other Side of the Post-Impressionist Coin," in M. Barasch and L. Sandler (eds.), *Art the Ape of Nature*, Abrams, New York 1981, p. 710–712.

[7] Signac, "Impressionistes," p. 4.

[8] The lecture was given March 17, 1891, under the title "Harmonie des formes et des couleurs"; in April 1889, Signac wrote to van Gogh expressing his desire to equip workers with Neo-Impressionist color theory; see *Complete Letters of Vincent van Gogh*, III, Greenwich, CT, 1948, no. 548a. On these texts, see R. and E. Herbert, "Artists and Anarchism," p. 48 ın.

[9] Signac, "Impressionistes," p. 4.

[10] John Rewald (ed.), "Extraits du journal inédit de Paul Signac," in *Gazette des Beaux-Arts*, 6ᵗʰ per., XXXVI (July–September 1949), p. 126; entry dated September 1, 1891.

[11] Mallarmé, "Impressionists," in Moffett, *New Painting*, p. 33.

[12] Clement Greenberg, "Collage," in *Art and Culture*, Boston, 1961, p. 70–83; revision of "The Pasted Paper Revolution," 1958, reprinted in Greenberg, *The Collected Essays and Criticism*, ed. J. O'Brian, University of Chicago Press, Chicago 1992, p. 61–66.

[13] Ibid., p. 70.

[14] For the most persuasive statement of this position from the time, see Craig Owens, "The Allegorical Impulse: Toward a Theory of Postmodernism," *October*, 13 (Fall 1980), p. 79. I am happy to say that the dialogue continued when Owens took up the present argument in his assessment of the then-flourishing gallery scene on the lower east side of Manhattan, "The Problem with Puerilism," *Art in America*, LXXII (Summer 1984), p. 162–163.

[15] Greenberg, "Avant-Garde and Kitsch," in *Collected Essays*, I, p. 6.

[16] Greenberg, "Towards a Newer Laocoon," in ibid., p. 32.

[17] Greenberg, "Avant-Garde and Kitsch," p. 10–11.

[18] The historical account sketched in this paragraph is partly based on the author's research on David's pre-Revolutionary painting, the audience of the Salon exhibitions, and the politicization of culture in Paris during the final crisis of the Ancien Régime, published in "*The Oath of the Horatii* in 1785: Painting and Pre-Revolutionary Radicalism in France," *Art History*, I (December 1978), p. 424–471, subsequently incorporated into *Painters and Public Life in Eighteenth-Century Paris*, Yale University Press, New Haven and London 1985. The author's more recent *Emulation: Making Artists for Revolutionary France*, Yale University Press, New Haven and London 1995, concerns the pathos entailed in this belief for the first generation of artists to be formed

within David's studio. For Courbet at the Salon of 1851, see T.J. Clark, *The Image of the People*, Thames and Hudson, London 1972, p. 130–154 and *passim*.

[19] Meyer Schapiro, "The Social Bases of Art," proceedings of the First Artists Congress against War and Fascism, New York, 1936, p. 31–37; "The Nature of Abstract Art," *The Marxist Quarterly*, I, January 1937, p. 77–89, reprinted in Schapiro, *Modern Art: The Nineteenth and Twentieth Centuries*, George Braziller, New York 1977, p. 185–211.

[20] Schapiro, "Abstract Art," in *Modern Art*, p. 192–193.

[21] Schapiro, "Social Bases," p. 33; the passage continues: "Thus elements drawn from the professional surroundings and activity of the artist; situations in which we are consumers and spectators; objects which we confront intimately, but passively or accidentally—these are the typical subjects of modern painting ... The preponderance of objects drawn from a personal and artistic world does not mean that pictures are more pure than in the past, more completely works of art. It means simply that the personal and aesthetic contexts of secular life now condition the formal character of art ... "

[22] Ibid., p. 37.

[23] As Greenberg stated forthrightly at the conclusion of "Avant-Garde and Kitsch," p. 22.

[24] Ibid., p. 12.

[25] See, for example, Eugen Weber, "Gymnastics and Sports in Fin-de-Siècle France," *American Historical Review*, LXXVI (February 1971), p. 70–98; Richard Holt, *Sport and Society in Modern France*, Macmillan, London 1981, *passim*.

[26] See Michael Miller, *The Bon Marché: Bourgeois Culture and the Department Store 1869–1920*, Princeton University Press, Princeton 1981, *passim*.

[27] On the political convictions and involvement of both in Marxist circles of the period, see Allan Wald, *The New York Intellectuals: The Rise and Decline of the Anti-Stalinist Left from the 1930s to the 1980s*, University of North Carolina Press, Chapel Hill 1987, p. 207–208, 213–217.

[28] Karl Marx, *The Eighteenth Brumaire of Louis Bonaparte*, New York, 1963, p. 104. Recent research has documented the virulence of the official campaign against republican institutions and values during Bonaparte's brief presidency: see Thomas Forstenzer, *French Provincial Police and the Fall of the Second Republic*, Princeton University Press, Princeton 1981.

[29] Walter Benjamin, "The Paris of the Second Empire in Baudelaire," in *Charles Baudelaire: A Lyric Poet in the Age of High Capitalism*, trans. H. Zohn, New Left Books, London 1973, p. 59.

[30] Ibid., p. 106.

[31] For a detailed summary of the documents, see Bruno Chenique, "Géricault: Une Vie," in Régis Michel and Sylvain Laveissière (eds.), *Géricault*, I, Réunion des Musées Nationaux, Paris 1991, p. 280–287.

[32] See Jules Michelet, *L'Étudiant, cours de 1847-1848*, Paris, 1877. On the use of Delacroix's *Liberty* in 1848, see T.J. Clark, *The Absolute Bourgeois*, Thames and Hudson, London 1972, p. 16–20.

[33] Schapiro, "Abstract Art," p. 192.

[34] There were immediate political and biographical reasons for his shift, which the research of Serge Guilbaut has amply demonstrated: see his "The New Adventures of the Avant-Garde in America: Greenberg, Pollock, or from Trotskyism to the New Liberalism of the 'Vital Center,'" *October*, 15 (Winter 1980), p. 63–64; subsequently incorporated into his *How New York Stole the Idea of Modern Art*, University of Chicago Press, Chicago 1982, p. 21–26.

[35] Guilbaut, *How New York Stole*, p. 25, first noted this quality of openness.

[36] The term comes, of course, from the work in the sociology of leisure-based subcultures in postwar Britain fostered

during the 1970s by the Centre for Contemporary Cultural Studies at the University of Birmingham. The specific line of approach was laid out by Phil Cohen (see below) in his "Sub-Cultural Conflict and Working-Class Community," *Working Papers in Cultural Studies* (Spring 1972), p. 5–51. For a summary of work in this vein, see Stuart Hall and Tony Jefferson, *Resistance through Rituals*, Hutchinson, London 1976. A brief aside in that volume (p. 13) made the first connection between the subcultural response and the phenomenon of an artistic avant-garde: "The bohemian subculture of the *avant-garde* which has arisen from time to time in the modern city, is both distinct from its 'parent' culture (the urban culture of the middle-class intelligentsia) and yet also part of it (sharing with it a modernising outlook, standards of education, a privileged position vis-à-vis productive labour, and so on)."

[37] Hall and Jefferson, *Resistance*, p. 47.

[38] Phil Cohen, "Subcultural Conflict and Working-Class Community," p. 22–33 and *passim*.

[39] See Patricia Mainardi, "Courbet's Second Scandal, *Les Demoiselles du village*," *Arts*, LIII (January 1979), p. 96–103.

[40] Antonin Proust, *Edouard Manet, Souvenirs*, Paris, 1913, p. 15: "Quelque effort qu'il fit en exagérant ce déhanchement et en affectant le parler trainant du gamin de Paris, il ne pouvait parvenir à être vulgaire."

[41] The critical commentary in 1865 of Jean Ravenel (a pseudonym of Alfred Sensier) stressed this clash, as has been elucidated by T.J. Clark in "Preliminaries to a Possible Treatment of *Olympia* in 1865," *Screen*, XXI (Spring 1980), p. 17–22; subsequently incorporated into his *Painting of Modern Life: Paris in the Art of Manet and his Followers*: Knopf, New York, 1984, p. 139–144.

[42] See Michel Butor, "Monet, or the World Turned Upside-Down," in Thomas Hess and John Ashbery (eds.), *Art News Annual*, XXXIV (1968), p. 25.

[43] For a summary of evidence concerning the deliberate pairing of the pictures, see John House, "Meaning in Seurat's Figure Painting," *Art History*, III (September 1980), p. 346–349.

[44] Emile Verhaeren, "Georges Seurat," *La société nouvelle*, April 1891, trans. Norma Broude, in *Seurat in Perspective*: Prentice-Hall, Englewood Cliffs, 1978, p. 28.

[45] See Robert Herbert, "Seurat and Jules Chéret," *Art Bulletin*, XL, March 1958, p. 156–158.

[46] Verhaeren, "Seurat," p. 28.

[47] See Holt, *Sport and Society*, p. 115–120.

[48] T.W. Adorno, "On Commitment," in A. Arato and E. Gebhardt (eds.), *The Essential Frankfurt School Reader*, Blackwell, Oxford 1978, p. 318.

[49] Mallarmé, "Impressionists," p. 33.

[50] Letter of January 9, 1887, in Camille Pissarro, *Letters to His Son Lucien*, ed. J. Rewald, Kegan Paul, London 1943.

[51] See J.P. Crespelle, *The Fauves*, New York, 1962, p. 112.

[52] See Ellen Oppler, *Fauvism Reexamined*, Garland, New York 1976, p. 13–38.

[53] André Derain, *Lettres à Vlaminck*, Flammarion, Paris 1955, p. 146–147.

[54] See Raoul Hausmann, *Courrier Dada*, Le Terrain Vague, Paris 1948, p. 40.

[55] Maurice Raynal, "Quelques intentions du cubisme," *Bulletin de l'effort moderne*, 4, p. 4; quoted in Benjamin H.D. Buchloh, "Figures of Authority, Ciphers of Regression," *October*, 16 (Spring 1981), p. 44.

[56] See William Weber, *Music and the Middle Class*, Croom Helm, London 1975, p. 105–106. Weber describes how artisan-class, radical choral groups emerged during the Revolution of 1830 and by 1832 were sufficiently organized to give a massed concert involving 20 singing clubs and six hundred singers. Several of the clubs subsequently

began to perform at commercial theaters and promenade concerts. This improvised form of communal musical life was suppressed by the state in the general crackdown of 1833–1835, but the form was resurrected by an entrepreneur named William Wilhem, who began receiving state subsidies for singing classes in 1836. Called the Orphéon Societies, their membership was drawn primarily from the working and artisan classes, but the audience at their well-attended and fairly expensive concerts was middle class and aristocratic. The climax of the development came in 1859 when the Orphéon Societies were summoned to perform in the new Palace of Industry for Napoleon III.

[57] The work of Toulouse-Lautrec as a designer and illustrator can be taken as emblematic of this shift. His cultivated irony, perversity, and compositional extremism continued previously established kinds of avant-garde attention to lowlife spectacle. In his commercial work, however, certain patented modernist devices became the preferred vocabulary of an emerging sector of the entertainment industry. The collapse of art into its subject was displayed as concretely as possible in 1895, when the Folies-Bergère entertainer La Goulue went out on her own at the Foire du Trône, setting up her act in a structure that appeared from the outside to be literally constructed out of two large painted panels by Lautrec. See P. Huisman and M.G. Dortu, *Lautrec by Lautrec*, New York, 1964, p. 84.

This essay was first published in Thomas Crow, *Modern Art in the Common Culture*, Yale University Press, New Haven 1983. Reprinted with the permission of Yale University Press.

Imprint

Edited by Chantal Pontbriand

EDITORIAL COORDINATION
Clément Dirié

COPY EDITING
Clare Manchester

DESIGN CONCEPT
Gavillet & Rust, Geneva

DESIGN
Nicolas Eigenheer, Vera Kaspar

TYPEFACE
Genath (www.optimo.ch)

PRINT AND BINDING
Musumeci S.p.A., Quart (Aosta)

Parachute: The Anthology is a project initiated in 2000, on the occasion of the 25th anniversary of the publication.
A preselection of texts was elaborated with the contribution of the editorial team at the time: Chantal Pontbriand (editor), Colette Tougas (managing editor), Jim Drobnick, and Thérèse Saint-Gelais (both assistant editors).
Sarah-Jane Lewis coordinated the project for *Parachute* in the years 2003 and 2004. A book in French entitled *Parachute, Essais choisis 1975-2000* was published in 2004 by La Lettre volée, Brussels. The current table of contents was established following the initial preselection, with the input of the editors at JRP|Ringier.

Parachute wishes to thank the authors for giving their permission for the reproduction of their text, as well as the artists and other lenders who have supplied images. Finally, we are most grateful to our readership, to the governmental agencies in Canada and Québec, for their continuous support, and to the galleries and museums that also supported the publication through publicity throughout the years. This particular project has been realized through the support of the Canada Council for the Arts and the Conseil des Arts et Lettres du Québec.

Canada Council Conseil des arts
for the Arts du Canada

Conseil des arts
et des lettres
Québec

PUBLISHED BY
JRP | Ringier
Limmatstrasse 270
CH–8005 Zurich
T +41 43 311 27 50
E info@jrp-ringier.com
www.jrp-ringier.com

IN CO-EDITION WITH
Les presses du réel
35, rue Colson
F–21000 Dijon
T +33 3 80 30 75 23
E info@lespressesdureel.com
www.lespressesdureel.com

ISBN 978-3-03764-196-5 (JRP | Ringier)
ISBN 978-2-84066-575-5 (Les presses du réel)

Distribution

JRP|Ringier publications are available internationally
at selected bookstores and from the following distribution
partners:

GERMANY AND AUSTRIA
Vice Versa Vertrieb
www.vice-versa-vertrieb.de

FRANCE
Les presses du réel
www.lespressesdureel.com

SWITZERLAND
AVA Verlagsauslieferung AG
www.ava.ch

UK AND OTHER EUROPEAN COUNTRIES
Cornerhouse Publications
www.cornerhouse.org/books

USA, CANADA, ASIA, AND AUSTRALIA
ARTBOOK | D.A.P.
www.artbook.com

For a list of our partner bookshops or for any general
questions, please contact JRP|Ringier directly at
info@jrp-ringier.com, or visit our homepage
www.jrp-ringier.com for further information about
our program.

Documents Series 9:
Parachute: The Anthology [Vol. I]

This book is the ninth volume
in the "Documents" series,
dedicated to critics' writings.

The series is directed by
Lionel Bovier and Xavier Douroux.

Parachute: The Anthology
Next volumes:
Performance and Performativity [Vol. II]
*Photography, Film, Video, and
New Media* [Vol. III]
*Painting, Sculpture, Installation,
and Architecture* [Vol. IV]

Also available

DOCUMENTS SERIES (IN ENGLISH)

Saul Anton, *Warhol's Dream*
ISBN 978-3-905770-35-3 (JRP | Ringier)
ISBN 978-2-84066-200-6 (Les presses du réel)

Dorothea von Hantelmann, *How to Do Things with Art*
ISBN 978-3-03764-104-0 (JRP | Ringier)
ISBN 978-2-84066-361-4 (Les presses du réel)

Christian Höller, *Time Action Vision*
ISBN 978-3-03764-124-8 (JRP | Ringier)
ISBN 978-2-84066-396-6 (Les presses du réel)

Bob Nickas, *Theft Is Vision*
ISBN 978-3-905770-36-0 (JRP | Ringier)
ISBN 978-2-84066-206-8 (Les presses du réel)

Hans Ulrich Obrist, *A Brief History of Curating*
ISBN 978-3-905829-55-6 (JRP | Ringier)
ISBN 978-2-84066-287-7 (Les presses du réel)

Gabriele Detterer & Maurizio Nannucci, *Artist-Run Spaces*
ISBN 978-3-03764-191-0 (JRP | Ringier)
ISBN 978-2-84066-512-0 (Les presses du réel)

Raymond Bellour, *Between-the-Images*
ISBN 978-3-03764-144-6 (JRP | Ringier)
ISBN 978-2-84066-513-7 (Les presses du réel)